INSIDE THE
OHIO PENITENTIARY

INSIDE THE
OHIO PENITENTIARY

DAVID MEYERS, ELISE MEYERS WALKER
AND JAMES DAILEY II

THE
History
PRESS

Published by The History Press
Charleston, SC 29403
www.historypress.net

First published 2013

ISBN 9781540208651

Library of Congress Cataloging-in-Publication Data

Meyers, David, 1948-
Inside the Ohio Penitentiary / David Meyers, Elise Meyers Walker and James Dailey II.
pages cm
Includes bibliographical references and index.
ISBN 978-1-62619-097-9
1. Ohio Penitentiary (Columbus, Ohio) 2. Prisons--Ohio--History. I. Walker, Elise
Meyers. II. Title.
HV9475.O4M49 2013
365'.977157--dc23
2013025759

Contents

Acknowledgements

T here were a lot of people who contributed to this book simply by listening when we were thinking out loud. If you were one of these people, consider this your thanks in case we neglected to say something at the time. Your forbearance was appreciated, especially if you were one of those people who didn't really care about prison history. We would also like to acknowledge those who went out of their way to provide us with assistance, encouragement and tolerance: Beverly Meyers, Sam Walker, Lindsay Boggs, Jack Parente, Perry Dailey, Pam Coon, Michael Dailey, Jim Bowsher, Tara Narcross, Joe Gartrell, Karen Wilcox, Kent Crabtree and Tom Smith. Every image used in this book was taken from the Dailey Archives except for those provided by Tom Smith and the Library of Congress.

Introduction

It's ugly, ugly, ugly—a scar on the face of Columbus.
It's a monument to many thousands of mistakes.
 Dana "Buck" Rinehart

When Mayor Dana Rinehart personally clobbered the façade of the old Ohio Penitentiary with a wrecking ball on August 1, 1990, spewing bricks and concrete across the parking lot, historians, preservationists and state officials were aghast. It may not have been the worst crime ever committed in Columbus, but the city's top-elected official had not only merely but also most sincerely broken the law. Despite making a $100,000 down payment to purchase the property, he had not secured permission to demolish it. Neither had he commissioned the required study to determine whether the existing buildings could be reused. Instead, Rinehart had climbed up onto the crane's seat and struck a blow for freedom—sort of.

"I know I probably shouldn't have done it," Rinehart later conceded. "But we were trying to get the message across that we don't have to be the way we are." Always controversial, the feisty young politician had been reelected unopposed just three years earlier and was determined to change the face of the city. To his mind, knocking down stuff in order to start over seemed like a good first step. He wanted to start out with a blank canvas. What he got was the threat of a fine from the EPA while the city scrambled to erect a fence around the site and patch up the damage.

It wasn't until 1997 that "Buck" (a fitting nickname if ever there was one) got his way—and then only after a large portion of the imposing west wall unexpectedly collapsed onto Neil Avenue, burying a car beneath tons of rubble.

The "ugly dinosaur eyesore" was finally razed. But by this time, the mayor had changed his tune. He was insisting that portions of the remaining edifice should be preserved. Otherwise, "it would be a grievous loss to the city of Columbus."

Grievous loss or not, the Ohio Penitentiary (OP) was completely torn down and hauled away while tiny chunks of stone were hawked as souvenirs. The former prison site has since completely disappeared beneath the offices, condominiums, restaurants and other assorted buildings that constitute the Arena District. As was hoped, this development did inject new life into the downtown, although partially at the expense of an earlier one, the Brewery District. But there are some who continue to believe that the old prison façade would have made a distinctive architectural feature or a truly Spartan bed-and-breakfast.

Fifteen years after the Ohio Penitentiary was leveled, memories of it remain. After all, it had been one of the most prominent landmarks in the capital city for more than 160 years, second only to the statehouse. Time was that the citizens of Columbus took particular pride in their new prison, which was hailed widely as being the best the country had to offer (but in those days there was little else in the young city to boast about). Later, however, they were equally ashamed of the hellhole it had become.

Those who worked there and those who lived there have similarly conflicted attitudes. Some feel it should have been preserved as a symbol of man's inhumanity to man. Others believe it deserved to be torn down for the same reason. And a few think that it should have been left standing because—good or bad—it was a part of our history and we tend to forget things when they are out of sight.

Inside the Ohio Penitentiary is just that: a collection of true stories about life inside the legendary prison. For the most part, they are not happy or inspiring or educational. Nobody wants to read those. (Seriously, go to any library; true crime is where the action is.) Rather, it's about the men, and occasional woman, who didn't get with the program but continued to find trouble to get into, even after being locked away. The focus is on what they did behind the walls rather than how they got there (although there is some of that, too): the executions and the escapes, the riots and the fires, the rumors and the madness. Sartre could have been thinking of the Ohio Penitentiary when he wrote: "Hell is other people." He wasn't of course, but few would argue it didn't apply.

Along with Elise, my daughter and coauthor of three previous books, I am joined, this time, by our friend James Dailey, proprietor of the Dailey Archives, one of the most impressive collections of prison memorabilia anywhere. Let this be your introduction to it and him.

David Meyers

"The Year Clark Was Hung"

During the nineteenth century, there were few spectacles that could simultaneously unite the law-abiding community and provide an object lesson for the young and impressionable like a public hanging. This was certainly true on February 9, 1844, when an estimated eight to twenty thousand people gathered on a bitter cold day to watch the first "legal" execution ever held in Franklin County.[1] "For a week or ten days every road leading to Columbus, for the distance of fifty or one hundred miles, was lined with wagons and vehicles of every character, bringing whole families" to see William Graham (a.k.a. James or William Clark) and Esther (possibly Hester) Foster die on the gallows.[2] Due to the freezing weather, many of the spectators took refuge inside taverns and public houses for as long as possible.

Although the event was not scheduled to take place until two o'clock in the afternoon, ordinary citizens began assembling at the site the day before and continued to arrive throughout the night. Among them were members of the Columbus Guard, a local militia group, who had a personal stake in seeing that Graham got his just desserts: his victim had been one of them. No less than a quarter of those in attendance were "FEMALES!"—a fact local newspaper reporters found both fascinating and appalling, particularly when some of them began pushing and shoving in order to get a "conspicuous position, so that they could gloat their eyes with the rare sight."[3]

Public executions were not an especially rare occurrence during the nineteenth century, although a double event was, and the hanging of a man and a woman side by side was virtually unheard of.[4] A little over a year

earlier, some fifty thousand spectators had swarmed Bellefontaine to see Andrew Hellman swing for poisoning his children. And just a month before, a crowd of some fifteen to twenty thousand flocked to Zanesville to witness the hanging of Solomon Shoemaker for the murder of his brother.[5]

One county often borrowed a scaffold from another as a cost-savings measure, and executing two people on the same day was even more economical. Unfortunately, the officials charged with carrying out the sentence were typically "amateurs," having no previous experience in putting someone to death. As a result, some hangings were badly botched.[6] For example, in 1858, Ohio Penitentiary inmate Albert Myers lived for ten minutes and forty-five seconds "after the drop," undoubtedly because his neck failed to break. In 1885, it took eleven minutes for James Greiner to have the life choked out of him in the Franklin County jail.[7] A year later, the noose slipped when William Bergin was being hanged in Mount Vernon, and he fell to the ground. Hauled back up on the platform, he was dropped through the trap a second time. It took twenty-eight minutes for him to slowly strangle to death. When Patrick Hartnett was hanged at the Ohio Penitentiary in 1894, a group of prison guards had to support his body as it dangled at the end of the rope, fearful he would be decapitated. The same thing happened a year later, when Michael McDonough was dropped a distance of six feet and blood from his partially severed neck drenched nearby spectators. There was a science to hanging people that involved taking into consideration weight, height, drop distance, etc., but there were few earnest students.

In 1840, Columbus was a budding community with a population of 6,048, which climbed to 17,882 just ten years later. It had little to recommend it, save for the fact that it was the state capital and the site of a rather fine new penitentiary opened in 1834. That same year, Graham was sentenced to fifteen years for highway robbery. He was twenty years old and headstrong; twice he tried to escape. On June 9, 1841, Graham, who worked in the penitentiary stone shop, had slain the twenty-two-year-old guard Cyrus Sells by striking him with a cooper's ax while he was combing his hair. Five blows had nearly severed his head from his body.[8] Sells had earlier whipped the entire prison company for some violation of prison rules, and Graham had vowed revenge.[9]

Foster, a resident of the prison's Female Department, was serving a twenty-year sentence for aiding an assault and rape with intent to murder. Although it was an ugly offense, the penalty was still regarded as unusually harsh. A former chambermaid from Cincinnati, she had killed another

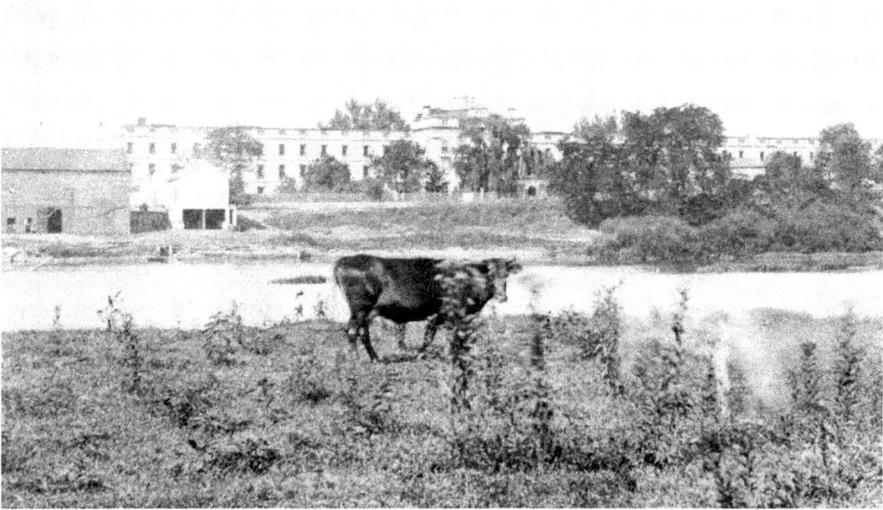

An early view of the Ohio Penitentiary when Columbus was truly a "cow town." *Courtesy of the Dailey Archives.*

female convict, Louisa White, on March 13, 1843, by bashing in her head with an iron fire shovel while they were working in the kitchen. Until then, Foster had been a rather docile inmate.

According to early prison historian Daniel J. Morgan (superintendent of the prison school), Foster was assisted by another prisoner, whose trial, for some reason, was continued until the next term. Nothing more was heard of her.[10] What is known, however, is that the victim was white and Foster was "colored" (as was her codefendant). Foster purportedly was a woman of limited intelligence who "did not have a bad history."[11] Graham, on the other hand, had been a troublesome inmate from the start. Sells was a member of the soon-to-be-famous Sells Brothers circus family.[12] He was also the first prison employee killed in the line of duty.

Because Graham's trial was postponed until December 1843 at the request of his attorneys, both cases—his and Foster's—were tried in the same term of court. Graham's defense was insanity. He was represented by Gustavus Swan, later president of the State Bank of Ohio, and John W. Andrews.[13] Swan, who had never lost a criminal case, said that if he lost this one, he would never practice law again. He did, and he didn't.[14] While the name of Foster's attorney is unknown, many openly questioned the first-degree murder charge against her since the crime clearly was not premeditated. However, prosecutor John Heyl, a young and relatively

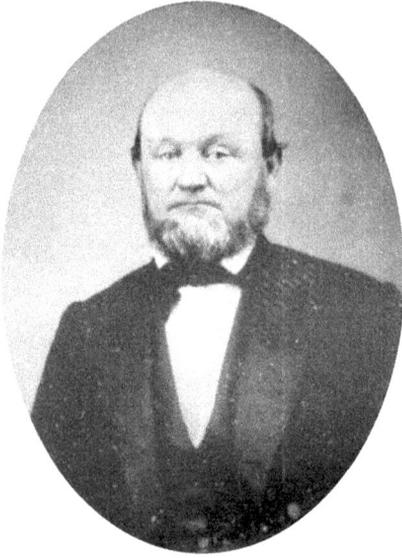

Sheriff William Domigan had the responsibility of overseeing the first (and last) public hanging in Columbus. *Courtesy of Tom Smith.*

inexperienced attorney, prevailed in both cases, assisted by Colonel Noah H. Swayne.[15]

From the time of Ohio's founding in 1803, all executions were public events carried out in the county in which the offense took place. As Stuart Banner wrote in *The Death Penalty: An American History*, "Hangings were conducted outdoors, often before thousands of spectators, as part of a larger ritual including a procession to the gallows, a sermon, and a speech by the condemned prisoner." For Franklin County's first official execution, a scaffold was constructed in a ravine that created a natural amphitheater. This was adjacent to "old Penitentiary hill" at Scioto Street and Court Alley (near Mound Street), site of the original Ohio Penitentiary.

"It was truly the greatest event in the history of Columbus and for years was computed by the elder inhabitants by referring to 'the year Clark was hung [*sic*].'"[16] A reporter for the *Ohio State Journal* wrote, "We witnessed this day more drunkenness, more brutality and more calculated to degrade men in the estimation of their fellow beings, than we ever beheld in one day, save on a similar occasion." In fact, one respected Franklinton citizen, Sullivan Sweet, a blacksmith, was accidentally bowled over by the crowd and trampled by a horse. His face and head were "horribly mangled," and he died several hours later.[17]

As the time approached, several ministers attempted to pray with the condemned. An emotional Foster knelt to join the pastors in prayer. If she had any last words, they were not recorded. Graham, however, twice refused to participate, defiant to the end. He did make a short statement: "My name is Graham, my father and brother killed a traveler in Missouri and were lynched for it." His last words were, "Let her go quick." After a "short, fervent and solemn exhortation" by Reverend Whitcomb, Sheriff William Domigan adjusted the nooses around Graham's and Foster's necks, and then they dropped through the trapdoor and into eternity. Domigan's grandfather

(and namesake) was one of the original pioneers of Franklinton. He arrived in the county with Lucas Sullivant and others in 1797. When Ohio became a state in 1803, he was issued one of the first two tavern licenses in Franklin County. William, born in 1812, was elected to the first of four two-year terms as sheriff in 1841.[18]

Whether Foster and Graham died quickly or not is unknown. In exchange for all the "candy and sweetmeats" she could eat, Foster had agreed to allow a Columbus doctor to dissect her body after her death. A number of other local physicians attended Graham's autopsy to test a theory held by many phrenologists that criminals had certain physiological deficiencies and could not be held morally responsible for their behavior. However, there was disagreement over what his brain revealed.[19]

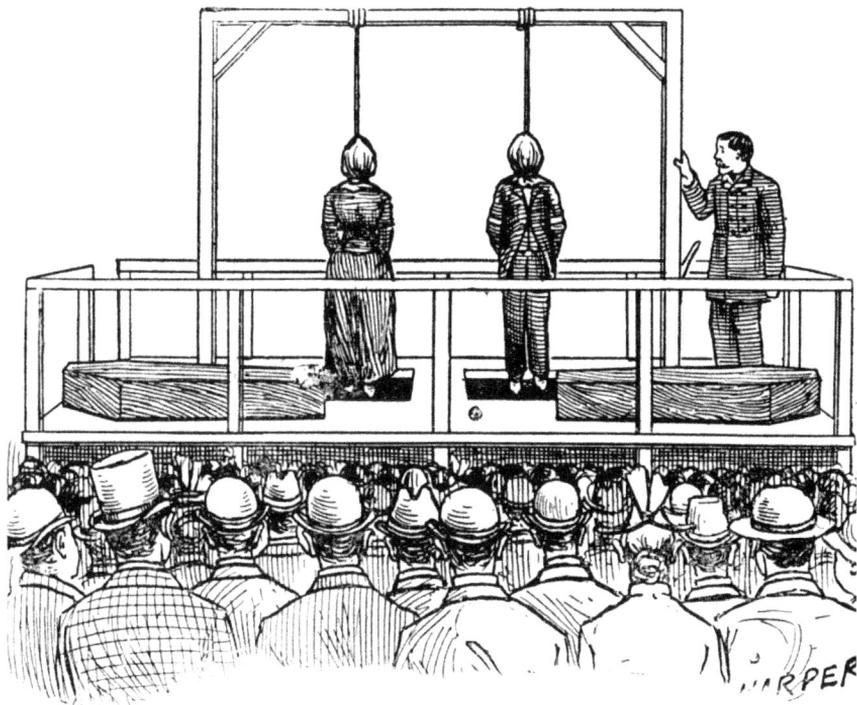

The "dual event" was captured in this widely circulated woodcut from *Harper's Magazine*. *Courtesy of the Dailey Archives.*

Sheriff Domigan had promised Graham that he would not end up as an anatomical specimen, so his remains were interred in the old prison graveyard nearby. Nevertheless, two groups of physicians had designs on Graham's corpse. As one crew was digging him up, the other fired on them, causing the would-be grave robbers to flee. The rival group then took possession of the body. For many years, Dr. Ichabod Gibson Jones and his colleague, Dr. Little, kept one of Graham's feet in a body of alcohol in their office on East Town Street between High and Third Streets. And a "good wax figure likeness" of Graham was on display at Captain Walcutt's museum.[20]

In 1861, some seventeen years after the execution of Clark and Foster, an armory was built at 139 West Main Street on the site of the original Ohio Penitentiary. This Italianate-style brick building continued to serve as an armory for more than one hundred years before being renovated in 1976 by the Columbus Recreation and Parks Department for use as the Cultural Arts Center.

According to Robin Smith in *Columbus Ghosts*,[21] there have been several reported sightings of a phantom woman in nineteenth-century dress in the pottery room addition on the west side of the building. Not surprisingly, the ghost has been named "Esther" or "Hester," but that is highly speculative. The race of the ghost has not been mentioned, nor does she apparently wear stripes.

Of course, the building has no connection to the historic Esther Foster. And the exact site of the temporary gallows on which she died had been forgotten within ten years of the event. Even the mound of earth on which it stood had been leveled, and the sand and gravel hauled away and sold. A less well-defined spirit with no name and no back story also purportedly haunts the basement of the building, but it has not been reported that it is missing a foot.

Chapter 2

The Greatest Escape

Although the state of Ohio played a major role in nearly every other aspect of the American Civil War, there were only two battles fought within its borders—Buffington Island[22] and Salineville—and they were rather minor skirmishes at that. On the other hand, one of the most famous incidents of the entire conflict was the daring escape from the Ohio Penitentiary by a band of Confederate prisoners. The key figure in both the battles and the escape was General John Hunt Morgan.[23]

A native of Alabama, Morgan was born in 1825, the first of ten children. His grandfather, John Wesley Hunt, was the former postmaster of Lexington, Kentucky, and a millionaire horse-breeder. After his father's business failed, young Morgan moved with his parents to his grandfather's ranch. He attended Lexington's Transylvania College but was suspended for dueling with a fraternity brother. He subsequently joined the military in 1846 and saw service in the Mexican-American War. When he married two years later, he had risen to the rank of first lieutenant. In 1849, John Wesley Hunt died, leaving a fortune to his daughter and Morgan's mother, Henrietta. However, Morgan had little interest in a life of leisure.

Instead, Morgan attempted to organize his own military company in 1852, while still in his twenties. However, the artillery unit he founded was disbanded by the state a couple years later. Three years after that, he established the Lexington Rifles, an independent infantry. He then enlisted in the U.S. Army but left in 1862 to join the army of the Confederacy. He was appointed colonel of the Second Kentucky Cavalry and led them with

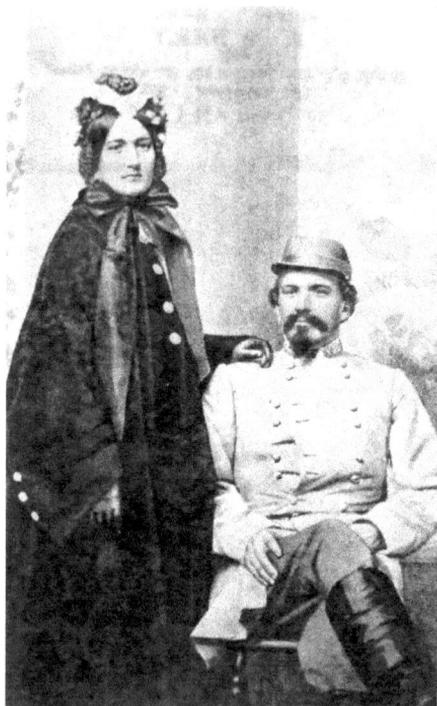

Brigadier General John Hunt Morgan and his wife, Martha "Mattie" Ready. *Courtesy of the Dailey Archives.*

distinction in the Battle of Shiloh. After several more successful campaigns, Confederate president Jefferson Davis promoted Morgan to brigadier general.

There are few episodes of the Civil War better known than "Morgan's Raid." From June through July 1863, Morgan and a crack group of cavalry crossed the Ohio River into southern Ohio and Indiana, capturing soldiers and plundering Union supplies. It was a brilliant move from a public relations standpoint but politically dangerous because General Braxton Bragg had expressly forbidden him to do it. Nevertheless, Southern newspapers applauded Morgan, calling his exploits "the Great Raid of 1863." Their Northern counterparts, however, mocked what they dubbed "the Calico Raid" because most of what the soldiers stole was from private houses and general stores.

On July 19, Morgan's Raiders were routed as they tried to ford the Ohio River to West Virginia near Buffington Island. More than half of his 1,700 troops were captured and shipped off to Camp Douglas, a prisoner-of-war camp near Chicago. The remaining men, approximately 200, were caught at Salineville, near Lisbon, Ohio, seven days later. Morgan and 30 of his officers were packed off to the Ohio Penitentiary. They arrived in Columbus by train from Cincinnati on July 30.[24]

As prisoners of war, Morgan and his officers were not given numbers and were treated better than common criminals—but not much. To their chagrin, they were "scrubbed in hogsboards of water by negro [sic] convicts, and all their heads were shaved and their beards shaven off." Several days later, they were joined by sixty-eight other officers under the command of General Basil Duke, Morgan's second in command, brother-in-law and eventual biographer. He arrived from Johnson's Island, where he had been shipped following his capture at Buffington Island. Meanwhile, the remnant

of Morgan's troops was incarcerated at nearby Camp Chase Military Prison on the west side of Columbus under much more austere conditions.

By order of Governor David Tod, the Confederate officers were prohibited from working in the penitentiary shops in an effort to separate them from the other inmates. Many years after the conclusion of the war, one of them expressed his belief that if they had been allowed in the shops, they would have most certainly taken the prison over. According to a memo, the governor instructed Warden

Morgan and his officers were confined at the Ohio Penitentiary for fear that they might escape from a regular prison camp. *Courtesy of the Dailey Archives.*

Nathaniel Merion to "furnish them everything necessary in the way of food and clothing for their comfort, and impose only such restrictions upon them as may be necessary for their safe keeping."[25]

As POWs, Morgan and the men were technically prisoners of the U.S. military. Their incarceration was paid for and controlled by the federal government in the person of Major General Ambrose E. Burnside. Burnside promptly prohibited them from speaking to the press or giving interviews. Secretly, he was of the opinion that there was not an existing military prison capable of holding them.

Unwilling to accept confinement, General Morgan and his officers planned to escape by tunneling their way under the cellblock. On the night of November 27, 1863, twelve to fifteen of them carried out their plan. For six weeks, they had been digging a hole from the cell of Thomas Hines into the prison's inner yard, breaking into a preexisting air duct and hiding the excavated dirt in it. Hines had been reading Victor Hugo's famous novel *Les Misérables* and was reportedly inspired by Jean Valjean's escape through the sewers and catacombs of Paris. He also had theorized there was an air duct below his cell because, despite a lack of sunlight, there was never any mold.[26]

Although a dozen or so men participated in the plan, only seven—Morgan, Hines, Captain Ralph Sheldon, Captain Samuel B. Taylor, Captain Jacob C. Bennett, Captain L. D. Hockersmith and Captain Augustus (or G.S)

Magee—actually slipped out of the penitentiary. After crawling through the tunnel, they emerged into a driving rain. Under cover of darkness, they climbed over the outer walls using a homemade grappling hook fashioned out of bed sheets and a fireplace poker. The officers who stayed behind included Morgan's younger brothers, Colonel Richard "Big Dick" Morgan and Captain Charlton Morgan, and brother-in-law Basil Duke. Dick had traded his first-floor cell for John Hunt's second-floor cell to aid the latter's escape. Basil would have escaped as well, but no suitable cell "trade" could be found for him.[27]

Hines left the following note behind in his cell:

> *Warden N. Merion, the Faithful, the Vigilant. Castle Merion, Cell No. 20. November 27, 1863. Commencement, November 4, 1863. Conclusion, November 20, 1863. Hours for labor per day, three. Tools, two small knives. La patience est amere, mais son fruit est doux.* [Patience is bitter, but its fruit is sweet.] *By order of my six honorable confederates. Henry Hines, Captain C.S.A.*

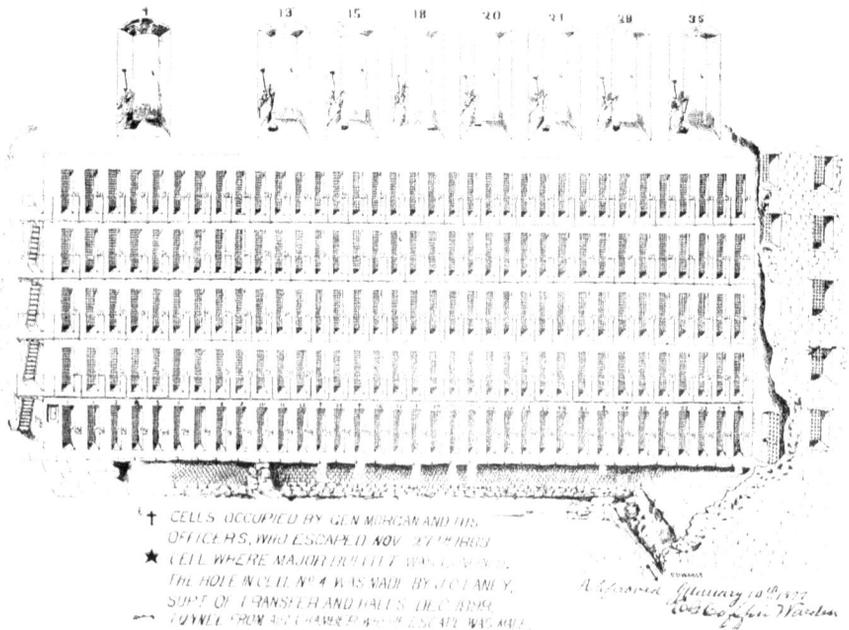

This diagram shows the relationship of the officers' cells to the tunnel through which they made their escape. *Courtesy of the Dailey Archives.*

While authorities searched cellars throughout the Columbus area on the chance that escapees were still in town, the men hopped a train to Cincinnati that was scheduled to arrive in the morning. Both Morgan and Hines exited the train before it pulled into the station, hired a boat to take them across the Ohio River and disappeared into Kentucky. Sheldon and Taylor were caught several days later, but Bennett, Hockersmith and Magee were never retaken. A $1,000 reward was offered for Morgan, dead or alive. After hearing of the escape, a Southern sympathizer in Canada, coincidentally named J.H. Morgan, started registering in local hotels under that name. This led the Union to focus its attention on Canada and away from Kentucky.[28]

For at least one night, Morgan and Hines were put up in the home of Ben Johnson in Bardstown, Kentucky, before making their way to Confederate lines. Both Ben and his father were state senators. Ben's mother, Nancy, had been a member of the committee to pick the Confederate flag. Morgan also sought the assistance of William (Will) Samuel Pryor, a future chief justice of the Kentucky Supreme Court and neighbor Frank Pollard, as noted by Hines in his memoirs, and by the descendants of Pryor and Pollard.

In a contemporary account, Hines was described as a "mason and bricklayer." He also turned out to be quite an amateur escape artist. Recaptured in Tennessee, he was sentenced to hang. However, he put his guards at ease by telling stories, incapacitated them when they were distracted and got away. Although he was soon apprehended, Hines escaped yet again before making his way back home. Later that year, he was dispatched to Canada on a mission for the Confederacy. When Union soldiers came to the house he was staying in, he hid in a mattress that was beneath the homeowner's bedridden wife. He later slipped out among guests who had come to visit the sick woman, concealed beneath an umbrella.

On his return to the South, Morgan was assigned to command an undisciplined and talentless bunch of men in Tennessee as punishment for defying General Bragg's orders not to cross the Ohio River. Stubbornly, he resumed his raids with his new regiment and was killed by the Union forces in 1864. It is popularly believed that the Grand Army of the Republic had no interest in taking him alive for fear that he would only escape from prison again.

A rumor came to light thirty years later when the *Columbus Dispatch* reported that Civil War veteran John Radebaugh claimed that Morgan's break from the Ohio Penitentiary had actually been a release disguised as an escape to keep from riling up an already excitable public. A reporter had originally contacted Radebaugh in an effort to get the names of the men who led the horses for Abraham Lincoln's hearse, but the old man was

Fighting opposite Morgan during the Civil War was Union general Charles C. Walcutt, who later became warden of the Ohio Penitentiary. *Courtesy of the Dailey Archives.*

eager to tell an even more interesting story. As chief clerk to U.S. assistant quartermaster, Colonel Raymond Burr, he claimed that he had attended a secret meeting with Governor Tod, Colonel Young, Warden Merion, Colonel Burr, Secretary of War Edwin Stanton and several others to discuss the subject of Morgan's captivity. Stanton felt that the general was being held illegally and in violation of the rules of war, since he was confined in the Ohio Penitentiary instead of a POW camp. As a result, the Confederates were threatening retaliation against Union prisoners.

Radebaugh said that after Morgan and his six companions "walked out the front door," he had personally escorted the general to the Columbus train depot. He chose to make his tale public in 1895 because he believed that he was the last man alive who knew the "real story," and he was worried it might die with him. However, some minor aspects of his account do not coincide with what is known to be true, including the time of the escape. Radebaugh said that he met General Morgan at ten o'clock in the evening, but it is believed the general did not scale the wall until midnight. Furthermore, he does not explain why Morgan's brothers and brother-in law had to be left behind if it was so easy to walk out the door. It would also be unlikely that the scheme could be kept secret so many years when at least some of the guards would have had to be privy to it.

In December 1898, Radebaugh's story was roundly refuted when all surviving members of Morgan's Raiders involved in the escape were invited back to the penitentiary to help explain exactly how they had accomplished it. Unfortunately, only three of them remained. Morgan and Hines were

both gone, Hines having died earlier that year. He was buried in his family's plot in Kentucky with his distant cousin, famous food authority and brand name, Duncan Hines.

Thomas Bullitt, a lieutenant in Morgan's command, denied that anyone other than the officers who escaped and the officers that assisted knew about the plan. He had participated in the escape but did not leave the prison himself. He was in cellblock number four, too close to a guard to chance it. But he did admit to helping dig the tunnel with stolen dinner knives and one shovel and helping "clean-up" the dig site every morning before inspection. (In 1898, a carload of dirt was discovered in the air duct under the cells from which they had escaped.)[29] He also dismissed the rumor that Warden Merion had assisted in any way, adding that he had never liked the man.[30]

Radebaugh's story was also contradicted by the General Morgan's brother Captain Charlton Morgan. His description of the incident was virtually identical to Bullitt's, but he added the intriguing detail that the seven escapees left dummies in their cots. He even claimed to have heard the warden exclaim, upon discovering that the escapees were all from the first floor (and not the second where Morgan was housed), "I am glad the General did not escape. I would rather all the rest got away than him. Let's go up and see the General." Of course, when they went to the general's cell, Merion found brother Dick in his place and realized that he had been duped. Charlton's account does differ from Bullitt's in that he claimed none of the other men knew of the escape until they were gone. But at the very least, Bullitt, Dick and Duke must have.

Immediately after Morgan's escape, rumors began to circulate that the Rebel prisoners had been assisted by so-called copperhead sympathizers to the Southern cause who were members of the prison staff. Although Ohio was solidly in the Union, the same could not be said of all of its citizens. The Civil War had divided many families, communities and institutions. There were Confederate sympathizers everywhere. Finally, in 1911, a newspaper article claimed that "further investigation" disclosed that there never was a tunnel dug under penitentiary.[31] But by then, Morgan's cell was also gone.

Until new cells were installed in 1909, cell twenty-one in the old East Hall, Morgan's cell, was a popular feature of any Ohio Penitentiary tour. At that time, it was purchased by Kentucky businessman John A. Kelley for shipment to the John Hunt Morgan Memorial in Lexington. However, according to David Roth, publisher of *Blue & Gray* magazine, there is no record of it ever being received there, and its whereabouts are unknown.

Chapter 3

America's First Vampire

America's first vampire was born in Columbus, Ohio. Not born, really, but likely invented—the creation of a forgotten newspaper reporter. And whether he was actually the first "vampire" is also a matter of dispute, as is nearly every other "fact" known about him.

In 1892, five years before novelist Bram Stoker gave the world *Dracula*, James Brown, a convicted murderer, was transferred from the Ohio Penitentiary, where he had been imprisoned since 1889. Some five hundred miles away, the *Brooklyn Daily Eagle* reported:

> *Columbus, Ohio, Nov. 4.—Deputy United States Marshal Williams of Cincinnati has removed James Brown, a deranged United States prisoner, from the Ohio Penitentiary to the National Asylum at Washington, D.C. The prisoner fought like a tiger against being removed.*
>
> *Twenty-five years ago he was charged with being a vampire and living on human blood. He was a Portuguese sailor, and shipped on a fishing-smack from Boston up the coast in 1867. During this trip two of the crew were missing, and an investigation made. Brown was found one day, in the hold of the ship, sucking the blood from the body of one of the sailors. The other body was found at the same place, and had been served in a similar manner. Brown was returned to Boston and convicted of murder and sentenced to be hanged. President Johnson commuted the sentence to imprisonment for life.*
>
> *After serving fifteen years in Massachusetts he was transferred to the Ohio prison. He has committed two murders since his confinement. When*

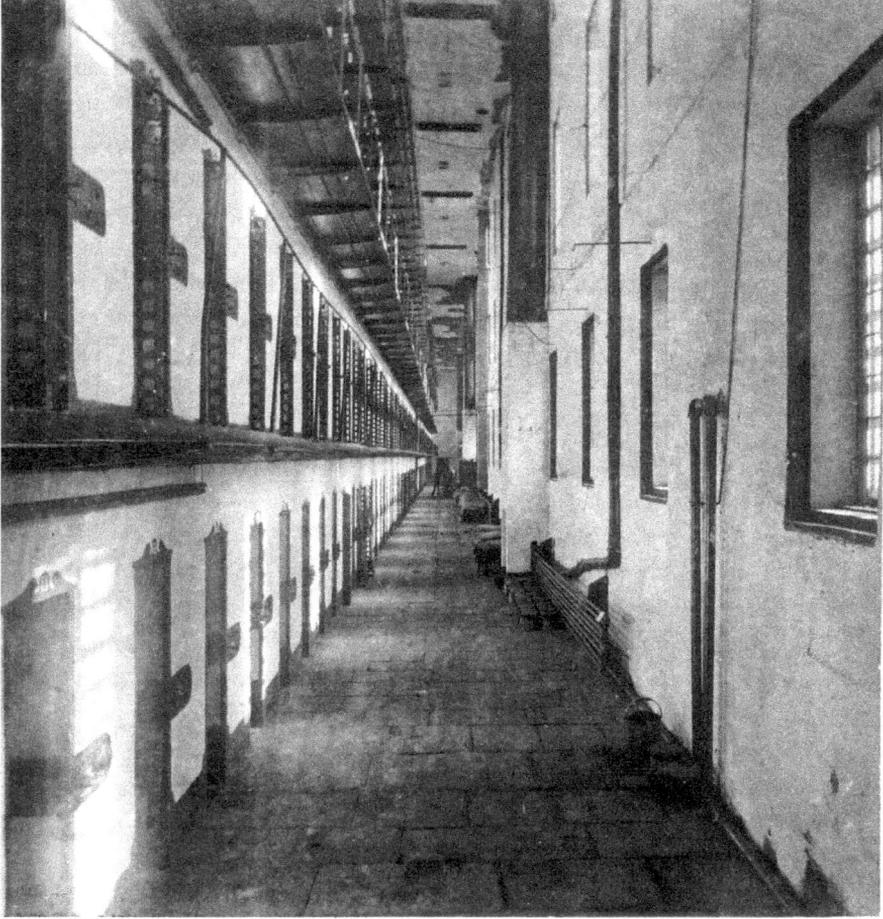

A cellblock in the Ohio Penitentiary is pictured in this antique stereoview slide. *Courtesy of the Dailey Archives.*

being taken from the prison, he believed that he was on the way to execution and resisted accordingly.

Most everything written about Brown since then has been derived from the *Brooklyn Eagle* article.[32] Based on little more than this, Brown has often been touted as America's first vampire. But there are problems with this claim.

To begin with, the *Eagle* got the year—1867—wrong, as writer Robert Damon Schneck discovered when he checked the *Boston Daily Evening Transcript*. Schneck, author of the *President's Vampire*, found that the saga of

James Brown began on May 23, 1866, aboard the bark *Atlantic*, hunting for whales in the Indian Ocean. A "staunch, well-built craft of two-hundred and ninety tons," the *Atlantic* was manned by a crew of thirty. Among them were twenty-five-year old Brown, a "negro cook" from New Bedford, James W. Gardner, the blacksmith, and John Soares (or Suarez/Siars), a seaman.[33]

The weather was fair with the breeze from the southeast, and most of the men were occupied bundling up whalebone, while keeping an eye open for whales. Brown was scrubbing a pan when James M. Foster, for some reason, called him a "damned nigger." As recorded in the Grand Jury finding of September 11, 1866, Brown

> *wilfully, feloniously and of his malice aforethought an assault with a certain knife of the length of six inches and the breadth of one inch did then and there make, and him the said James Foster with the aforesaid knife which he the said James Brown then and there had and held did then and there strike, stab and wound and in and upon the said James Foster in the left side of the breast of him the said James Foster with the aforesaid knife, so as aforesaid had and held by him the said James Brown, one mortal wound of the length of one inch and of the depth of four inches did then and there inflict, of which said mortal wound so as aforesaid inflicted with the knife aforesaid, which the said James Brown so as aforesaid had and held, the said James Foster did then and there languish, and so languishing did then and there for the space of five minutes linger and then and there so languishing, on the day and year aforesaid, did then and there die.*

The witnesses agreed on little. Soares thought Brown merely struck Foster with his fist while Gardner saw Brown cut Foster and helped him to the wheel. He asked the wounded man, "What was the matter," but Foster "could not speak, and lived but five or six minutes."

Benjamin Franklin Wing, the ship's captain, had Brown locked in double-irons in the fore hold. He entered in the ship's log that Brown admitted to stabbing Foster with a double-edge sheath knife, which he then threw overboard. As soon as he was able, the captain transferred Brown and the two witnesses to other ships to be taken to Boston where he was placed in the Suffolk jail. Following a brief trial on November 13, 1865, the defendant was found guilty and sentenced to death.

As Brian M. Thomsen relates in *Oval Office Occult: True Stories of White House Weirdness*, Brown's case reached President Andrew Johnson, who issued the following commutation on January 3, 1867:

Whereas, at the October term 1866, of the United States Circuit Court for the District of Massachusetts, one James Brown was convicted of murder and sentenced to be hung [sic].

And whereas, I am assured by the United States District Attorney, Marshal and others, that there are certain mitigating circumstances in this case which render him a proper object of executive clemency.

Now, therefore, be it known, that I, Andrew Johnson, President of the United States of America, in consideration of the premises, divers other good and sufficient reasons me thereunto moving, do hereby commute the said sentence of death imposed upon said James Brown to imprisonment at hard labor in the Massachusetts State Prison at Charlestown, Massachusetts, for the term of his natural life.[34]

Schneck believes the story of James Brown was confused with that of Mercy Brown, which took place in Exeter, Rhode Island, just prior to James's transfer to the asylum. Three members of this other Brown family had already died of consumption, and a fourth—father George Brown's son, Edwin—was seriously ill. Someone suggested they exhume George's wife and two daughters to check for evidence of vampirism. Both Mrs. Brown and her elder daughter were found to be in an advanced state of decomposition, but nineteen-year old Mercy was not. Of course, she had only been dead two months and had been buried in the middle of winter, but as a precaution, both her heart and liver were removed and incinerated. Edwin then drank a potion made from some of her ashes, but he soon died anyway.

Thomsen offers a different possibility: "As it was related to the press after the fact, James Brown was actually Jem Brown of Liverpool, who had supposedly died in an 1866 cholera epidemic." He was buried with other victims in a mass grave but, later, was seen skulking in the shadows near the Duck House pub. A prostitute claimed that she had an encounter with him in which he had bitten her on the arm and sucked her blood. He then signed aboard a ship bound for America, and her forearm soon became gangrenous and had to be amputated. This explanation seems unlikely, though, since James Brown's metamorphosis into a blood-drinking fiend did not begin until nearly twenty years later.

On June 27, 1885, the following appeared in the *Richmond Dispatch*:

A Boston special says: The 6:30 Washington train on the New England road to-night conveyed from these scenes a bloodthirsty wretch who for a dozen years has tenanted a solitary cell in the Massachusetts State's prison.

The involuntary passenger was James Brown, a Portuguese negro, who, in 1865, killed his captain at sea and drank his blood from the cloven skull. He was tried and convicted in the United States Court here and sentenced to death, but in 1867 his sentence was commuted to life imprisonment, and since that time he has committed no less than twenty-six murderous assaults on fellow-prisoners and on officials of the prison. All efforts to tame him hare [sic] failed, and for several years no human hand has ventured within the gratings of his cell-door.

Visitors who have curiously peered into the iron-room have instinctively likened him to a tiger in a menagerie, for his bloodthirsty eyes and his constant pacing back and forth have made this comparison the most fitting. A few days ago, much to the relief of the warden, an order was procured for Brown's removal to the Government Insane Asylum at Washington, and tonight United States Marshal Banks and his deputy, Galloupe, took him to that place.

The prisoner was closely ironed and, in addition, his arms were pinioned behind him, and with his guards he occupied the smoking-room of a Pullman car, a close watch being constantly kept on his every motion, lest his murderous propensity should find opportunity for exercise.[35]

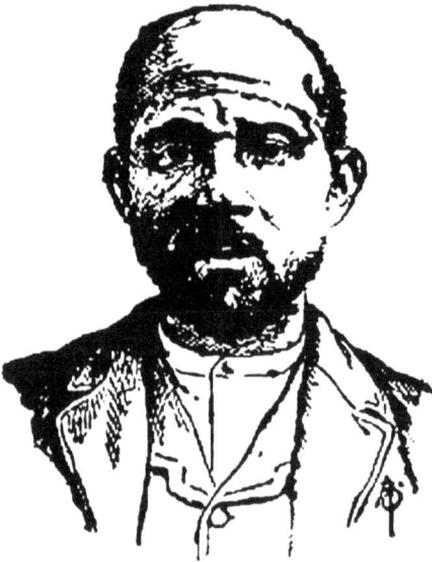

This woodcut of alleged vampire James Brown has apparently not been reprinted in over one hundred years. *Courtesy of the authors.*

Although it was now alleged that Brown had slain his captain and drunk his victim's blood (and from a skull at that), the *v* word had yet to be mentioned. Following his commutation, he was transferred from the Suffolk jail to the Charlestown State Prison, Massachusetts, where he spent the next twenty-two years.

On April 14, 1889, Brown was shipped to the Ohio Penitentiary, which had a contract to accept many federal prisoners. The prison register describes Brown as five feet six inches tall with black hair, light-maroon eyes and numerous tattoos of eagles, anchors, hearts and, on his right

forearm, a woman wearing a skirt. He also was said to be from "South Amerika [*sic*]."

Three and a half years later, Brown was transferred to St. Elizabeth's, the federal insane asylum in Washington, D.C. The fact that he had gone mad wasn't unusual. The Ohio Penitentiary was a hard place. As Thomsen notes, Brown was nearly fifty, suffered from cataracts in both eyes and probably had been worn down in the prison rock quarry.

Once at St. Elizabeth's, Brown sought a full pardon from President Grover Cleveland, claiming that the men who testified against him were his enemies and were not even on deck when the incident took place. Furthermore, they did not speak English and were not allowed to be questioned by his lawyer.

> *Everyone in the court saw that I was shamefully deal*[t] *most unjustly they all asked to have my sentenced remitted from capital sentence to prison for life all desired this because the witnesses were Portuguese sailors and could not speak English therefore their testimony was not sufficient.*
>
> *Mr. Charles Train my lawyer is dead I have been told by Doctor W.W. Godding and also the judge and the attorney general who had prosecuted me they are in their graves…*
>
> *…I request of you Your Excellency President Cleveland to give me my release I want to leave the United States.*
>
> *Yours most respectfully James Brown 3th*
> *From the United State of Spanish Columbian Confederation*
> *New Grenada*

However, Brown failed to obtain a pardon and, presumably, spent the remainder of his days in the federal asylum.

One of the unanswered questions regarding Brown is the allegation that he had "committed two murders since his confinement." As Schneck points out, these additional murders did not appear on his record when he was processed into the Ohio Penitentiary. Had he killed anyone while at the Suffock jail or Massachusetts State Prison, there would surely have been some record of it.

So that leaves his brief stay at the Ohio Penitentiary. Previous authors apparently did not review the contemporaneous accounts published in the Columbus newspapers. If they had, a somewhat different story would have emerged. Both the *Columbus Evening Post* and the *Ohio State Journal* covered Brown's arrival at the Ohio Penitentiary on Sunday, April 14, 1889.

In the *Post* article, "Brown claims that the steward of the ship gave him orders to cut down the rations of two sailors, who afterward blamed him for it and assaulted him, he defending himself with an iron stake." He also stated that rather than being transferred to a ship, he was:

> Left at the island of Mauritius in the Indian ocean, in company with two Portuguese sailors, one of these being the partner of the man he killed.
>
> He remained on this island nine months and was then sent to Bedford, arriving in September, 1866, and from there he was taken to Boston, where he was tried October 16, 1866, for murder in the first degree and sentenced to be hung [sic] March 15, 1867, which sentence was afterwards commuted to life imprisonment and he was taken to Charlestown prison. Here he remained until February, 1885, when he was adjudged insane and taken to the hospital for the government insane at Washington, where he remained until January 29, 1887.
>
> On recommendation of W.W. Godding, superintendent of the hospital, who had watched him carefully during the entire time, he was taken to Boston and again confined in prison.

The *Post* article added the following regarding his stay at the Charlestown State Prison: "In 1871 Brown made an assault on a fellow prisoner, and in 1873 he was put in solitary confinement and has remained for sixteen years, which is supposed to be the cause of his insanity." It concludes: "Brown, it is claimed, drank the blood of his victim but this he denies."

Interestingly, the story in the *Dispatch* has a different emphasis. After reviewing his trial, sentencing and commutation (owing to "mitigating circumstances"), the reporter wrote:

> Brown was put in confinement at Charlestown, and proved to be such a dangerous prisoner that for thirteen years and more he was kept in solitary confinement. Information at the penitentiary is to the effect that Brown's isolation was effected only after he had killed one guard and attacked several others.

Here, it is reported that he committed his second murder at Charlestown, killing one guard and assaulting others. While in solitary confinement, he wrote "several letters" to the governor of Massachusetts, Oliver Ames, to complain about being constantly locked up in a cell. Governor Ames wrote back that he should "conduct himself as other prisoners do and he will

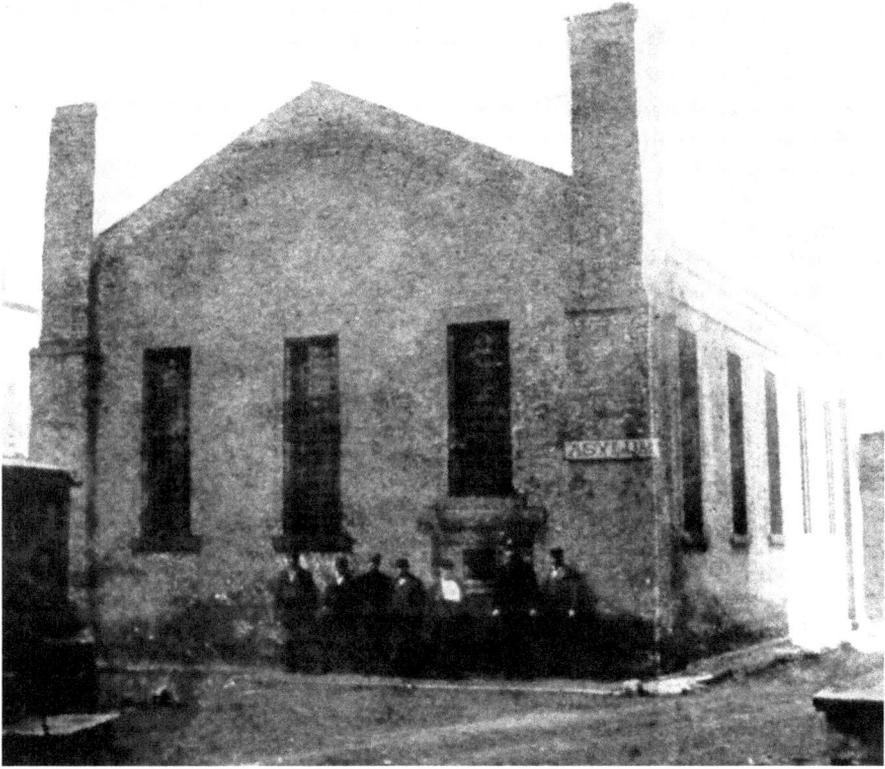

The Ohio Penitentiary had its own insane asylum, housed in the basement of the hospital. *Courtesy of the Dailey Archives.*

receive the same treatment." The transfer to the Ohio Penitentiary was initiated to see if he would benefit from "a change of officers."

Both writers mention that Brown attempted to smuggle two large knives into the institution. He was accompanied by a box that contained "lots of tobacco" and "lots of books" in French and Italian and was said to speak very good English. Prison officials believed he was a Portuguese from South America.

Brown's departure on November 3, 1892, was covered by the local papers. Brown was described in the *Columbus Dispatch* as a "triple murderer" and "probably the most desperate and vicious criminal ever confined within the walls of the Ohio Penitentiary." Although guard E.O. Gump, who prided himself "on his muscular prowess," had boasted he would remove the inmate from his cell unassisted, it took six men to accomplish the task. Gump

received a punch in the jaw as the inmate "thrashed about like a madman, glaring at his captors, cursing them and telling them what he would do if he were only unloosed."

For thirteen of his twenty-four years in prison, Brown was kept in solitary confinement. When taken from his cell, he was under the impression that he was about to be hanged. The superintendent of subsistence (i.e. prison kitchen), Nathan Munshower, accompanied two U.S. marshals who escorted Brown and another inmate, J.W. Davidson, to the asylum in Washington, D.C.

It was an article in the *Ohio State Journal*, however, entitled "A Prison Vampire" that seems to have been the source of the better-known account in the *Brooklyn Daily Journal*. The author wrote:

> *Twenty-five years ago his crime was the talk of the nation. He was charged with being a vampire and it was alleged that he lived on human blood. Brown was a Portuguese sailor and cook about 22 years of age and shipped on a fishing smack from Boston for a trip up the coast in the summer of 1867. There was a crew of about thirty men and one day one of the men was missing. It was thought he had fallen overboard and nothing was thought of it until the mate, a healthy young sailor, was missing. Two days afterward his body was found hidden in the hold and near it the body of the common sailor. A remarkable fact was that there were cuts in various parts of the bodies and they were sucked dry of blood. The men watched for several hours and were rewarded finally by seeing Brown stealthily creep up to the bodies and move them to another part of the hold. He was pounced upon and taken back to Boston and tried for murder.*

The reporter did not stop there. He claimed that immediately after Brown's sentence was commuted by President Johnson, Brown had killed one of his keepers with "the stool of a chair and when found was lapping up his victim's blood like a dog." As a result, he was placed in solitary confinement for fifteen years until the government arranged his transfer to the Ohio Penitentiary: "Soon after his arrival here he assaulted a guard and stabbed him with a fork."

The prison physicians had studied him "for years," including experiments in which he was given raw meat (which he preferred) to eat. He purportedly killed a rat that had wandered into his cell and was observed by the guards "cooly [*sic*] sucking" its blood.[36] A small, wiry man with gray hair, Brown was regarded by some as a "mullato" and spoke with a Spanish accent. His

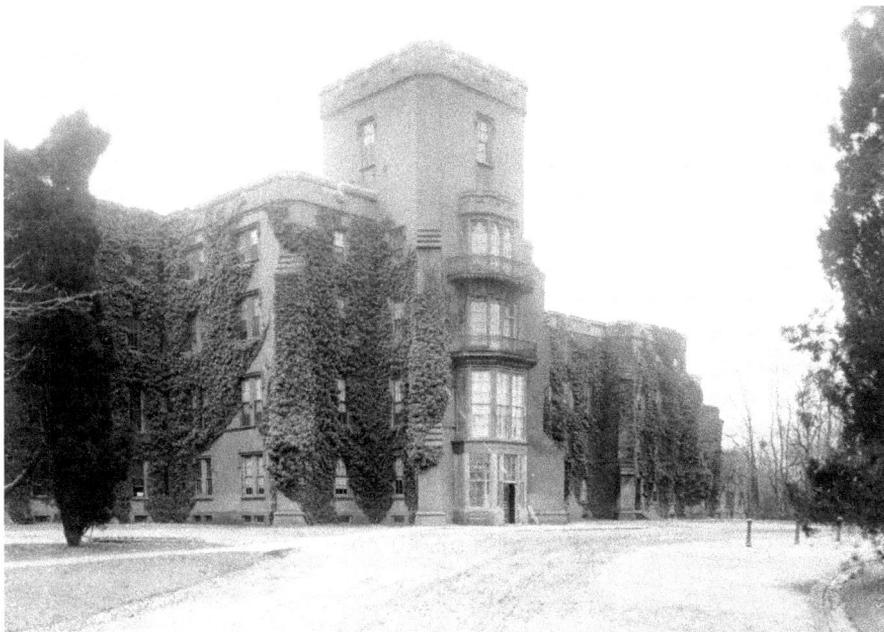

America's first vampire eventually was transferred to St. Elizabeth's Hospital in Washington, D.C. *Courtesy of the Library of Congress.*

fingernails were "long like talons," and some days he had to be placed in chains. Other days, he spent his time scrubbing the floor of his cell with a pumice stone.

After he had "nearly laid Guard Adams out by kicking him in the stomach" and "smacked" guard Gump in the left jaw, Brown had to be "choked into submission."[37] He then was wrestled out of his zebra-striped prison uniform and into a suit of clothes appropriate for traveling by the train. A copy of his commutation papers was found in his cell, along with a manuscript that dealt to a considerable extent with a woman named Emma F. Cary (an heiress, philanthropist and friend of the actor Edwin Booth). The manuscript was signed, "Thomas Azzote James Brown."

Several months after Brown was shipped off to Washington, D.C., an article appeared in the *Cedar Rapids Evening Gazette.* The author wrote that "when enraged [Brown's] eyes shine like coals of fire." He also wrote that Brown sometimes believed himself the warden of the Ohio Penitentiary or the president of the New York Central Railroad. "He is even haunted by visions of a former sweetheart, Mary [sic] Carey, and will eat nothing sometimes for days because she has touched the food."[38]

While Brown may have been many things, it seems unlikely he was a practicing vampire. However, he was quite possibly America's first *reported* vampire courtesy of an anonymous *Ohio State Journal* newshound.

Chapter 4

The Original Prison Demon

On May 7, 1890, Ira Marlatt murdered seventy-five-year-old Barak Ashton in Columbiana County, Ohio. As homicides go, it was fairly unremarkable. The killer, however, was soon to be known from coast to coast as the "Prison Demon." Many articles would be written about him. His palm print was included in a scientific treatise on hand reading.[39] And visitors to the Ohio Penitentiary paid an extra twenty-five cents to see him in his "cage."

Ashton, an unassuming Quaker, had incurred Marlatt's wrath three years earlier by purchasing his farm at a sheriff's sale. Despite the fact that the killing was premeditated, Marlatt was found guilty of only second-degree murder.[40] The defense had argued that the twenty-eight-year-old farmer was insane, possibly due to a head injury. However, it was also claimed he was something of a genius who talked of attaching a gasoline engine to a buggy—a novel, if not unique, idea for the time.

After the slaying, Marlatt had fled to his home, where he barricaded himself in the upstairs bedroom. Sheriff John Wyman bravely (or foolishly) charged into the house, climbed to the second floor and broke down the door. He was shot at once with a .32 caliber revolver. The slug drilled through the double fold of his overcoat, an undercoat and vest and struck the big key-wind-watch in his pants pocket. The sheriff immediately threw his arms around the suspect and overpowered him.

Although otherwise an excellent student, Marlatt had stuttered since childhood. He was incessantly teased about his speech impediment, refused

Ira Marlatt murdered Barak Ashton, a Quaker businessman, at Bell's Mill in Columbiana County. *Courtesy of the Dailey Archives.*

to read aloud and developed a persecution complex. Eventually, he came to focus his pent-up anger on Ashton, feeling the wealthy businessman had conspired to cheat him out of his land.

Buying a cheap revolver, Marlatt had arranged to meet Ashton at Bell's Mill near Oakville, where he demanded $600 in damages for his lost property. When Lou Bell, a thirty-seven-year-old miller, grabbed the barrel of the gun, it discharged, shooting away part of his jaw. A second bullet caught him in the elbow. Ashton then rushed out of the room, but Marlatt shot him in the back, piercing his lung. Stumbling forward, he fell across the township road, dead.[41] When the verdict was read, Marlatt responded he would rather be hanged: "Imprisonment to me is death."[42]

From the day he entered the Ohio Penitentiary, Marlatt resisted all efforts to control him. He was assigned to a prison shop that operated under the "abominable contract system."[43] Some of the inmates were allowed to work overtime for extra pay, but he was not.[44] When he complained, he

was disciplined for insolence. Charles Edward Russell noted that Marlatt possessed one of those minds that "get stubborn" under punishment. Believing he had been unjustly treated, he refused to work at all. "They paddled him until there was no place left to paddle," Russell wrote. "They had torn the skin from him. Then they hung him up in the bull rings. Then they gave him the water cure. Against every punishment he fought like a tiger; he could be subdued only by making him unconscious."

By July 1896, Marlatt had been confined nearly two years in a special cell in the basement of the prison insane asylum. Despite constant vigilance by the prison guards, he managed to manufacture a new weapon every week. He fashioned "stabbers" out of the wire handles of cell buckets. On one occasion, Warden Eli G. Coffin ordered guard John O'Brien to disarm him. As soon as O'Brien entered the cell, Marlatt stabbed him repeatedly. Although the cell was too small to admit anyone else, one of the other guards managed to reach through the bars and knock Marlatt down with his cane.[45]

In *Beating Back*, fellow inmate (and failed train-robber) Al Jennings described his initial contact with Marlatt:

> *As I passed the prison demon's cage I caught a glimpse of a haggard face at the low opening into the stone cell. Like a dumb, pathetic apparition, wretched and uncertain, the lumbering figure groped from corner to corner. The red, sunken eyes seemed to be burning deep into the smeared and pallid cheeks.*
>
> *One hand that was but a mammoth yellow claw was pressed against the rough mat of black hair. More like a hurt and broken Samson than like a hell fiend Ira Marlatt looked as his eye met mine in startled fear.*[46]

Taking an apple from his pocket, Jennings reached through the bars and rolled it to him.

> *In a moment I saw the huge creature creeping stealthily forward on his hands and knees. The great yellow claw reached out. The broken cuff and link on his arm clanked on the cement. The chain was imbedded into his wrist and the flesh bulged out over it. The hand closed over the apple. The Demon leaped back to his corner.*

Later, Jennings asked his friend William Sidney Porter (who would gain fame as short story writer O. Henry) whether he thought the man was a demon. He wrote that it had been Porter's job as the hospital attendant to revive Marlatt whenever he was beaten. "Colonel," Porter replied, "the

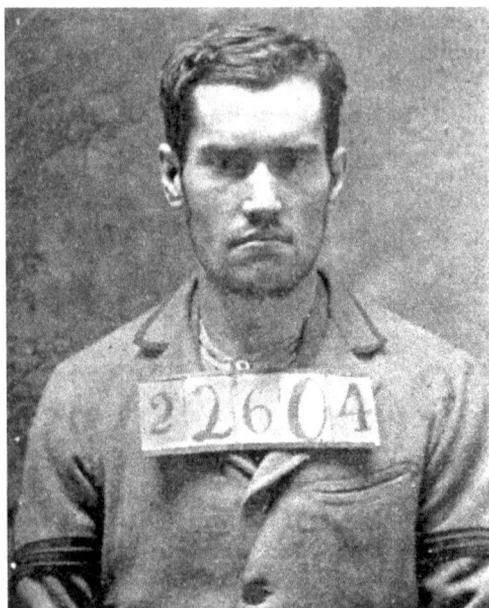

After entering the Ohio Penitentiary, Ira Marlatt became widely known as the most incorrigible inmate in the country. *Courtesy of the Dailey Archives.*

man should be in an insane asylum, not in a prison. There's something pressing on his brain. That's my opinion."

After that, Jennings said he visited Marlatt every night, feeding him pieces of biscuit or meat from the warden's table. Not only did "the demon" eagerly await these morsels, but he also would talk to Jennings about his life, although he did so with effort, as though he had difficulty remembering. He told Jennings that he had headaches because he got "a lick on the head once. Coal car hit me."

Marlatt was later transferred to a new cell lined with sheet iron in the basement of the one-year-old James Hospital. The intent was to deprive him of food and water until he promised to obey prison rules.[47] But he remained dangerous. For example, he removed the metal points from his shoelaces, rubbed them against stone until they were razor sharp and then used them to slit a guard's face from ear to ear.

In November 1896, Marlatt refused to come out of his cell so that it could be cleaned. Consequently, he was extracted by means of an iron hook around his neck. With a dagger concealed in his hand, he repeatedly lunged at Warden Elijah G. Coffin and the guards, but they beat him back with their wooden canes. He finally retreated to a corner of the hospital ward. Coffin then ordered the guards to disarm him, by shooting him if necessary. Marlatt finally surrendered the knife and was placed in the ducking tub until he identified the prisoner who gave him the metal he used to make the weapon.[48]

Daniel J. Morgan, superintendent of the penitentiary schools, wrote of Marlatt:

He is not crazy, neither is he sane; nor is he a monomaniac, unless the one insane idea of killing someone might be his monotonia. He is

*constantly in trouble, and is seldom good. He has assaulted at least half
a dozen officers, guards and prisoners with his self-made wire dirks,
thoroughly wicked and dangerous little weapons, made of wire which he
manages to get somehow…It seems that he cares nothing for punishment,
and would be pleased if someone would snuff out his very unprofitable
and unsatisfactory life.*[49]

For nearly a year, Marlatt had been on relatively good behavior. Then
in April 1899, just a few minutes after learning that a new unit was going
to be built to house him and other "prison demons," he threatened to kill
the warden and his deputy on sight. He was immediately remanded to his
cage, where he refused to eat or comply with any orders. Deputy Warden
Dawson told his staff to ignore him until his cell became dirty; then, they
would simply hose him off.[50] They also handed his food and drink to him on
the end of long poles.

On Monday, July 22, 1899, Marlatt, along with three other inmates—Otis
Hurley, Frank O'Neal and John Atkinson—was placed in Warden Coffin's
latest innovation: the "Demons' Cage." Constructed of steel painted white,
it enclosed five or six existing cells—creating a cage within a cage—at the
end of the east hall in the penitentiary. It was more than eleven feet square
and nearly twelve feet high with a green door. The ceiling was made of
heavy iron while a wire screen was assembled to cover the entire front and
prevent the smallest items from being slipped to the prisoners. Although it
projected above the second range of cells, a wall of iron sheeting cut off any
access from the second story. The north and east walls were of stone, as was
the floor.[51]

Coffin had selected these four inmates because: "Each one has shot or
stabbed a guard or two since his incarceration. They are all life men, and,
though subjected to the severest punishment, absolutely refuse to work.
Though the warden does not admit it, it is believed the men will sooner
or later kill each other." As one reporter noted, "Little regret will be
expressed by the prison officials if the four exterminate one another, for
past experience has shown that only in borne such manner can the lives of
the guards and the other prisoners at the Institution be secured."[52] Only
Marlatt refused to enter the cage willingly. Harry Ogle, superintendent
of the clothing and shoe department, and three guards were given the
assignment of moving him into his new "home." As soon as one guard
opened his cell, the other three men rushed in, but they fell back when he
drenched them with the contents of a bucket and a cuspidor. Momentarily

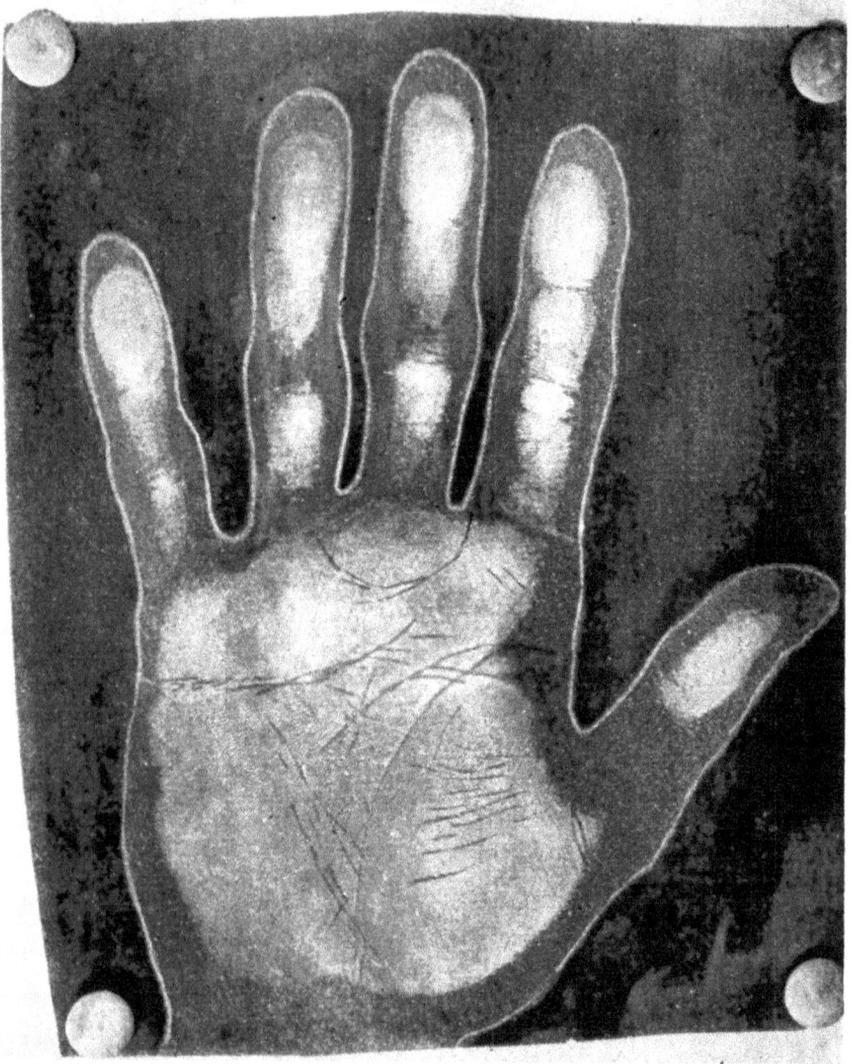

The "Prison Demon" was such an object of curiosity that his handprint was published in a book on "scientific" palm reading. *Courtesy of the Dailey Archives.*

blinded, they regrouped and then threw their combined weight against him. Marlatt was knocked to the floor and held down until manacles could be applied.[53] Ultimately, it took six men and a good drenching with the fire hose to subdue him.[54]

In *Through the Shadows with O. Henry*, Jennings described Marlatt's placement in the cage:[55]

I saw the Prison Demon. Hulk-shouldered, gigantic, lurched forward, he towered above the dozen guards like a huge, ferocious gorilla-man. I could see his face. The hair was matted about him, the clothes torn in ragged strips.

The guards stood at a distance, pushing him forward with long poles. They stood on either side. The demon could not escape. At the ends of the poles were strong iron hooks, fastened into his flesh, and as the guards pushed the hooks jagged into the prisoner's bones. He was compelled to walk.

On his foot was the monstrous Oregon boot. Every step must have been an agony. There was no sound from the Prison Demon. Across the grass to the new-made dungeon in the old A and B block the hellish procession took its way. Ira Marlatt was riveted to his steel cage and a sign, "Prison Demon," pasted above the grating.

Jennings may not have been the most reliable source of information. He was a name-dropper and self-aggrandizer who always put himself in the center of the action. For example, he claimed to have shared what he had learned about Marlatt with newly appointed Warden William N. Darby.[56] The warden responded that if what he said was true, he would take him out of the Demons' Cage. Jennings recounted:

We went down the next morning to the cage. The warden ordered the door opened. I could see the dark outlines of Ira's figure. The guard was frightened. Darby took the key, turned the lock and stepped forward. If he had suddenly flung himself under a moving engine, death would not have seemed more certain. Ira drew back, hesitated, then leaped with all his mighty bulk toward Darby.

"Ira!" I shouted. The massive figure stiffened as though an electric voltage had suddenly gone through him. The Prison Demon dropped his arm to the ground and came creeping toward me. "Be good, Ira," I whispered.

The warden braced himself. We went into the tiny cell room. The stench and filth of the hole came up like a sickening wave against us. "Come outside, Ira," the warden said. I nodded. "If I give you a good job, Ira, will you behave?"

It was the first time Ira had heard a kind word from a prison official. He looked about, his eyes narrowing distrustfully, and began to edge away from the warden.

"He'll treat you square, Ira."

The towering giant could have crushed me in his two hands. He was about a foot taller than I, but he shuffled along at my side, looking down at me with a meek docility that filled the guards with wonder.

The warden made straight for the hospital, ordered good food and skilled attention for the Demon. Three weeks later the Ohio penitentiary had a soft tongued Hercules in the place of the insensate beast that had been Ira Maralatt [sic]. The doctors had found the skull pressing on the brain, operated and removed the "dent" that had sent Ira into his mad fits of murderous, unreasoning rage. Memory returned to him. Ira told a story, moving and compelling in its elemental tragedy.[57]

But Jennings didn't stop there. He gave Marlatt a pregnant wife named Dora and said he had worked as an iron peddler in the steel mills of Cleveland. But when a strike occurred, he left his family to take a job in a West Virginia coal mine. While there, he saved the lives of twenty others when he caught a runaway coal car with his bare hands. That was when he suffered the injury to his head.

At the conclusion of the strike, Marlatt returned home to find that his wife had been evicted. A woman who was living in his former house told him Dora had left before the baby was born. So he went to see the man who had turned his wife out of "the bungalow on the hill." When the man referred to Marlatt's wife as a "damn scrub," an argument ensued, and like "a blood-crazed panther," Marlatt leapt over the counter and strangled the man to death. It took three officers to pry his hands from the man's throat. At his trial, he offered no defense.

Of course, Jennings's tale bears little resemblance to what is known about Marlatt's crime, so it is hard to say how much of the rest to believe. He claimed that Darby subsequently made the ex-demon caretaker of the prison annex, responsible for cleaning out the cells of the condemned men and the death house. He said Marlatt also began raising canaries in his cell.[58]

Then one day, the warden returned from Cleveland with some news for Marlatt. He had learned that Dora died not long after losing her home. However, her baby, Mary, had been adopted by a wealthy couple in Columbus. On top of that, Darby had discussed Marlatt's case with the governor who had issued him a pardon effective the next day.

Of course, Marlatt attributed his good fortune to his friend, Jennings. "You did all this, Mr. Al," he said, the tears pooling in his eyes. He left the prison with a new suit, five dollars and two canaries, which he planned to give to his daughter. When a week or so went by with no news, Warden Darby became concerned and contacted the girl's "foster mother" (a relative of Marlatt's wife). He learned that an "old bird-peddler" had paid them a visit and sold them a pair of caged canaries for a dollar, but did not identify

himself. When she was told it was Marlatt, little Mary's father, they searched for him everywhere, but to no avail. Then one night he showed up at the Ohio Penitentiary, "his thin prison suit drenched and hanging in a limp rag about him" as he knelt in the snow at the prison door. He asked to be admitted because he had nowhere else to go. The warden sent for his daughter and a tearful reunion took place:

> *The young girl, graceful and white as an angel, flung herself into the old man's arms.*
>
> *"Don't die, daddy! Why didn't you tell me? See, I'm your girl, Mary. Just look at me! Oh, why didn't I know? If you only knew how many times I longed for a father—any one, any kind. Why didn't you tell me?"*
>
> *Marlatt looked at her in dim, feverish gladness. He took the delicate hands in his gigantic palm and turned to her.*
>
> *"I looked all over for you, Mary," he said. "I'm so glad you came."*
>
> *With a smile of wondrous peace on his lips, the prison demon sank back on the pillows. The old hero had won his palm at last.*

Jennings claimed that Marlatt became a model prisoner and that Warden Darby also "tamed the rest of the prison demons, and the steel cage became a curiosity." However, Charles Edward Russell attributed his second chance to Senator Isaiah R. Rose of Marietta, a new member of the Board of Prison Managers. A survivor of Andersonville Confederate Prison Camp, Rose was appointed to a four-year term in 1896. When he came to visit the Ohio Penitentiary, he purportedly asked to see Marlatt, the man he had heard so much about. Shown to the Demons' Cage, he requested the key. Naturally, prison officials objected, warning him that it was not safe. Nevertheless, he said he would take his chances. So the door was opened, and the senator walked in.

"Come, Marlatt, let's be friends," Russell quoted Rose as saying. The Prison Demon proffered his hand, and the two men shook. "Now," said the prison manager, "let's sit down here. I want to talk with you." For half an hour, they talked together. Afterward, Rose went to the warden and said, "This man wants to go to work." As a result, Marlatt was returned to the general population where he became a trusty and janitor in the hospital—not the death house.

The concept of prison "trusty" was not new. Originally, the Trusty System was developed in Mississippi in 1903 as a prisoner hierarchy. On the work farm, the highest-level trusties were even given rifles and acted as assistant prison guards. A second level of unarmed trusties was given clerical and

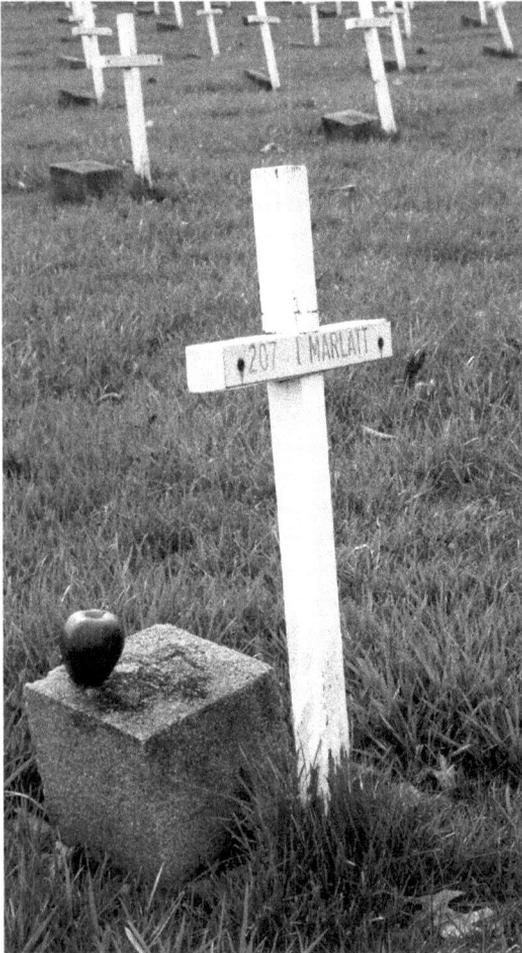

An apple left at the grave of Ira Marlatt in remembrance of his friendship with Al Jennings. *Courtesy of the Dailey Archives.*

janitorial work for the prison staff. A less egregious system was instituted in Ohio.

Although Jennings would have readers believe that Warden Coffin, Darby's predecessor, had no interest in ever releasing Marlatt from the cage, the fact is that he did try in May 1900. While endeavoring to persuade him to return to work in the bolt shop, the warden mentioned Marlatt would have the same "liberties of the corridor" as Otis Hurley. Given the bad blood between the two prisoners, that was the wrong thing to say. Grabbing a water bucket, Marlatt began breaking the windows of the cage and then raised it to strike guard Lefever. Coffin struck Marlatt on the head several times with a club. The inmate wrestled it away from him and beat him on the head repeatedly, blacking his eyes and bruising him severely. Neither Lefever nor another guard, Kolb, could render any assistance, but inmate Edward Leonard was called upon to help. Climbing over Coffin and Kolb, he grabbed Marlatt and proceeded to thrash him. Had Lefever not called him off, there was little doubt he would have killed Marlatt.

That Marlatt did change, at least for a little while, is indisputable. However, in December 1904, he stabbed yet another inmate, John Jones, allegedly in self-defense.[59] Around Christmas 1906, the *Columbus Citizen*

reported: "Late Monday evening a fir tree was smuggled into the [prison] hospital and while the help were busy sleeping, Ira Marlatt, the former Prison Demon, and little Lonne Wooten [an African American inmate] trimmed the branches to the proper size. Cotton from the surgical ward was used with a generous amount of tinsel to decorate the tree which was then quietly placed in the sleeping ward."[60]

Marlatt sought a pardon in 1909. He was said to have been on good behavior for nine years: "Kind treatment converted him into tractability."[61] None was granted. Five years later, he wrote a letter to President Poincare of France. He offered to sell the French leader a dirigible balloon, which, he claimed, was superior to Germany's Zeppelins and could be used to triumph over the country's enemy. In exchange, he asked for "the trifling sum of $500,000,000."[62] He did not get that, either.

On October 24, 1910, after nineteen years in prison, Marlatt was granted fifteen minutes of "freedom." The warden allowed him to walk out in the front yard, presumably because his recent behavior had warranted it. The prisoner was so overcome with emotion that he was unable to say a word to anyone.[63] Two years later, he was complaining that he couldn't hear at all out of one ear and was in considerable pain.[64]

Filmmaker Rodney J. Diegel recalled that the former demon was very sensitive regarding his pronounced speech impediment. So when a visiting state official asked him where the hospital was, he replied, "Hell, t-t-h-h-e-r-res f-f-i-f-teen h-u-ndred m-en in this dam place and y-y-ou've g-o-t to a-a-sk m-me."[65]

On Sunday, August 29, 1915, Marlatt stabbed a guard by the name of W.C. Beineke (or Veinecke) in the leg with a knife after he learned he would soon be transferred to the State Hospital for the Criminally Insane at Lima. It was thought that he was reluctant to leave the Ohio Penitentiary because he had come to regard it as his home. Although the guard lost a large quantity of blood, he did not die, and Marlatt was successfully removed to Lima early in September.[66]

The following March, Philbrick and Rorick, two members of the state board of administrators, visited the hospital to investigate the claim that some of the patients were not, in fact, insane. They paid special attention to the former demons: Otis Hurley, Frank O'Neal and Ira Marlatt.[67] Hurley may have been sent back to the Ohio Penitentiary as a result.

On June 14, 1929, while still an inmate at the Lima State Hospital for the Criminally Insane, Ira Marlatt passed away. He had lived there in relative obscurity for fourteen years.[68] Sadly, he never received a pardon and neither was he reunited with his daughter, Mary, if, in fact, she ever existed.

Chapter 5

The Courtship of Daisy Sprague

O tis Hurley was madly in love with Daisy Sprague. Or else he was just mad. Either way, when she didn't respond to his advances, he wanted her dead. The fact that he was already in prison didn't matter. So was she. When he arrived at the Ohio Penitentiary on July 21, 1896, at age twenty-two, Hurley had already served a sentence for grand larceny and was back to do another one, this time for five years. He just liked to steal bicycles.

Two years later, in September 1898, Hurley took a knife from the shoe shop and concealed himself behind a stairway. Daisy Sprague, a fetching nineteen-year-old, was bookkeeper for the Hallock Glove Factory, which operated inside the prison walls using convict labor. When the object of his ardor made her entrance, he sprang from his hiding place and plunged the knife into her breast.[69] Although she sustained a two-and-a-half inch wound just above her heart, the downward thrust of the blade had been deflected by a rib, sparing her life. Hurley was thrown into solitary confinement to think about what he had done. A ball and chain was fastened to his ankle, and another twelve years was tacked onto his sentence for attempted murder.

It was agreed that Miss Sprague had "always deported herself in a most lady-like manner." But in the Ohio Penitentiary, just being female was provocation enough. Another inmate had also gotten into trouble for trying to strike up a relationship with her. Nevertheless, she resumed working at her prison job because her widowed mother, Iselin, depended on her for support.

Hurley was not the kind to forgive and forget. Some six months later, he was discovered hiding on top of a safe in the office where Daisy worked. Somehow, the wily convict had obtained a steel saw and used it to free himself from his fetters and his cell. This was after he had failed in his bid to escape from the prison using a rope supplied by another inmate. He admitted he was waiting to pounce on the girl with a "shiv" he had fashioned out of half a pair of scissors.[70]

A few weeks later, Warden Elijah G. Coffin announced his intention to construct the "Demons' Cage," a rare admission of defeat by the renowned prison reformer.

If Otis Hurley couldn't have Daisy Sprague, he didn't want anybody to have her. *Courtesy of the Dailey Archives.*

Although Ira Marlatt came, in time, to be viewed more as an object of pity, Hurley clearly had a screw loose. While jailed in Dayton, he allegedly "played insane," forcing the sheriff to beat him with a length of rubber hose to obtain his cooperation. Afterward, he thanked the lawman for the "striking" lesson he had been taught.[71]

Following the second attempt on her life, Daisy never went anywhere in the prison unaccompanied by an armed guard, even though her "suitor" was confined in a steel cage in the hospital basement. It was a good thing, too, for one evening in April 1899, Hurley made a third attempt on the girl's life. Somehow, he had once again freed himself from his restraints, overpowered the guard and rushed into the prison yard. This time, he was apprehended by Superintendent Harry Ogle just as Daisy came into view. While Hurley was wrestled back to solitary confinement, a trembling Daisy hurried home to pen her resignation.[72]

Whatever Hurley may have thought of this development, he soon turned his attention to other, equally sinister matters. On Wednesday, July 12, 1899, just after eight o'clock in the evening, he summoned guard Samuel

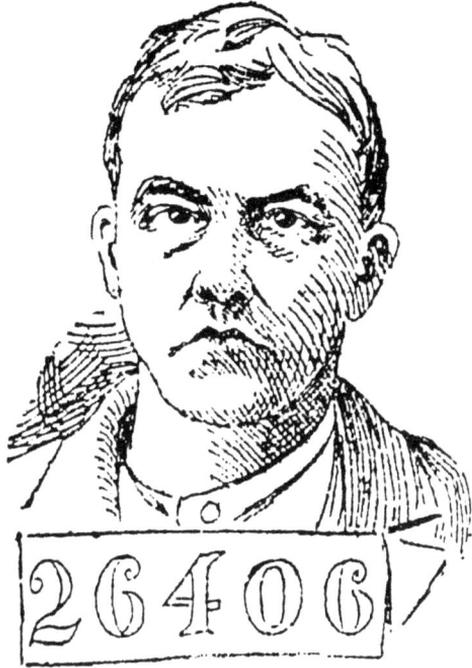

D. Blocker to his cell on the pretext of sharing some information with him regarding an escape plot. He said he knew about some saw blades that were about to be delivered to the prison.

Later, while Blocker was conducting the count, Hurley waved a package at him, saying, "I've got them all right." Believing the inmate had the saw blades, the guard unlocked the cell door. As he stepped inside, Hurley laughed and gave him "a stiff poke" in the abdomen, remarking, "Get out of here; what do you want in here anyhow?"

Blocker did not feel any pain, just a "peculiar sensation." The package contained nothing but an old hymnal. Resuming his duties, the guard climbed up to the fifth tier. He began to feel sick but did not tell anyone what had transpired. Even though he became very weak and suffered a severe attack of bloody diarrhea, he remained at his post until three o'clock before asking permission to go home. Through noon of the next day, he experienced a total of twenty-eight internal hemorrhages as a consequence of having been stabbed in the stomach.

When prison officials learned what had happened, they searched Hurley's cell. A piece of wire about six inches long and sharpened like a needle was

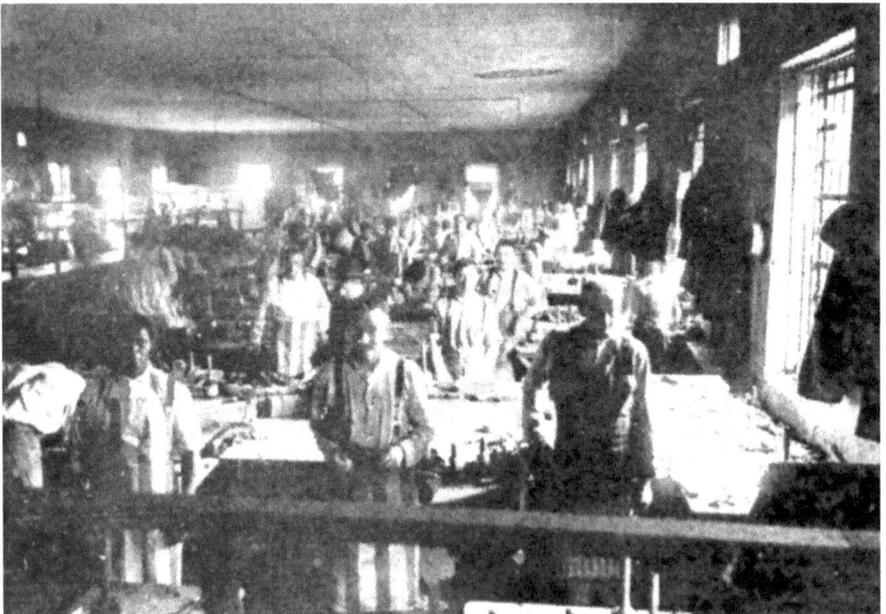

The Glove Shop was typical of the private businesses that operated under contract within the prison walls. *Courtesy of the Dailey Archives.*

found outside his cell. Inside was a short piece of wire that had a fresh break that perfectly matched the longer piece. He had taken the wire from the handle of his cell bucket and straightened it out, bending one end to make a sort of handle.

A former deputy sheriff, Blocker, age forty, had secured his position as night guard of cellblock H through his state representative. Married with three children, he was not known as a risk-taker. Fortunately, he had recovered sufficiently by the next day that doctors no longer felt he was in any danger.[73] A week later, his attacker was "taken in the cellar and punished…for a continuation of his devilry." It seems he had wrenched the iron leg from his bed and announced he was "going to get a turn at some of the officials yet," namely, Warden Coffin.[74]

Within a few days, Otis Hurley, Ira Marlatt, John Atkinson and Frank O'Neal were transferred to the newly constructed Demons' Cage, all but Marlatt without incident. Hurley delighted in antagonizing Marlatt, who openly despised him. Amused by the whole affair, Hurley even suggested that another inmate, "Delmonico" (Del Bello), be thrown in with them.[75] Although Hurley had been thoroughly searched, the very next day guard Short discovered him fooling with one of his shoes. When he was told to change them for a pair that had been repaired, a weapon like the one he used on Blocker was found concealed in the lining. From that point on, all buckets delivered to the cage had their handles removed first.[76]

Most prisoners try to say what prison officials want to hear at a parole hearing, but Hurley was not like most prisoners. On August 1, 1899, he met with Manager Isaiah R. Rose of the Prison Board. When asked what he would do if he were set free, he replied, "I intend to kill that girl." When Rose replied that he could expect to remain in the cage for the rest of his life if he "entertained such ideas," the inmate had a sudden epiphany. He promised he would lead a good life if he were given his freedom and not kept caged up like an animal. However, the manager was not persuaded.[77] He was proved right when on Monday, December 4, 1899, Hurley stabbed Frank O'Neal several times in the Demon Cage. O'Neal (or O'Neill), from Cleveland, had killed guard Lauderbaugh a year earlier.[78] The weapon was a sharpened piece of steel wire. One plunge pierced O'Neal's lung.[79]

Since Hurley wasn't likely to gain his freedom through good behavior, he took matters into his own hands. Early in 1901, he scaled the wall at the Ohio Penitentiary. While waiting for Charles French, a Cleveland robber, to join him, he was discovered on the lawn outside the prison by Captain George A. Wood. Both men were apprehended.[80]

A year later, Hurley was back in good graces with prison officials. He had behaved himself for several months and was considered to be "perfectly trustworthy." However, when he was acting strangely one day, he was escorted to the office of Warden William N. Darby to be searched. A table knife, ground to a razor edge and stiletto point, was found concealed on him. He purportedly had a "fancied grievance" against the warden and was waiting for an opportunity to stab him. As a result, he was placed back in the cage and, once again, closely watched.[81]

Hurley could not be watched closely enough, though, for in August 1902, he did it again. Somehow he got out of his cell, opened one of the locks on a door leading from the cell house into the inner court and in another second would have been well on his way to liberty. This time, he was spotted by a guard, Sam Williams, who fired at him. He was easily apprehended and returned to his cell.[82]

"I report this man for telling me to go to hell," guard Black complained to Deputy Warden Woods on August 18, 1904. Guard David Williams added that Hurley had refused to work. After Dr. John M. Thomas assured them the prisoner was fit enough to work, Hurley was placed in cellblock A, second range, under constant surveillance for twelve days.[83]

Just two days later, he was making trouble again. Williams, who was in charge of the hall on which Hurley was kept in solitary confinement, discovered that he had apparently obtained a saw, cut some of the iron bars in his door and severed a gas pipe in his cell to use as a tool to pull the bricks from their places. While he made quite a hole, there still was more work to be done before he would be out of his cell, to say nothing of making his escape over the walls. He was taken before the prison court and paddled.[84] As a reporter put it, "He seems to be the kind of man who never learns anything."

Through it all, Hurley's obsession with Daisy Sprague remained. When his sentence expired on June 18, 1908, he said he intended to "follow her to the ends of the earth." He later called Warden Coffin late in November and asked for information regarding his beloved. The warden promptly wrote a letter to Columbus chief of police John F. O'Connor and asked him to apprehend and hold Hurley because of his previous threats toward the young woman. At the time, Daisy was believed to be living in New York, but Coffin wasn't taking any chances. Hurley had been staying in Hope Hall, operated by the Volunteers of America, but had recently left town, presumably to search for her. He had obtained her address from an aunt in Springfield by telling her an ex-warden wanted it.[85]

Hurley resurfaced in May 1911, when "J.D. Kramer" (as he identified himself) was arrested at Union Station and hauled into a Columbus police court to face two charges of petit larceny and one of grand larceny. He had also claimed to be Arthur Lamb but was positively identified by J.A. Davis, former Bertillon officer at the penitentiary.[86] The "former demon" readily conceded he stole the property but argued that it was "so divided" that it really represented five instances of petit larceny. He was fined $300 and sentenced to thirty days in the workhouse, despite the fact that he had escaped from a posse in Xenia four days earlier, where he had been charged with stealing a horse.[87] He also pleaded guilty to

Warden E.G. Coffin was a renowned prison reformer who didn't always practice what he preached. *Courtesy of the Dailey Archives.*

grand larceny and was sentenced to two years in the penitentiary.[88]

On September 11, 1911, Hurley and two other prisoners grabbed an extension ladder, planted it against the east wall and were scrambling up it when guard Michael Fletcher fired at them. Fletcher was about two hundred yards away, but all tumbled to the ground and took cover in the dining hall.[89] Then on October 21, Hurley was foiled in another escape attempt. Guard Edward Connors found he had sawed the nuts off the bolts that held his cell lock on. All he had to do to gain freedom was to push out the bolts.[90]

Five months later, on a cold day in February, Hurley and William Brennan, an inmate from Cuyahoga County, made a bold bid for freedom. After cutting off the Oregon boot that Brennan was wearing due to a previous escape attempt,[91] the two men secured a couple ladders that were being used by construction contractors and scampered over the wall where a new guardhouse was being erected. Almost immediately, guards Charles Jackson, Ed Buenkardt, Abe Gordon and Fred Hatzer, the best shots in the institution, "rained fire on them with rifles and shotguns." It is likely they would have killed them, too, except that some of the workmen outside the prison got in

the way. As soon as they reached the ground, the convicts started running toward the railroad yard, following the Pennsylvania-line tracks.

A posse quickly overtook Brennan, who had been wounded in the foot and leg by Jackson, and returned him to the institution. Although Hurley was believed to have been struck in the shoulder, he did not stop. Nevertheless, Warden Thomas H.B. Jones felt confident he would soon be recaptured, and he was.[92] Then just after Christmas 1912, he briefly escaped once more.[93]

Though he gained his release earlier in 1913, by May, Hurley was being held in Xenia's Greene County jail for horse theft and grand larceny. While there, he sawed through seven steel bars separating the turnkey's room and the corridor in the failed attempt to escape. Sheriff W.B. McAllister suggested Hurley had brought a saw blade with him from the penitentiary.[94] Quickly recaptured, he was sent back to prison for five more years. An editorial in the *Dayton News* argued that "Otis Hurley, no matter how black his record, deserves our sympathy. The system under which he was developed into the sort of man he is today deserves our best thought."[95]

In September 1915, Hurley and thirty other inmates from the Ohio Penitentiary were declared deranged and shipped off to the Lima State Hospital for the Criminal Insane for treatment. Gradually, he had come to be regarded as "the demonest demon of them all." On January 18, 1916, he was on the lam, having attacked a guard and made his escape from the facility; some six hundred people later reported seeing him roaming around Greene County.[96] He was said to be wearing everything from prison stripes to a full dress suit and top hat. Ten days later, however, he was captured by three detectives in Chicago as he was striking and choking Mrs. Emma Miller in her home.[97] Sent back to Lima, he, along with the other thirty convicts who had been transferred with him to the hospital seven months earlier, was "declared cured" and returned to the penitentiary to complete his sentence.[98]

In September 1916, Hurley was in the middle of a political dispute and, undoubtedly, loving it. A probe had been launched into charges of brutality at the Ohio Penitentiary, pitting Warden Preston Thomas against C.C. Philbrick, chairman of the state board of administration.[99] Hurley had been moved from the penitentiary to the Lima hospital when Dr. Charles Clark was superintendent. He alleged that Clark and Philbrick had attempted to bribe him with the promise of a pardon if he would testify that he had been mistreated at the penitentiary and had witnessed the shooting of an inmate named Johnson in the back. He signed an affidavit to that effect but only after warning Warden Thomas of the "frame-up."

On the witness stand, Hurley stated that he had seen more brutality during six months at Lima than in eighteen years at the Ohio Penitentiary and that he knew of two instances in which inmates at the hospital had been killed by an overdose of salts.[100] On September 23, he was released from prison, his five-year sentence for horse stealing having expired. He was described as a model prisoner, despite ample evidence to the contrary.

Given a job in Dayton, Hurley laid low for about a year, living under an assumed name. However, in May 1918, one Clifford Hale was arrested in Cincinnati for horse theft. After a few days in jail, police officials discovered that Hale was actually Otis Hurley, "up to his old tricks."[101] He had been on the run for two years.[102] When World War I broke out, Hurley registered for the draft at the Ohio Penitentiary on September 12, 1918, although his permanent addressed was listed as the Dayton Military Home. He listed his closest relative as Miss Flora Hurley of Dayton.

Nothing is known of Hurley's later life, although it is rumored he died at Lima. As far as Daisy Sprague is concerned, she apparently succeeded in covering her trail.

The Birdman of the Ohio Penitentiary

There are many reasons for quitting your job, but getting shot has to rank near the top. That's what caused Charles B. Lauderbaugh to rethink his career choice on June 6, 1896. A police lieutenant for the village of Mount Vernon, he and three officers were scouring the area for two men who had robbed a safe at Beck's Mills Store. When one of the suspects stepped off a train right in front of them, the officers tackled him. In the ensuing struggle, the safecracker discharged a revolver, and the bullet cut through Lauderbaugh's scrotum, lodging in his thigh.[103]

A little over two years later, on November 18, 1898, thirty-three-year-old Lauderbaugh was working as a guard at the Ohio Penitentiary. He had been on the job for six months when he stumbled on three inmates in the hoe shop early one morning: John Atkinson, Frank O'Neal and James "Jimmie" O'Neil.[104] They were looking for a ladder to aid them in going over the wall. They were also armed with revolvers that they acquired back on July 4 but had waited for cooler weather when fewer guards were likely to be working outdoors.[105]

Although Lauderbaugh twice squeezed the trigger of his own pistol, it did not go off, so the men immediately trained their weapons on him. He then pulled the trigger again, winging one of them. His companion returned fire, riddling the guard's body with five slugs. This time, Lauderbaugh did not survive; he left behind a wife, a daughter and three sons.[106] During the confusion, James O'Neil jumped out of a shop window and fled.[107]

Following the shootout, Atkinson and Frank O'Neal[108] rushed into a nearby broom shop supervised by guard L.H. Davis, who was unarmed. He

saw that Atkinson was cradling his crippled right arm, which was broken in two places. Nevertheless, the wounded inmate managed to get off a shot at guard R.H. Lime, who was standing some distance away. By this time, guard E.O. Gump had entered the shop. Atkinson fired at him ten times before Gump knocked him to the ground, striking him twice on the head with a heavy hickory cane.

Through an interpreter, Walter Taylor, a full-blooded Seminole serving time for horse theft, testified that he saw the three inmates emerge from the shops together just after the shooting occurred.[109] It was later established that James O'Neil had been forced to accompany them. On March 4, 1899, Atkinson and Frank O'Neal were found guilty of murder in the first degree without clemency.[110] The charges were subsequently reduced to second-degree murder because there was no evidence of premeditation.[111]

The revised verdict did not sit well with Warden Elijah G. Coffin, who vowed to severely restrict the prisoners' liberty and privileges.[112] Both were placed into a double cell in which famed prison inventor Billy Carroll[113] had spent eleven years before his pardon.[114] Only a month later, on April 4, Coffin announced plans to construct a cage to house the most hardened criminals in the institution: Ira Marlatt, Otis Hurley, John Atkinson and Frank O'Neal. Marlatt, the original "Prison Demon," and Hurley, his heir apparent, were obvious choices, but Atkinson and O'Neal were elevated to this status because they had killed a guard. In addition, Dr. Carpenter of the prison insane asylum had testified that the latter was a "degenerate" not of strong mind.[115] His head was "small and runs up to a peak."[116] At the time, the warden told the Board of Penitentiary Managers that there were at least two hundred men who deserved to be isolated from the other inmates, but he intended to start with these four in accordance with "advanced methods of penal discipline."[117]

Atkinson and O'Neal had originally been committed from Cuyahoga County for fifteen years on a charge of robbery. They argued that they had been sentenced to hard labor, not solitary confinement.[118] But it wasn't lack of exercise that concerned them; it was being in such close quarters with such dangerous and unpredictable characters as Marlatt and Hurley.

After the slaying of Lauderbaugh, Atkinson and O'Neal had been housed together in a double cell. Both Hurley and Marlatt were already in solitary, the latter occupying the one-man cage that had been constructed for him earlier. Much to everyone's surprise, the four inmates got along remarkably well, at first anyway. During the day, they worked in one area of the hall sorting broom corn, a task they were given after they refused

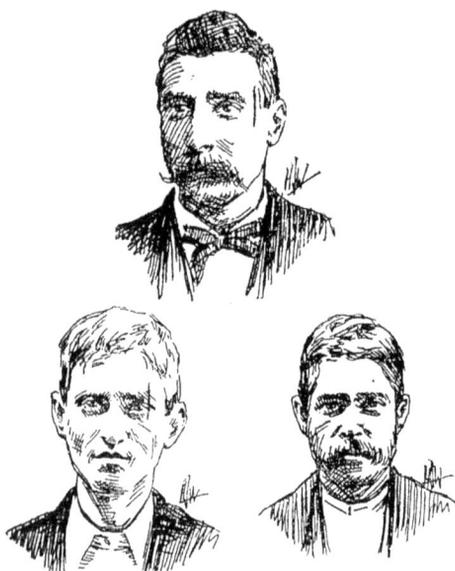

Clockwise from the top: guard Charles Lauderbaugh with his killers, John Atkinson and Frank O'Neil. *Courtesy of the Dailey Archives.*

to do any work.[119] At night, they were locked in individual cells within the cage. They were on such good behavior that the guards should have suspected something was up.

Not long after entering the cage, Atkinson began working on a plan to escape. It was nearly identical to the one Confederate general John Hunt Morgan and his officers had used during the Civil War. He began by digging a hole in the corner of his cell, number twenty-seven, breaking through into an air chamber beneath the cellblock. The chamber was, roughly, two and a half feet deep and four feet wide—ample room for a man to crawl from one end of the building to the other undetected. From there, he could cut a hole through the outside wall and get away under cover of darkness. He did all his work at night, and no one suspected a thing, not even his fellow demons. As it turned out, that was his mistake.

On Friday morning, September 15, 1899, an officer observed Hurley tossing a note out of the cage to another prisoner, Eddie Hoxter (or Hockstein). It was a request for several files and a saw blade, presumably to be used for Hurley's own escape plan. Since Friday was the scheduled bath day for the prison demons, guards Edward Patton and Selders took the opportunity to search all of their cells and discovered the hole beneath some crumpled newspapers.

When confronted with the evidence, Atkinson readily confessed, saying he was tired of being locked up in the cage with three crazy men. He had used one of the legs of his iron bed to tunnel through the floor along with a pick fashioned out of wire. All of the debris from the excavation had been hidden under his bed until he was able to pour it down the hole. He estimated that he would have accomplished his goal in fifteen more days.[120] For his misbehavior, Atkinson was severely paddled and had a ball and chain riveted to his ankle.[121]

A contingent of prison staff prepare to attend the funeral of Lauderbaugh in his hometown of Mount Vernon. *Courtesy of the Dailey Archives.*

Following the failed escape attempt, the animosity among the four residents of the Demons' Cage escalated. Still, they managed to maintain an uneasy truce for the next nine months. Finally, on December 5, 1899, Hurley attacked Frank O'Neal while he was asleep, stabbing him a half dozen times with a heavy piece of wire sharpened like an ice pick. He undoubtedly would have killed him had the weapon not broke off at the hilt while stuck in O'Neal's shoulder, leaving him clinging to life with a punctured lung.

Hurley insisted that he was acting in self-defense and that O'Neal had earlier threatened to kill him. Although he was paddled, placed in the ducking tub and had his good time taken away,[122] he did not apologize. He threatened to attack O'Neal again as soon as he had the chance.[123] At this point, O'Neal disappeared from the record until 1904, when he was found to have a "wicked" knife in his possession.[124] After that, he kept a low profile until he was quietly shipped to the Lima State Hospital for the Criminally Insane.

For the next ten years, Atkinson was on good behavior. Unlike Marlatt or Hurley, no one had ever questioned his sanity. He had been a bad man for sure, but he apparently was not beyond redemption. In time, he became a trusty and in 1909 was assigned to maintain the death chamber. Soon, he asked Warden Thomas H.B. Jones for permission to

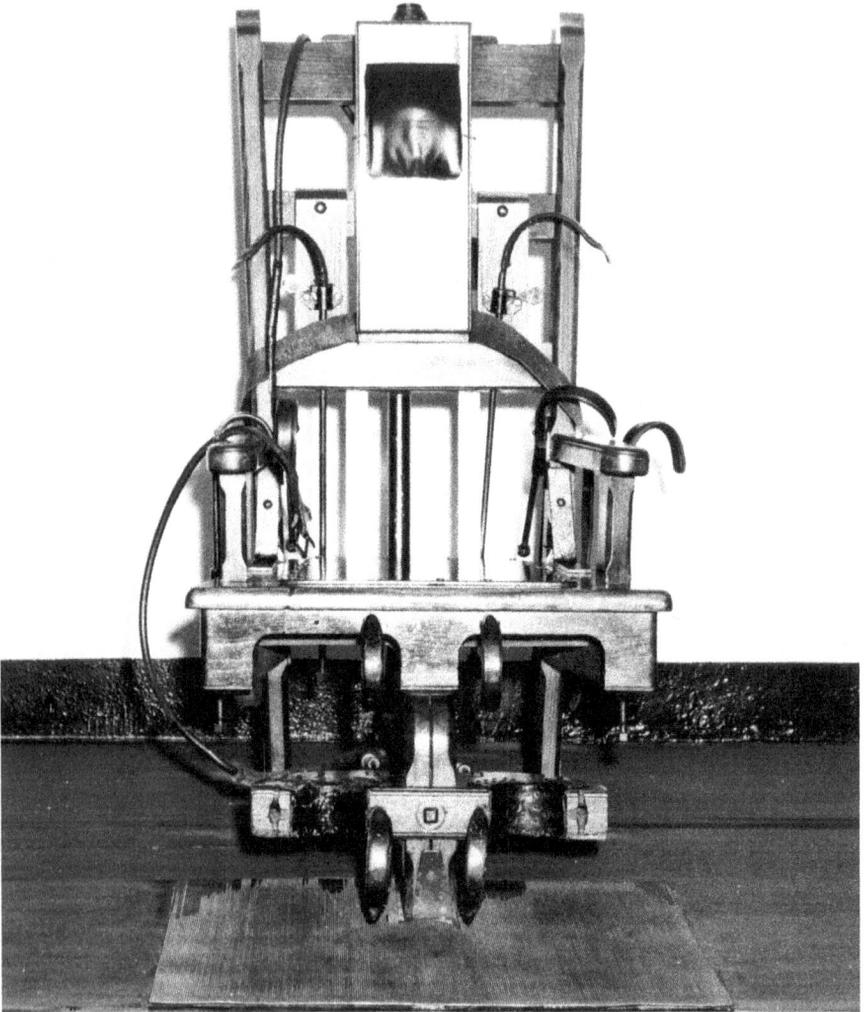

After Atkinson became the trusty in the Death House, he became famous for breeding canaries. *Courtesy of the Dailey Archives.*

breed yellow canaries. While he was neither the first nor the last inmate at the Ohio Penitentiary to raise canaries,[125] he was the only one to be profiled in the pages of *Popular Mechanics*.[126] He would first teach the birds to fly from one arm of the electric chair to the other and then from the chair to the old gallows. As soon as they had mastered flying, he would

give them singing lessons with the aid of a gramophone, always careful to play "slow, dreamy waltzes" and never ragtime.

Often Atkinson would pass the birds to the condemned men in the adjoining room through a peephole in the door so that they could enjoy their singing. Based on strong evidence he had reformed, his sentence was commuted on July 23, 1915, by Governor Frank B. Willis. He was released immediately.[127]

The tale of the prison demons—particularly Marlatt and Hurley, but also Atkinson and O'Neal—has been told and retold. Unfortunately, much of what was written about them was a fairy tale. Following the appearance of Charles Edward Russell's article, "Beating Men To Make Them Good" in *Hampton's Magazine*, several letters were published in newspapers throughout the country that sought to provide more details. One inmate gave his take on the story to the *Arizona Republican* late in 1911. He claimed, "A guard with loaded rifle was placed outside the cage to keep them in check yet despite this, they broke off the iron legs of their wall cots and held a mêlée that was historic, fighting like the famed killkenny cats."[128]

The ex-con also recalled that Warden "Avis X. [*sic*] Darby"[129] was responsible for closing down the Demon Cage after meeting with them. "What was said no one will ever know, but at the conclusion of the hour, he led the four 'demons' out into the prison campus, into the glow of the sun and under the green of the trees they had not seen for years, and those who saw these five strong men, four of whom had never weakened before many officials [and] the other a strong man, with a strong man's knowledge of human character said that every man was weeping, for strong men do occasionally weep."

Finally, he stated, "It is a matter of prison history, that these four men were never afterwards punished nor did they violate the confidence placed in them by Mr.

Robert McKay was a later-day birdman who went on to write a series of well-received young adult novels. *Courtesy of the Dailey Archives.*

Darby. Hurley is now out on parole. Marlatt, who is a 'lifer' says he does not want out. O'Neill and Atkinson died in the prison."

In truth, Atkinson was the only one to ever see freedom again; Marlatt, Hurley and O'Neal, as far as can be determined, all died at the Lima State Hospital.

The Frankenstein Myth

It is commonly believed that the inventor of Ohio's electric chair was also its first victim. Although Charles Justice is often credited with this dubious distinction, records show he was not at the Ohio Penitentiary during 1896–97 when the device was originally constructed.[130] However, Harry "Biddy" Glick, serving the third of four terms, was. A carpenter by trade, Glick modeled his creation after photographs of Sing Sing's electric chair. Released two years later, he subsequently returned to prison in 1912 on a first-degree murder charge for the slaying of a Wooster police officer. He would have died in the chair except for the fact that his sentence was commuted to life.[131] These facts would seem to completely debunk this bit of prison folklore, but maybe not.

For over 250 years, hanging had been the favored method of capital punishment in the United States.[132] Frequent occurrences of strangulation and even decapitation, however, had begun to dampen public enthusiasm for it. In 1885, Patrick Hartnett's head was nearly torn from his body at the Ohio Penitentiary. So when Dr. Albert Southwick, a dentist and former steamboat engineer, suggested electrocution as a more humane alternative, many people listened, inventor Thomas Edison among them.

Southwick had witnessed the "painless" death of a drunk who had touched the terminals of an electrical generator in Buffalo, New York. Overnight, he became an outspoken advocate for "electro-cution" (as the newspapers dubbed it). Nine years later, on August 6, 1890, ax murderer William Kemmler became the first person to die in an electric chair at

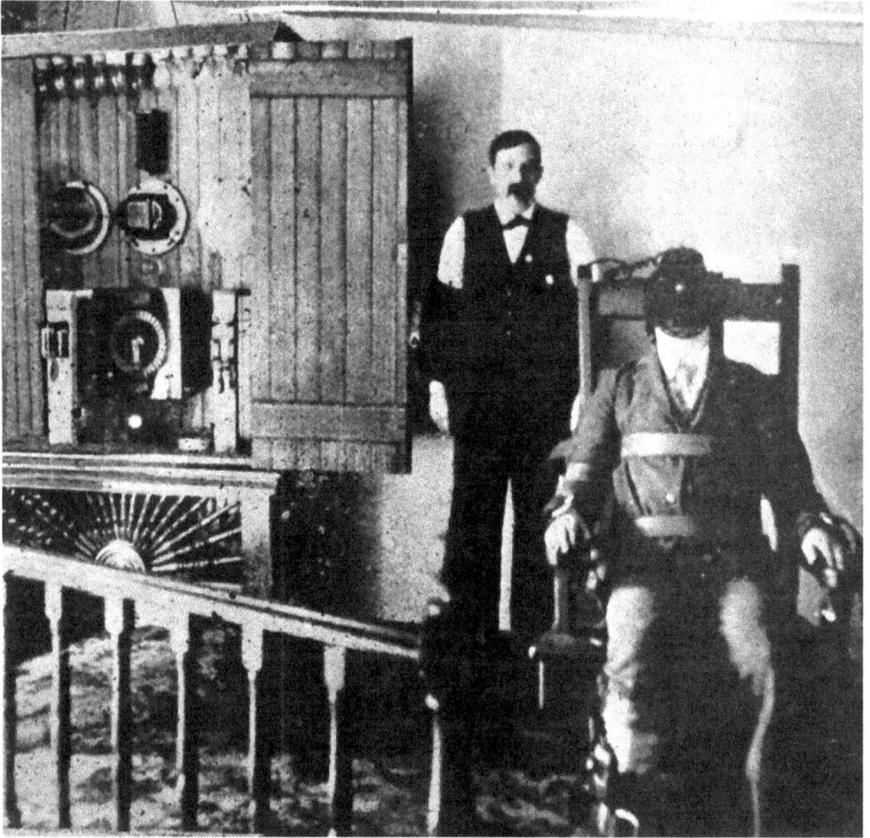

The electric chair was installed immediately below the trapdoor of the original gallows. *Courtesy of the Dailey Archives.*

Auburn Prison. By then, Edison had demonstrated the lethality of electrical current on a dozen assorted animals. He would go on to "execute" Topsy the elephant at Coney Island in 1903.[133]

Despite numerous tests on cats, dogs, a horse and even slabs of meat, Kemmler was not killed outright, and a second charge of electrical current was required to finish him off.[134] Nevertheless, the electric chair captured the popular imagination in a way the gallows never had. The Ohio legislature responded by passing a law on July 1, 1896, requiring that the condemned be executed by "means of electricity."[135] It became the second state in the union to do so.

In all likelihood, the Ohio Penitentiary's chair was developed by R.C. Green, superintendent of the Gas Works and Electric Light Plant, assisted

by a team of employees and inmates.[136] Harry L. Canfield, former superintendent of the municipal electric plant in Jackson, Ohio, installed the killing machine, using Glick's handiwork and other components.[137]

On April 21, 1897, Ohio entered the age of the electric chair when it executed two men. William Haas, who had drawn the short straw, went first. He was followed five minutes later by William Wiley, who had drawn the long straw and took delight in his short-lived victory. It seems he hated Haas.

Next up were Frank Miller, who expired quickly, and Albert Frantz, who did not.[138] With 150 unruly spectators vying to see, Frantz was strapped into the heavy oak chair on November 19, 1897. A sponge saturated with salmoniac was bound with leather bands to his forehead and the top of his head. Metal bands encircled both legs above his ankles. Wires led from the sponges on his crown and the metal restraints on his ankles directly to the electrical dynamo. A dark hood was slipped over his head, and the warden switched on the power:

> *As the current passed through the body it heaved and surged forward. The sponge on top of the head hissed and the steam rose from it in a small cloud. There was a smell of burning hair. In a few seconds the current was turned off. The expanded chest contracted and from the lips was emitted a loud groan. Several times the man seemed to gasp for breath but it was believed to have been caused by the contraction of the muscles of the chest.*
>
> *After a short examination Dr. Wagenhals stated that the heart was still beating. The current was then turned on again. Two more shocks followed at short intervals, making four in all. The first three shocks were of 1,700 volts and the last was 2,000. At each of the shocks except the last a groan was emitted from the lips.*[139]

Frantz's death became a cause célèbre, prompting the formation of an International Brotherhood League by the Theosophical Society in Cincinnati. Its objective was the abolishment of "legalized murder." However, the Ohio State Medical Society concluded that "the prisoner was in all probability rendered unconscious at the instant of the first contact and subsequent convulsions were likely of a purely unconscious or mechanical nature."[140]

Everyone agreed that Frantz died hard. The chinstrap had been so loose that the electrode on top of his head had slipped about two inches out of place. Also, his thick hair had prevented the sponge from making good contact with his scalp. Steps were taken to ensure that the same mistakes

weren't repeated when Frank Early was put to death six months later on May 14, 1898.[141] As an extra precaution, Warden Coffin ordered the inmate's head shaved.

> *Three times a current of 1,900 volts was shot through the prisoner. The doctors pronounced him dead at 12:17.*
>
> *The straps were half removed, when the giant chest moved and groan after groan came from the foaming mouth. "He is dead," said the doctors. "He is not dead," shouted somebody else. Warden Coffin ordered the negro strapped again, and again the body stood rigid under the current. A deep groan answered this shock. Another shock and smoke rose from the right ankle. The third shock at 12:21 was not answered, and so with six shocks and seven distinct groans Early was dead, 330 seconds after the first current entered his body.[142]*

By contrast, Charles Nelson took less than sixty seconds to give up the ghost. Warden Coffin had instituted a new regimen: 1,700 volts for seven seconds followed by 250 volts for the remainder of the minute. Unfortunately, the plan failed the very next time it was used. Bruno Kirves required three separate jolts spread over three and three-quarters minutes on August 17, 1899. When the rubber hood was removed, it was apparent that his forehead, eyes and upper nose had been baked due to another loose sponge problem.

On November 9, 1900, Richard Gardner died promptly when administered 1,750 volts for two seconds and 250 volts for another ninety seconds. An autopsy revealed that the current had bored six separate holes in his brain. The next year, Rosslyn Ferrell[143] and Edward Ruthven also died quickly.[144] Then, by chance, there was a hiatus of nearly three years.

As it turned out, 1904 was an exceptionally busy year for "Old Sparky." Before it was over, an even dozen men met their maker, and in a handful of instances, they did not go gently. The first was John Bennett, and the second Carl Berg, both of whom died unremarkably.

Up to the last minute, wife-murderer Michael Schiller of Youngstown had hopes that the governor would commute his sentence. He didn't, and Schiller met his fate on June 17. As reported in the *News Herald*:

> *He was strapped in the chair and the electric current of 1,750 volts was applied for 33 seconds. The condemned man was pronounced dead by the four physicians present but in a few minutes it was noticed that he was breathing and the current was again applied for 40 seconds. Schiller*

was again pronounced dead and the body was unstrapped and laid on the floor of the execution room…when the physicians again discovered signs of breathing. Warden [Edward A.] Hershey was hurriedly recalled and Schiller was again strapped in the chair. The current was then applied at 1,800 volts and was kept on for a full minute. At 12:11, he was pronounced dead for the third time when the physicians fully satisfying themselves that life was extinct.

Superstitious inmates noted that Schiller was the thirteenth man to die in the chair. One theory for how he had survived eight amperes of current (when five was thought to be the limit) was that he had drunk little water in the days leading up to the event.[145] Another was that "when the current was turned into Schiller the marked contraction of the muscles threw out the leg electrode, held in place by a spring, leaving only a small portion of its surface in contact with the limb." Therefore, a larger replacement electrode was made that strapped tightly to the leg.[146] It was also decided that the one extra shock would be administered after the inmate was pronounced dead.[147]

No one was more upset by the news of Schiller's grisly death than Mose Johnson. He "raved for hours like a mad man, finally giving up to sobs and pleadings."[148] On June 18, the day after Schiller's death, Johnson took his turn in the chair. Not until the fifth shock had been applied was he pronounced dead.[149] Apparently, the sponges attached to the electrodes on his calf and his head were dried out by the first surge of power. The succeeding charges then burned the skin "to a crisp." The sight was so horrible and the stench so bad that many of the spectators were sickened.[150]

No doubt embarrassed by this gruesome spectacle, Charles A. Marden, superintendent of gas and electric lights, called in electricians from the Edison Company to affect the necessary repairs. As reported in a *Columbus Citizen*:

New wire was laid at the power house and new cable from the switchboard to the chair. New registering voltmeters and ammeters will be put in both on the switchboard and underneath the chair, so that in the future it will be possible to determine while the current is being turned into the victim whether or not there is any loss of current between the switch and the chair. A new electrode for the leg will also be used.

When Albert "Dutch" Fisher, scheduled to die on July 7, inquired about the noise in the annex, he was informed that the electric chair was being

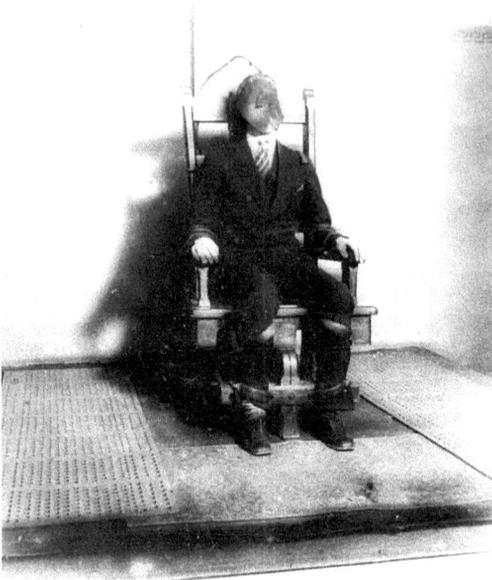

This is taken from the only known stereophoto of a man seated in the electric chair. *Courtesy of the Dailey Archives.*

repaired. So he asked a guard to "kindly close the door. It's not a pleasant sound."[151] A couple weeks later, brothers Albert and Benjamin Wade were the next to go. No doubt the deaths of Schiller and Johnson were on the latter's mind, for his last words were, "Now boys, don't burn me up. I want to be a respectable looking corpse." Both men expired quickly, and it seemed that any problems with the device had been resolved. When Charles "Dayton Slim" Stimmel was executed, the chair was said to have performed flawlessly.[152] Still, no matter how efficient and effective it might have become, electrocution remained an ugly way to die. A certain amount of charred flesh, dancing flames and foul smells was to be expected. Nevertheless, Alfred "Strangler" Knapp and "Dutch" Fisher (after a three-month stay of execution) both died unremarkably.

Lewis Harmon, Otis Loveland and Miles Wallingford were all complicit in the murder of George Geyer. Wallingford later committed suicide, but Harmon and Loveland were tried for the crime and both sentenced to death. Harmon, the larger of the two men, was given two shocks on October 28. "From a scientific standpoint, the execution was successful," according to the *Pittsburgh Press*.[153] Loveland, however, was thin and wiry. In the days leading up to the execution, he had been encouraged to drink plenty of liquids—water, milk, coffee and tea—to improve the flow of electricity through his body.

Two shocks were administered. The first failed...The electrodes were readjusted. When the second shock was administered Loveland's body jerked and twisted. The straps had not been properly fastened. During the last

shock flame and smoke issued from the victim's head and right leg…the
death chamber was filled with a strong odor of burning flesh.[154]

Owing to a problem with the straps, it took three zaps at five and a half amperes before he succumbed on November 25, 1904.

Warden Edward A. Hershey, who had been under increasing pressure to resign, died unexpectedly on August 21, 1904.[155] His successor, Orrin B. Gould, clearly inherited a mess. Still, Civil War veteran William Nichols met his maker without incident. Then, on March 25, 1905, Herman Hamilton's turn came. His execution was judged "the most successful of the thirteen that [had] occurred since April 15, 1904."[156]

The problems with the chair had been resolved, at least for a few years. Butler Styles, Fred Caster, Oliver Haugh and James Cornelius, some of the worst of the worst, all died efficiently.[157] Chief electrician Thomas Campbell had regularly tested the chair to ensure there were no problems. Then on July 19, 1907, Henry (a.k.a. William) White was put to death. At slightly after midnight, he was administered two applications of 1,750 volts, but his heart continued to beat. "On the third shock there was more smoke than either time before, and finally a sheet of fire shot from the top of White's head. Following his examination, Dr. Thomas pronounced him dead at 12:14.[158]

White was followed by Albert Davis and Royal Fowler, neither of whom presented any problems.[159] But then on December 20, 1907, something went wrong again. Frank Earl (a.k.a. Howard West), proclaiming his innocence to the end, was administered two shocks of 1,750 and 1,500 volts, yet his heart continued to beat.[160] So a third application was necessary.

During the next year, Harry Crooks, Harry Rife, John Kilpatrick (or Kirkpatrick), Charles Davis and William T. Swan all died as intended.[161] By then, the protocol had been established: about ten seconds at 1,750, forty seconds or so at 500 volts and then several more seconds at 1,750. When Crooks was executed, two men were hidden behind a screen: Deputy Warden Charles Beach and electrician D.B. Torpy. For the first time, the identity of the person who threw the switch was a secret.[162]

At some point following the execution of Frank Earl, someone replaced the original leather straps with a system of metal clamps that could be ratcheted down on the inmate's arms and legs. That someone, if Michael V. DeSalle is to be believed, was Charles Justice.[163] The one-time governor of Ohio provided the following account in his book, *The Power of Life or Death*:

Even more striking is the case of Charles Justice. Justice, a broom maker who was sentenced in 1902 to twenty years in the Ohio State Penitentiary after a cutting scrape—a third offense—was a trusty assigned to the housekeeping duties of the death house. He found the electric chair—an angular, ungainly contraption of polished golden oak—far from efficient. While obviously not designed for comfort, the chair was too big for the small, nervous type of prisoner, who would squirm in his seat and cause the electrodes to make imperfect contact. As a result, the powerful current would arc between the electrodes and the doomed man's body, causing flesh burns and an unpleasant odor which discommoded the witnesses and officiating representatives of the state. Justice corrected the deficiency by designing iron clamps—which are still in use—to immobilize the limbs of the condemned man during the death reflexes and thus make for neater execution.[164]

The *Xenia Republican* reported that Charles Justice (a.k.a. Jackson) had been in and out of prison during the period in which the electric chair was being constructed, but Ohio Penitentiary records contradict this. He did, however, serve twelve stints in the Greene County Workhouse and two years in a Canadian prison. As criminals go, he was strictly small time.

Born in 1868, Justice grew up in Xenia, where he worked as a butcher. A heavy drinker, he first entered the Ohio Penitentiary in 1889 at the age of twenty-two, convicted of burglary and larceny. He served less than a year. Two years later, in 1892, he again returned to prison for larceny and again was out in less than a year.

When Justice discovered that his wife had left him, he vented his anger on his father-in-law. This earned him a trip back to the Ohio Penitentiary in 1902 for cutting with attempt to wound. Having learned the ropes, he had no difficulty rising to the status of trusty with all the attendant privileges. He even collected a tidy sum of money selling souvenirs to those who came through the prison on tours.

On April 19, 1910, after serving eight years on a twenty-year sentence, Governor Judson Harmon commuted Justice's sentence "for exemplary service to the state."[165] Seven months later, on November 9, the Shoup brothers heard a commotion outside their Xenia farmhouse. Upon investigation, they surprised a man stealing their chickens. The would-be thief fired three shots at them, one of which struck and killed John Shoup. William Shoup later testified that it was Charles Justice who calmly picked up the bag of chickens and made his escape.

As Governor DeSalle wrote:

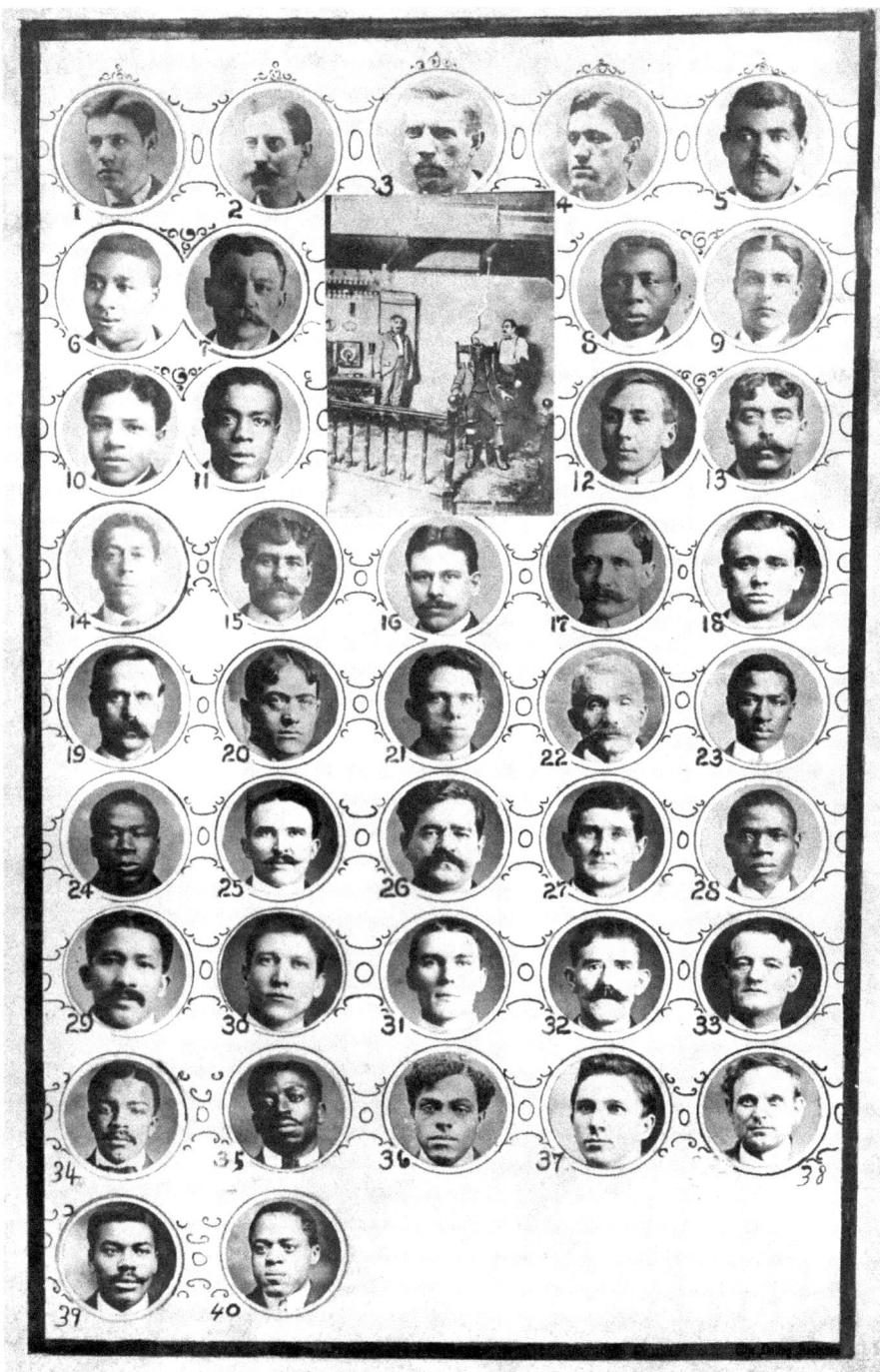

Souvenir cards were continually updated to reflect the latest executions. Charles Justice is Number 38. *Courtesy of the Dailey Archives.*

He was well aware of the fate reserved for murderers, a more efficient operation thanks to him. This awareness, vivid though it must have been, was not the deterrent it is supposed to be. In November of the same year, Justice returned to the penitentiary as Number 40,103. The charge: murder in the first degree. On October 27, 1911, undeterred Charles Justice died in the electric chair he had helped make more lethal, immobilized by the clamps he had invented. As a contemporary cynic remarked, it was poetic justice for Justice.[166]

When no friends or relatives claimed his body, it was turned over to a Columbus medical school for dissection.

For those opposed to the death penalty, the story of Charles Justice was almost perfect. Here was a man who had "first-hand knowledge of the efficiency of the death dealing chair," and yet that knowledge did not stop him from committing murder.[167] However, it would be even better if he had actually been the chair's inventor, so over time a few of the details got changed in the retelling. As a result, an urban legend was born: the oft-cited example of the creator killed by his own creation.

Chapter 8

Women in Prison

W hen the Ohio Penitentiary opened in 1834, it originally housed not just men but also women and children.[168] Within three years, a separate building was constructed to accommodate women and, occasionally, young girls.[169] Deemed the Female Department, it was a self-contained unit, "a prison within a prison."[170] It wasn't until 1913 that the Female Department was replaced by the Ohio State Reformatory for Women in Marysville.

Historically, all lawbreakers were treated much the same, regardless of age or sex. The first jail in what would become Columbus was built in 1804 and included thirteen whipping posts. According to Daniel Morgan, "Not only men but women and children were brought there, stripped of their clothing, lashed to the cruel posts and whipped until their backs resembled 'raw beef,' then tied face downward on the cold ground while shovels of hot ashes and coals of fire were sprinkled on the raw and bleeding flesh."[171] Over time, the treatment of inmates became more enlightened, albeit at a painfully slow pace.

One of the earliest descriptions of the Female Department comes from *Historical Reminiscences of the Ohio Penitentiary*, published in 1884:

> *This is the coziest place of all. The building is three stories high and is situated south of the old East Hall building. It is surrounded by a stone wall of the same height as the one surrounding the prison. On the first floor* [are] *the Reception Room, where female prisoners see their friends, Matrons' Apartments, and the Laundry. On the second floor* [are] *the*

*Sewing Room, the Dining Room, and the Dry Room. On the third floor
are the Sleeping Apartments. The room is long with cells on the sides; these
cells are more homelike in appearances than the men's, many of them being
daintily arranged with pictures on the walls, presents from friends outside,
arranged on the shelves in a very artistic manner. Miss Ray Houk, the
present Matron, and her assistant, Mrs. Julia Glines, are held in high
esteem by the officers of the prison for the manner in which they have
successfully conducted this department during the present administration.*[172]

The Female Department held a particular fascination for sightseers in the
1890s. For an additional ten cents (regular admission was twenty-five), one
could take a guided tour of the ladies' building, including stops in the dining
room, laundry and second-floor holding cells, most of which were decorated
with paintings and objects d'art. The third floor of the annex also contained
a workshop for sewing and broom making, as well as a classroom. Women
were often afforded privileges that the male prisoners were not, although
it seems that the rules and punishments were subject to the whims of the
head guard or matron. Some were kinder and more lenient than others. A
few, including one male "matron," were cruel and violent. There was no
small amount of rejoicing when this stern man was replaced by a "highly
cultivated" woman matron—as cultivated as would take the job, that is.

Descriptions of the behavior of the female convicts fluctuated depending
on who was asked. Contemporary newspapers tended to soften their image,
noting, for example, how one knit blankets for hospitals and suggesting
that others were not responsible for their actions because of certain mental
deficiencies. A report from 1842, however, recorded that they "fight, scratch,
pull hair, curse, swear and yell, and to bring them to order a keeper has
frequently to go among them with a horsewhip."[173] It is likely that the
horsewhip-happy keeper and the lone male matron were one in the same.

Women were given more freedom in terms of decorating their cells (almost
always called "rooms" by reporters) or in how their time was spent (no hard
labor for the fairer sex). Yet they were also held to a higher standard. The
same report described one of them as displaying a "deadness to all feminine
decency." The smart or lucky were able to use this double standard to their
advantage. In 1888, Mrs. Mary Garrett became something of a media
sensation when she was sentenced to death for setting her two "imbecilic"
stepchildren on fire while they slept. When she arrived at the penitentiary
from Medina, Ohio, she cradled a baby in her arms who had been born in
the county jail while she awaited trial. Governor Joseph Benson Foraker,

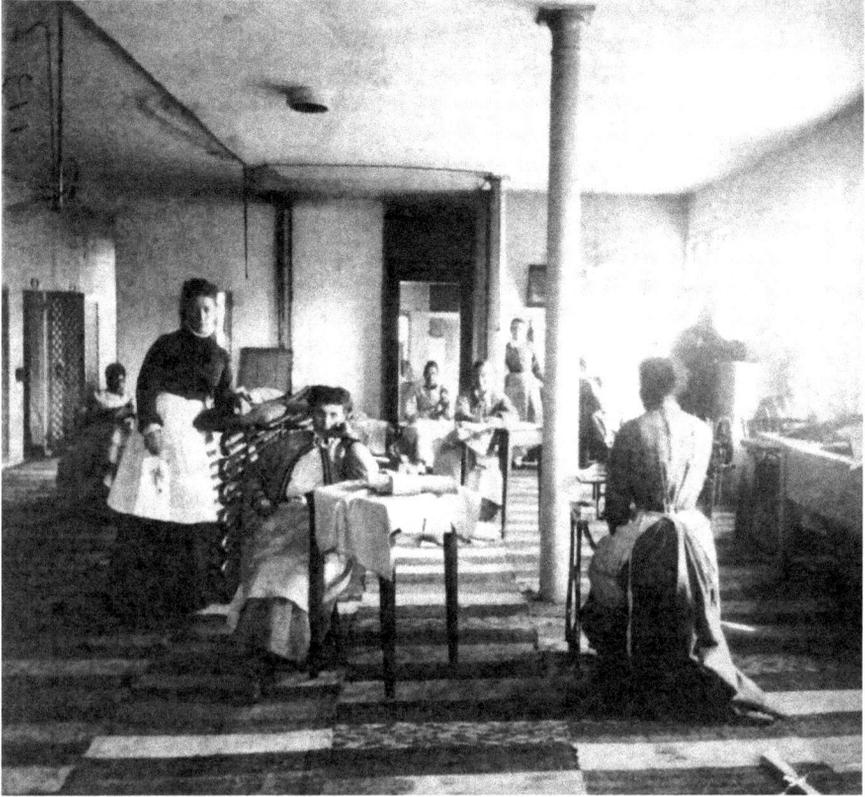

Detail of stereoview featuring women's quarters at the Ohio Penitentiary. *Courtesy of the Dailey Archives.*

perhaps unwilling to send a nursing mother to the gallows, commuted her sentence to life imprisonment. After a decade in prison, she received a Christmas pardon.

One of Garrett's sister inmates was 250-pound "Big Liz" Carter, who, in 1890, was imprisoned in the Ohio Penitentiary for poisoning her lover. Her sentence was also commuted, and she eventually went free. There was a clear reluctance on the part of the public and the judiciary to execute a woman, regardless of the offense. Julia Maude Lowther came close to getting the electric chair in 1931 for arranging the murder of her lover's wife but instead received a life sentence on appeal.

Perhaps the best description of the lives of female prisoners at the Ohio Penitentiary comes from a convict herself. In her autobiography, *The Life Story of Sarah M. Victor*, Sarah tells of her life before the death of her

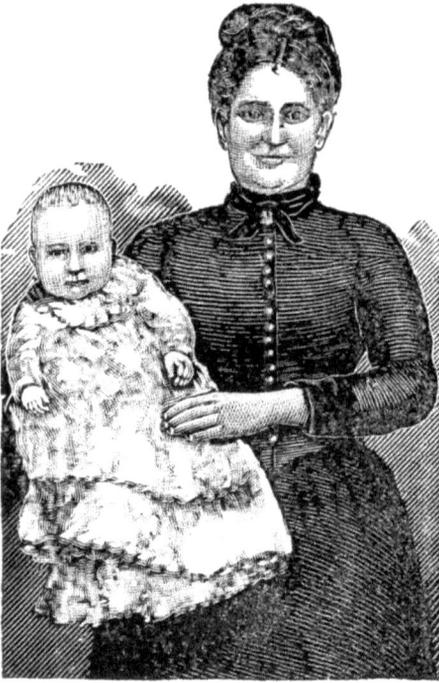

Child-murderer Mary Garrett garnered undeserved sympathy by benefit of her newborn baby. *Courtesy of the Dailey Archives.*

brother, whom she was accused of killing, as well as her court cases and her years in prison.[174] Women are statistically more likely to use poison to murder than men. In Sarah's case, she was accused of feeding her brother arsenic to collect on a rather small life insurance policy. She denied it.

During her imprisonment, Sarah "was given little cause for complaint," having been incarcerated under the reign of "an unusually humane matron," L.V. DeSallem. One assistant matron did mistreat her by "taking away flowers that were given to me, and hiding my dolls, to which I was much attached." Sarah believed she was given more freedom than her fellow prisoners, although she did witness injustices. She would go on a hunger strike when one of the other inmates was placed in "the dungeon," so the staff quit telling her when it happened. She thought that the prisoners would be better reformed if they were treated with love and kindness, which would be more readily accomplished if the jobs performed by jailers were made easier.

The "girls" were permitted to tend to peach trees in the yard, even using knives to trim them, although these were later taken away to prevent them from attacking each other. Sarah kept a pair of scissors, however, so she could piece quilts for the needy. She was also given extra clothes in the winter and food directly from the warden's table when she was ill. It seems likely that she used her grandmotherly appearance, possible mental instability and frequent physical impairments to engender kindness from both the staff and her fellow inmates. Of course, she also was something of a celebrity.

Sarah wrote about the prison wedding of her nurse, Annie McFarland, to a male inmate. Annie seems to have been her full-time nurse, even living

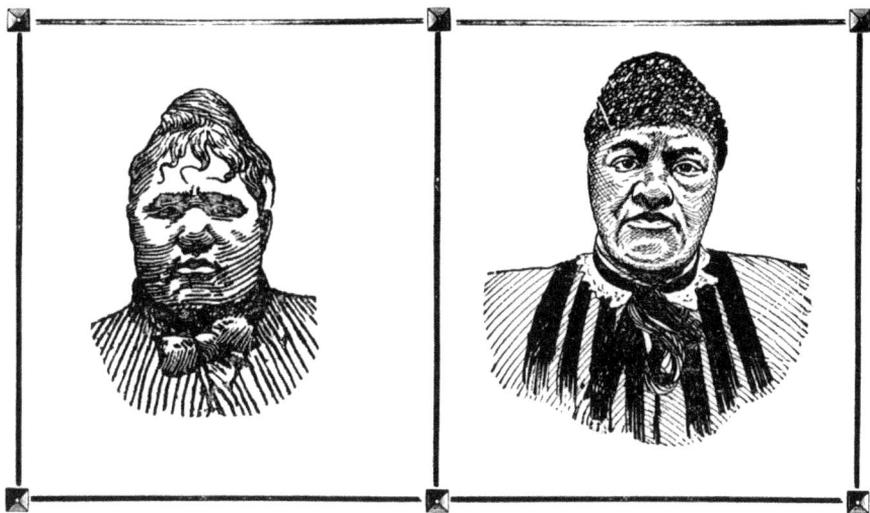

Sentenced to die by Isaac "the Hanging Judge" Parker, Elsie James (left) joined "Big Liz" Carter at the Ohio Penitentiary. *Courtesy of the Dailey Archives.*

in the prison to be near her and, concurrently, her fiancé. Originally the couple, who were engaged when they both came to the prison, intended to marry when he was released. However, he was later given extra time for misconduct. Three hundred people received tickets to the wedding, including members of the legislature. The groom later deserted Annie, and as Sarah recorded, she "was left to die alone and uncared for."

If Sarah Victor was one of the oldest female penitentiary residents, the youngest may have been Carrie Smith, who was only thirteen, according to the *Ohio Citizen Journal* of February 5, 1890. An African American girl, she was convicted of beating a child to death. The *Cleveland Plain Dealer* on April 26, 1887, reported that Robbie Brown, age two, died after being "whipped a little" by Carrie, as well as fourteen-year-old Hattie Jewell and Mrs. Jennie Docile Brown, Carrie and Robbie's foster mother. At the time of his death, Robbie was severely malnourished, weighing only eighteen pounds. Both Carrie and Hattie were sentenced to ten years in prison. Allegedly, they giggled at their sentencing. Jennie Docile Brown, the only adult, was set free after testifying that she was ignorant as to how the baby came to have so many bruises on his body.

Another famous "celebrity" resident of the Ohio Penitentiary was Cassie Chadwick, born Elizabeth "Betsey" Bigley. Cassie had several other aliases, including Lydia Scott, Madame Lydia de Vere, Cassie Hoover and

the Queen of Ohio. She was a white-collar criminal who ran up debts all over the country by claiming to be the illegitimate daughter of Andrew Carnegie. While in prison, she continued to live the life to which she had become accustomed as the wife of Dr. Leroy Chadwick, a wealthy Cleveland physician. Every night, her dinner was brought in from a restaurant at the then alarmingly high cost of two dollars per meal.

Cassie was a favorite subject of newspaper articles. The con woman arrived at the prison on January 1, 1906, with all her favorite possessions, including clothing, furniture, photographs and animal skin rugs. Her health seemed to decline almost at once, although the doctors could not explain it. At times, she was accused of "shamming" or pretending to be sick to get out of work. Other times, her rich diet of restaurant food was blamed for her upset stomach. She lost thirty pounds and was moved to the prison hospital, where she died on October 10, 1907, her fiftieth birthday. Just a month earlier, she had suffered a "nervous collapse," which left her blind. A Canadian by birth, Cassie was the subject of a 1985 made-for-TV movie in Canada called *Love and Larceny* and a 2004 musical of the same name.

In 1904, two years before Cassie came to the Ohio Penitentiary, many of the female inmates planned an escape. Emma Chapman, although described as a "negress," was said to have come from "Indian Territory." She had been imprisoned for four years but had been at the Ohio Penitentiary for less than a year. Assistant Matron Laura Rigby caught her plotting with other inmates from the Indian Territory. (Many federal inmates, male and female, were transferred to the penitentiary under an agreement with the government in Washington, D.C.) They intended to carry out their escape while the head matron, Miss Wells, was on vacation. For her efforts, Emma was sent to solitary confinement indefinitely. Sarah Victor expressed sympathy for the women who worked as matrons, noting that "the position of matron in the women's department is a hard one to hold long creditably, for when once a matron is overpowered by a prisoner or censured by the warden, she is considered disgraced, and her usefulness—usually her reign also—in the department is over."

At least one woman did escape, though. Lizzie Dimery Ruthven, wife of murderer Edward Ruthven—who was put to death in June 1901—had attempted suicide by cutting her throat when the governor refused to commute his sentence.[175] Five months later, on November 19, she used a screwdriver to get out of her cell and then two stepladders and a rope to go over the wall, where someone was apparently waiting for her. It is believed she fled to Canada. She was serving a six-year sentence for receiving stolen property.[176]

The "Queen of Ohio," Cassie Chadwick, was one of the most successful con artists of her time. *Courtesy of the Dailey Archives.*

Of 343 executions that took place at the Ohio Penitentiary, only 3 were women, and all were electrocuted. On December 7, 1938, Anna Marie Hahn became the first women to die in the electric chair. She was convicted of killing four men but was believed to have killed five between 1933 and 1937: Ernst Kohler, Albert Parker, Jacob Wagner, George Gsellman and Georg Obendoerfer. Hahn was at least as prolific a serial killer as Jack the Ripper, whose "official" total also stands at five. She would befriend elderly men, poison them with arsenic and then use the inheritance they left her (anywhere between $1,000 and $17,000) to pay off her gambling debts. Although she did not reside in the Ohio Penitentiary, she was transported from the Marysville Reformatory for execution on December 7, 1938.[177] She was only thirty-two and left behind a son, Oskar.

Blanche "Dovie" Myers Dean was the second to die. Executed on January 15, 1954, at the age of fifty-five or fifty-six years old, she was charged with killing her second husband with rat poison, spiking his milk for financial gain. In life, Hawkins Dean, age sixty-nine, provided Dovie with a refrigerator and washing machine; in death, she stood to gain $27,000, no strings attached. She became famous as the murderess who could not cry,

claiming an emotional inability to do so. The mother of six children from a previous marriage, the reporters believed that she actually enjoyed her time in prison. She took pleasure in the furnishings of her cell and in reading the fan mail she received from all over the country. Apparently, many of them were praying for Dovie. Like Hahn, the only time she spent at the Ohio Penitentiary was the brief period preceding her death.

Unlike Hahn and Dean, Betty Evelyn Butler was not a poisoner. She was convicted of the beating and drowning of thirty-three-year old Evelyn Clark, who Betty claimed had made sexual advances toward her. It was believed that the two women were lovers. As with all previous female inmates since 1913, she had been incarcerated in Marysville but was brought to the OP for execution. While in Marysville, she earned the nickname "the Sphinx" because she was so quiet. On June 11, 1954, at the age of twenty-six, she became the third woman to die in the electric chair while holding a rosary in her hand.

Inmates weren't the only women who walked through the Ohio Penitentiary gates. There were the aforementioned matrons, hired by the prison as guards and moral housemothers for the female prisoners. There were also various other female staff and even employees of the contract factories and shops that once operated inside the prison. Much less well known were the children of prison officials, many of whom resided in staff quarters within the walls. One of them even went on to serve unofficially as interim warden.

Amanda Adeline Thomas was the daughter of Warden Preston Elmer Thomas and his wife, Mary Elizabeth Blume, the prison matron. Her major claim to fame was the part she played in the Lindbergh baby–kidnapping case. Bruno Richard Hauptmann had been sentenced to death for his participation in the 1932 abduction and murder of the child of famed aviator Charles Lindbergh. It seems that Hauptmann had sent a coded letter to an inmate at the Ohio Penitentiary, outlining his plans to take the child and blackmail the wealthy parents. The letter was discovered by Amanda while performing her duties as prison mail clerk and censor. Although she thought the note curious due to its strange and apparently coded wording, she did not realize its connection to the "Crime of the Century" until after Hauptmann was arrested and she recalled seeing his name on the letter.[178]

From around 1916 until her father's forced resignation in 1935, Amanda worked at the penitentiary. Along with her official job as postmistress, she dabbled as the prison marriage counselor. A 1927 *Delphos Daily Herald* article described how she counseled the wife of inmate Nick DeSantos, who was

concerned because she had two children and her husband was serving a life sentence. The woman had picked out her second husband because her first husband was in agreement that a new marriage would be good for her and the kids. However, Amanda told her that "a divorce won't help matters." Apparently, Mrs. DeSantos was still attached to Nick and became concerned when she learned that as the ex-wife, she would no longer have visitation rights.

At times, Amanda was quite the unofficial spokesperson for the prison, interviewed by the press and testifying before a special grand jury for the investigation of Ohio's parole system. She came to her father's defense when he was accused of having inappropriate relations with the wives of some inmates. And she was also the prison gossip. In 1934, when two of mobster John Dillinger's lieutenants attempted to escape, Amanda told the press that one of the conspirators, Harry Pierpont, took part in the escape attempt because he believed that his girlfriend, Mary Kinder, was cheating on him. She commented, "I've always said that this would end in fireworks. I knew there would be trouble over them." Of course, Amanda had read the "Dear John" letter Mary had sent Harry at the beginning of the week.

In 1916, Amanda was but a twenty-year-old coed at Ohio State University when her father left her (and her trusty revolver) in charge of the entire prison while he was away in Kansas attending a convention. This was the first time in history that a woman served as warden in any state penitentiary. Amanda also took control of the prison office during the 1930 fire while her father supervised the efforts elsewhere. She issued both machine guns and orders to the guards, sending them to their posts. Afterward, she contacted medical personnel and called for the Ohio National Guard to assist in putting out the fire.

When the fire eventually endangered her residence in the main building, Amanda made the questionable call to have all her valuables carried to safety. She also oversaw the removal of the dead bodies following the fire. "We're sitting on top of a living volcano here," she later told the press. "There have been rumblings right along…When the cry of fire went up Monday night, and the yard was filled with smoke, I knew the volcano was loose." In view of the criticism regarding her father's handling of the fire and riot, the inmates might have been better off in her hands.

In 1935, the Thomases were forcibly removed from their jobs and "home" when an exposé was published detailing the privileges Warden Thomas allowed convicted murderer and Purple Gang member Thomas "Yonnie" Licavoli. During Thomas's administration, the prison population had swollen from 1,600 to 4,000. On Thomas's departure from office and

Serial poisoner Anna Marie Hahn was the first woman to die in Ohio's electric chair. *Courtesy of the Dailey Archives.*

James Woodard's stepping into the position, the prisoners were heard to cheer, "Woodard, hurrah for Woodard."

Long retired from corrections and living in Lancaster, the still unwed Amanda Thomas was elected president of the Ohio Society of the Daughters of the American Revolution in 1962. When elevated to organizing secretary general of the National Society three years later, she received the largest vote ever accorded a candidate for a cabinet office up to that time. She passed away in June 1985.[179]

One woman, Ysabel Rennie, will forever be associated with the prison. She was known as "the Ohio Pen's Avenging Angel."[180] Ysabel, a fifty-five-year-old veteran of the John F. Kennedy and Adlai Stevenson presidential campaigns, was accused of being a communist sympathizer and left-wing agitator who was inciting the prisoners to riot by the former warden, Harold Cardwell,[181] during a 1973 U.S. House of Representatives Internal Security Committee Meeting.

Neither an inmate nor an employee, Ysabel's first introduction to prison life was via the television coverage of the 1968 Ohio Penitentiary riot. She and a friend, Phoebe Edwards, felt the inmates were being treated horribly and wanted to do something about it. As members of the Saint Mark's Penal Study Committee, they set out to research prison conditions, operating out of their Upper Arlington church. Ysabel capitalized on her experience as a former employee of the Office of Strategic Services (precursor to the CIA), as well as the free time she had available as a stay-at-home-wife with a full-time maid, to gather information.

After listening to the courthouse testimony of two prisoners who were put in "the hole" (solitary confinement), Ysabel began a prolific letter-writing campaign to newspapers, community leaders and government officials. She

also corresponded with former and current penitentiary inmates, sometimes through official channels, other times clandestinely, including late-night meetings with shadowy figures and letters smuggled out of the prison in cigarette boxes.

In 1970, while testifying before the Senate Subcommittee on Juvenile Delinquency, Ysabel named forty guards accused of abusing prisoners. She also asserted that at the Chillicothe Correctional Institute, twenty-one cats—pets of the prisoners—were dispatched in a violent manner by prison staff. Then, as now, people were more often moved by the suffering of animals than of human beings. A year later, Governor John Gilligan appointed her to the Ohio Citizens' Taskforce on Corrections. From this post, she continued to draw attention to prison conditions. In 1973, a new correctional facility opened in Lucasville, and all inmates, except those in the prison hospital, were transferred from the Ohio Penitentiary. As a modern penal institution, Lucasville offered amenities to the prisoners that the pre–Civil War era edifice could not. Ysabel is credited with gaining them some of these rights, including the use of private radios and televisions.[182]

Since the creation of the Ohio Reformatory for Women, prison life for both genders has become considerably more equitable. In general, women are no longer afforded privileges that are unavailable to their male counterparts. Still, not everything is equal. According to a 2012 census, there are 50,142 prisoners incarcerated in Ohio. Only 3,820 are women. Of the 142 prisoners currently on death row in Ohio, Donna Roberts is the sole female. She was convicted of hiring a hit man to kill her ex-husband. Like Anna Hahn, who killed Ernst Kohler so she could have his house, Donna had Robert Fingerhut murdered so that she could take the house they shared. Some things don't change.

Chapter 9

The Warden's Pet

Type "Nesbitt" and "murder" into any search engine, and the first few pages of links will be about beautiful Evelyn Nesbitt—"the Girl on the Red Velvet Swing." In 1906, her lover (or rapist, depending on who's telling the story), architect Stanford White, was shot and killed by her husband (and rapist), millionaire Harry Kendall Thaw. A former Floradora girl, Evelyn quickly became a pop-culture icon when she testified at Thaw's media circus of a trial. By 1926, however, her fame was dwindling. Having left Harry, who was serving time in a psychiatric facility, she was replaced in the headlines by a couple other Nesbitts: thirty-year-old Jacob and his pretty young wife, Frances. On February 19, 1926, just a month short of her twenty-seventh birthday, "Fran" (as she was known to her friends) or "Fan" (as her husband called her) was found dead in the bathtub of her Troy, Ohio home.

Jacob Charles Nesbitt, born on November 16, 1895, came from a "socially prominent family." Frances Drake, born on March 20, 1899, did not. High school sweethearts, they were parted in 1917 after their senior year when World War I broke out and Jake enlisted. He was assigned to the 104th Supply Train in France. Meanwhile, Frances enrolled at Ohio State University, where she excelled in her studies and won the women's tennis championship three years in a row. Two years later, Jake joined her but distinguished himself neither as a student nor an athlete, failing to make the football team. Upon graduation, Fan was promptly hired by the Hobart Manufacturing Company to sell kitchen utensils. Within a few months, she had become one of their top salespersons. When Jacob graduated, she

wrangled him a job at Hobart as well. They later married on January 24, 1925.

On the day of the "Bathtub Murder," Jacob claimed he was in Dayton, some twenty to twenty-five miles away, on a sales call. He had expected to meet Fan for lunch but wasn't concerned when she didn't keep their appointment. Working in sales, it was not unusual for her to be called away unexpectedly. When he returned home late that night, he discovered she had been brutally slain. Nothing else in the house was disturbed, but a pair of blue pajamas and a silver vase were missing.[183] Frantic, Jake phoned his neighbor, attorney Johnson West. "Call a doctor, and the police," Nesbitt shouted. "Something terrible has happened to my wife."

High school sweethearts from Troy, Jake and Fan Nesbitt, pictured in happier times. *Courtesy of the Dailey Archives.*

Rushing over to the house, West found Frances lying facedown in the claw-footed bathtub in a pool of pink water. She was wearing a silk nightgown. Lifting her head, he saw two ugly wounds. She had been bludgeoned to death, and her skull was fractured. "She is beyond all help now," he told Jake.[184]

The local police department had few leads. There were no fingerprints or other evidence, and the young woman didn't seem to have any enemies. At Fran's funeral, the Reverend I.L. Dungan, pastor of the First Presbyterian Church, prayed that "God will make the guilty one repent and cause him to confess." Dissatisfied with the slow progress on the case, Hobart Manufacturing decided to hire a private investigator of its own: Ora Slater from Cincinnati. Dubbed the "Private Hawkshaw" (in reference to a Detective Hawkshaw in Tom Taymor's 1863 play, *The Ticker of Leave Man*), Slater was known for using a "folksy" approach

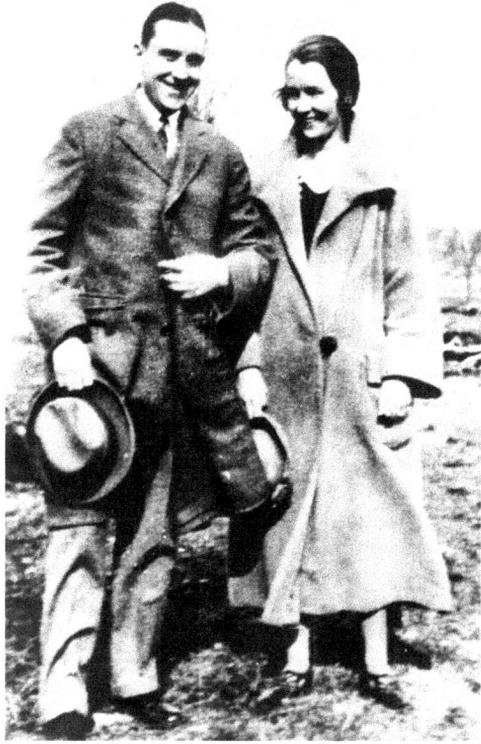

to solving crimes. He often said that "sugar catches more crooks than vinegar." Think TV's Columbo.

Slater immediately befriended the grieving widower, who had already been cleared of any suspicion both by the cops and his in-laws. Jake welcomed the opportunity to help the detective. During the next couple weeks, the two men spent many hours driving through the countryside and tracking down leads, but they turned up little of substance. However, the wily investigator did share with Jake his opinions regarding the mindset of the killer. "I would like nothing better than to clear up this case," Slater said, "but perhaps it will never be solved. Whoever did it must be suffering tortures. If he lives to be 100 years old, the bloody face, the staring eye of this lovely girl will haunt him in his dreams…I think he will live to regret that he did not throw off the burden of his guilt. She was so young, so strong, too young to die such a death as this." Little did Jake realize that Slater had considered him the prime suspect from the start.

Three weeks after he arrived in town, the Hobart executives responsible for hiring Slater—Herbert E. Johnson and E.E. Willard —chided him for not having more to show for his efforts (and their money). In a meeting at the Nesbitt house, Jake insisted the detective was doing a fine job; he just needed more time. At that point, Slater said that he had, in fact, discovered who had murdered Jake's wife: "I'm sorry for you, Jake, but I know you killed her. I've been watching you. I've noticed things. I've discovered that you are a person of very strong emotions, stronger than anybody around here seems to realize. I've noticed how you disliked the crosses marking auto fatalities along the road. I noticed that you looked away whenever we passed a cemetery, and that you shuddered at the mention of blood." Apparently, the guilt had been weighing heavily on him. Jake broke down and confessed.

In a statement to the Troy police, Jacob said that he killed Frances because she humiliated him. He accused her of publically mocking his shortcomings at the country club. On the night she died, she had pushed him over the line when she called his family "illiterate." He slapped her, and she struck him back. He added, "Then everything went red, and I do not remember what happened."[185] Apparently however, he choked her before he picked up a piece of wood or the silver vase and bashed in her head. "I had no defense," he said. "She was my superior. She knew it, I knew it."[186]

It was widely reported that Fan's last words to him were, "Jake, don't you love me?" He responded by striking her again. Afterward, Jake carried Frances upstairs, placed her lifeless body in the bathtub and burned his blood-soaked pajamas and the vase in the furnace. He then drove to Dayton

Jacob Nesbitt "discovered" the lifeless body of his wife, Frances, in the bathtub of their home. *Courtesy of the authors.*

for the day as though nothing had happened. This was a particular blow to Fran's parents, Mr. and Mrs. Charles Drake, with whom Jake had been living since the murder. "You are all we have of Fran now," his mother-in-law had said when she invited him to move in with them.[187]

L.H. Shipman, Jake's attorney, wanted to use the same defense that was used for Harry Thaw in the "Crime of the Century"—not guilty by reason of insanity. In the end, though, Jake pled guilty to second-degree murder, resulting in a life sentence instead of the death penalty. Later that summer, while still basking in the light of the Nesbitt case, Ora Slater was in the headlines again for helping to solve the murder of Canton's crusading newspaper publisher, Don Mellett, by five underworld figures, including the city's chief of police.[188]

Although sentenced to "hard time," Jacob Nesbitt's tenure at the Ohio Penitentiary was anything but hard. Shortly after the murder, several of his fraternity brothers had stepped up to mount his defense. They included George D. Nye (who resigned his post as county prosecuting attorney so

he could help), former judge R.W. Haggott and attorney Don R. Thomas, son of Warden Preston Thomas. While they were unable to prevent his conviction, Warden Thomas ensured that Jake's stay in prison was as pleasant as possible.[189] Although he had told the local media that he would not show number 55682 any favoritism, he had assured his cousin Clyde Hottle that Jake would soon be made a trusty.

After a week in prison, Jake was removed from the general population and placed in the hospital due to "an attack of diabetes." A special diet was recommended, and his tonsils were removed. During this time, he was purportedly studying math and teaching classes of some sort. Another account stated that he planned to study law, read a great deal of fiction and had access to an unlimited supply of newspapers. The prison chaplain, W.O. Reed, said that Jake was trying to occupy his mind while he awaited regular assignment.

At the Ohio Penitentiary, each inmate was given a job, and Jake was no different. However, his jobs—and there were many—seemed to come with an unusual amount of freedom and autonomy, especially for one who had yet to prove his trustworthiness. In June, he was working as a nurse in the prison hospital. He and convicted cop killer John Boggs were both being trained to operate the X-ray machine. When some local citizens reported seeing Jake walking the streets of Columbus, it was explained that he needed to leave the prison for his X-ray training. He was also receiving psychiatric treatment to help him cope with the death of his adoptive father, Samuel Hottle.

Jacob's parents had passed away when he was a young boy, and he had been reared by his mother's sister, Sarah, and her husband, Samuel, on their farm. Sam had died in September at the age of sixty-nine, just four months after Jake began serving his sentence. In the company of the OP superintendent Stout and his wife, Jake was driven to Troy and spent four hours at his boyhood home. He had dinner with his grieving relatives but had to return to the prison shortly afterward because he had not been granted an overnight pass. As a result, he missed the funeral.[190]

Rumors soon circulated that Nesbitt was being given preferential treatment—that he was "the Warden's pet." In February 1927, a small news item appeared to refute this. No longer working as an X-ray technician, Jake was now a transfer clerk. He was not permitted outside prison walls. Nevertheless, many insisted nothing had changed; he still could come and go without a guard accompanying him. It was whispered that he often visited the Ohio State campus, socialized with his fraternity brothers and

spent the night in Columbus hotels. Miami County sheriff Frank Matthews dismissed all such reports as gossip, but he was hardly in a position to know.

Then, seven years after Fran's death, Nesbitt landed a plum job as chauffer for John McSweeney, the state welfare director. As a result, he routinely left the Ohio Penitentiary to drive McSweeney to various state meetings. This in itself was not unusual; many state officials from the governor down had inmate drivers. But whether Jake had come by these assignments on merit alone or through preferential treatment was another story.

There were some who never believed that Jake killed Frances. They thought he took the rap for a well-connected Troy businessman, perhaps a Hobart executive with whom Fran was said to be having an affair. Although Jake would not be eligible for parole for four more years, McSweeney and various friends were quietly building a case for his release. Finally, Governor George White, who had just lost his bid for reelection, commuted Jake's sentence to thirteen years, giving him time off for good behavior. As an editorial in the [Xenia] *Evening Gazette* noted, "By the farthest stretch of the imagination one cannot see any connection between a change in state administrations and the amount of time a prisoner should spend in the penitentiary for a crime."[191] He was one of nineteen murderers granted clemency by White. Two of the convicts were given life instead of death; the other seventeen, including Jake, were immediately released. Among them were John Boggs, the other X-ray technician, and a brother, Dan. They were serving time for the murder of a Highland County police officer.

Almost from the beginning, Jake had garnered more sympathy than his murdered wife. One of the biggest "bombshells" to come out during the investigation was his revelation that Fan had smoked a cigarette the night before her death. This caused a furor in their little community of seven thousand people. Troy simply did not abide the idea of a woman smoking.[192] Combine that with the fact that she drove her own car, hated housework, wanted no children and earned $7,500 a year (or enough to "hire six colored girls" according to her mother),[193] and it wasn't surprising that many folks came to resent Frances for being a "modern woman."[194]

According to writer Allene Sumner,[195] Frances Drake Nesbitt had it coming. In a 1929 article, "Are Women Dominators Over Men?" she argued that Frances and another famous Ohio murder victim of the day, Theora Hix, were "aggressive girls" who proved Sigmund Freud's theory of male supremacy. "Normal nature demands one sex in ascendancy," Freud is quoted as saying. "Tradition, history of society, have always given this role to the male. Today woman is in the ascendancy. We must prepare for an epoch

of cataclysm while society becomes accustomed to what it regards as the abnormal reversal of sex roles."[196]

Theora, an Ohio State coed, was killed by her lover, Dr. James Howard Snook, a considerably older and married member of the faculty. Both women were described as "determined, capable…ready to take life in their own firm young hands and bend it to suit their own wills if it started off on a path they didn't like." In fact, Snook's attorneys tried to portray Theora as a "jazz age hussy."[197] Sumner pointed out that both women attended college and were still fairly young. She also claimed that both had "a quizzical, half-superior look in the eyes." She seemed to condemn each for knowing "what she wanted in life" and being "determined to get it."

In time, Warden Preston E. Thomas would become as notorious as the inmates in his prison. *Courtesy of the Dailey Archives.*

Frances and Theora were contrasted with Helen Snook, who "studied" her husband's habits and "adapted her own to conform with them." While Helen was praised for her sweetness and submissiveness, Frances, to an extent, and Theora, definitely, were thought by the public to be at least partially responsible for their own deaths because of their assertive and successful (i.e. "masculine") personalities. What man wouldn't kill an aggressive woman, especially if she makes him feel bad about himself, was the sentiment of the time. Ms. Sumner, then, concluded her article with the statement: "But, like Theora, she failed." (Many newspapers omitted this last line.) So if Theora failed, Helen failed and, by implication, Frances failed, readers were left to puzzle for themselves exactly how a woman should behave if she wishes to remain both alive and "happy," not to mention fulfilled.

Nesbitt left prison in January 1935, having served just short of nine years. In concert with his family, he decided that it would be best if he didn't return to Troy. He told newspapers that he would be going into business in Columbus with a friend. However, he soon moved to Cincinnati, married and had a son. A day after he died, on March 31, 1954, Mrs. Beatrice Nesbitt, to whom he had been wed for eleven years, learned for the first time that he had murdered his first wife. "He never told me," she said. "He was a wonderful man. He couldn't have been more tender."[198]

To What Red Hell

Over time, the Ohio Penitentiary had gradually devolved into a symbolic hell. In the damp, gloomy prison designed for 1,500, some 4,900 inmates were packed, like pellets in a shotgun shell.[199] Discontent and dissension spread among the filth, vermin and corruption. Then, on April 21, 1930, the OP became a truly hellish place as a fire spread that would stain the annals of American history. In the nation's worst prison fire, 322 inmates perished, many of them "trapped like birds in a cage."

Garland Runyon of Lawrence County had entered the penitentiary earlier that day for abandoning his children.[200] Around 4:30 p.m., he ate his first meal among his disgraced brethren. He then was led to his cell on the uppermost tier of "the New Hall." The west wing of the institution had been constructed in 1877 on a plot of land that was previously the prison cemetery.[201] Containing cellblocks G, H, I and K, it was in the process of being updated from little better than a medieval dungeon to having "modern" cells with running water and toilets. Since the work on blocks G and H was complete, they were overflowing with prisoners while I and K were being renovated. The new solitary confinement cells would be located there.

Joining Runyon on the after dinner march back to the cellblock was Oren Hill, a former Ohio Penitentiary guard. While employed at the prison, Hill had been bribed to aid in the escape of Cleveland cop killer John Whitfield.[202] Gunned down at the guard's home, Whitfield later died in the prison hospital. For his role, Hill received three years to life.

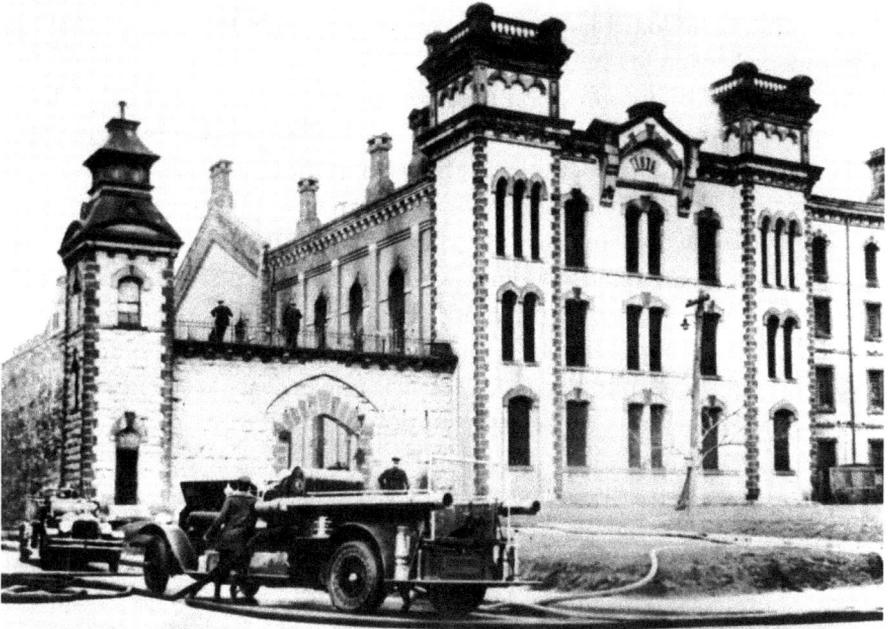

Fire engines arrive at the southeast gate of the prison after being alerted by bystanders.
Courtesy of the Dailey Archives.

Less than an hour earlier, Albert Holland had been admitted to the penitentiary to begin a sentence for burglary. What he, the others and hundreds more didn't realize was that they would be dead by the time the sun went down.[203]

Shortly before 5:30 p.m., the smell of smoke began to stir unrest among the inmates. Barry Sholkey, a Toledo convict, was the first to alert prison staff. He was known around the pen as a "great kidder," so the guard laughed at his "joke" and walked on.[204] Officials held no real fear of fire in the stone cellblocks. Occasionally, an unruly inmate would burn his mattress or try to smoke out bedbugs, but such incidents normally posed little danger. What prison staff didn't consider was the large amount of timber being used in the unfinished cellblocks. Additionally, much of the wood was soaked in oil to make it easier to remove from concrete forms. Nor did they think about the temporary wooden roof that stretched the entire length of the building.

Chaos soon began to descend on the Ohio Penitentiary. Screams of "Fire!" and rattling bars echoed from the uppermost tier of the six-level cellblock. Acrid smoke wove its way through the bars like a malevolent spirit, hungry for the sinners within. Meanwhile, seventy-two-year-old Captain

Hall of the night guard had just arrived on the scene. He ordered that the windows be broken for ventilation.

At 5:45 p.m., flames erupted through the roof of the empty cellblock. Warden Preston E. Thomas was notified while in his living quarters. "There was considerable smoke in the yard at that time," he said. Within minutes, he phoned the headquarters of the 166th Infantry Regiment of the Ohio Militia for support. He then went to the street to await the arrival of the guardsmen. Thomas was convinced that the fire was set by convicts with escape on their minds. He delayed calling the Columbus Fire Department for help, believing the inmate fire brigade could handle it. By 5:53 p.m., all phones and electrical power was dead. The warden immediately issued an order for the National Guard to shoot any prisoner attempting to escape.[205]

The cries of desperate convicts quickly reached a crescendo, joined by the roar of lapping flames. The fire rapidly raced along the wooden roof of the heavily populated cellblocks G and H. Convicts were screaming at guard Thomas Watkinson to release them, but he refused to do so without orders. Guards Thomas Little and William Baldwin wrestled the keys from him and bravely rushed into the powder keg, unlocking as many cells as they could. The Mason brothers of Zanesville were both saved. "Plenty of us would have died had it not been for the two guards passing out keys to our cells and battering locks from the cell doors," B.H. Mason said. "Any man in the prison would have given his life for either of them."[206] Both guards continued freeing prisoners until they were overcome by smoke and were, themselves, rescued. Though guard Little had left the Columbus police force after being caught selling liquor, on this day, he showed his true colors.[207]

The intensity of the fire quickly escalated, transforming the ancient enclosure into a furnace. Locks were welded shut by the extreme heat, pinning the screaming men behind bars that glowed red and white. Embers rained down from above.[208] Units from the Columbus Fire Department soon arrived, summoned by spectators who saw the inferno from outside the prison. However, the feeble streams of water from their hoses could not reach the men on the uppermost tiers where the fire was its most lethal. Hundreds of convicts futilely clawed at the bars that confined them. When the roof finally collapsed, all 136 of the men on the sixth tier were crushed and incinerated.[209]

Charles Oliver, a convict from Toledo, recounted how he and his three cellmates survived the terror on the fourth tier. "We finally got on the idea of turning on the water tap in our cell. We let it run wide open and pretty

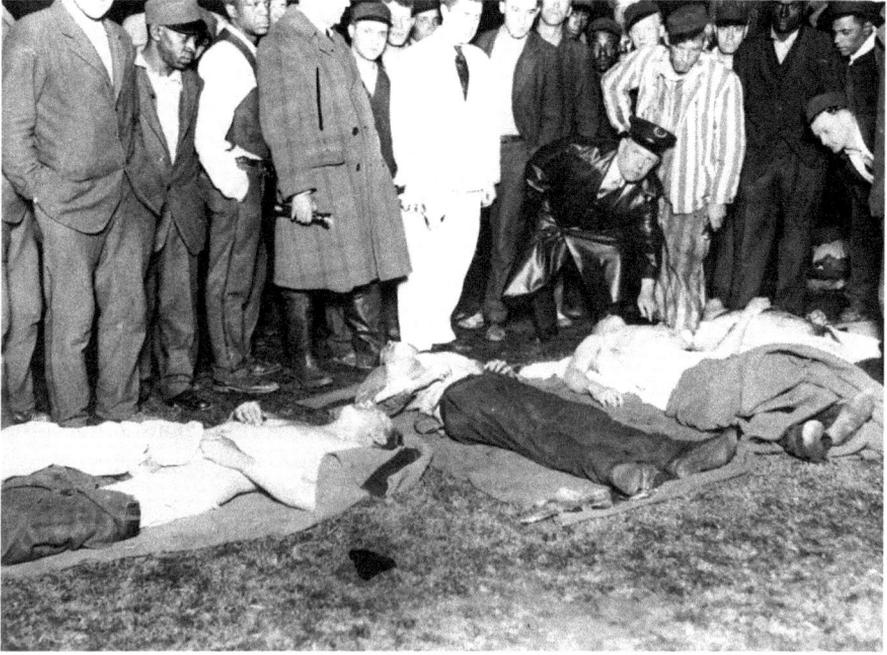

The bodies of those who perished during the Easter Monday Fire were spread out on the lawn. *Courtesy of the Dailey Archives.*

soon the floor was covered with water. We laid down and rolled around in the water, trying to get cooled off."[210] George Richmond, bank robber and editor of the *Ohio Penitentiary News*, described how he tried to free trapped men: "The smoke was so dense that we could scarcely see. I remember grabbing a pick and starting to break the locks on the doors. The men were shaking at the locks. We couldn't see them. We struck blindly. Sometimes they hit steel, sometimes human flesh."[211]

Amid the pandemonium, many inmates displayed incredible feats of heroism. Abandoning the safety of the open yard, scores of prisoners fought their way through the cordon of guards to return time and again, saving as many trapped men as possible. Inmate Frank Ward, an ex-police officer, used a fire ax to chop through the bars of several cells. He liberated several singed, half-conscious men.[212] "Big Jim" Morton, a notorious Cleveland bank robber, broke from his own cell with his bare hands and saved twenty comrades from certain death. When he could find no signs of life, he dragged out two dead bodies. He continued liberating men until he was overcome by smoke.[213]

Howard Crandall, a trusty from Cuyahoga County, was rushing to help a fallen inmate when he spotted the cellblock's pet kitten lying lifeless on the floor. He stuffed the sorry creature into his pocket while carrying the injured man to safety. The feline, whose playful antics were a constant source of amusement to the prisoners, was revived in the yard.[214] Narcissa Gaeta was discovered shivering in his third tier cell by the prison physician. After carrying fifty men from the ruins, he was suffering from shock.[215]

The *Cleveland Plain Dealer* headline read, "Negro Convicts Heroes of Penitentiary Fire: Dash into Blazing Cell Block to Rescue Fellow Prisoners, Most of Them White." One of the reports was that a "colored youth" of about twenty-two had staggered from the fiery inferno with a white man on his shoulders. As the hero collapsed, with burns so serious that he had little chance of surviving, it was discovered that the inmate he pulled from the building had likely been dead for several minutes. Though his face had been seared, a slight smile was detected on his lips before a guard began pumping air into his lungs.[216]

When the fire broke out, there was one inmate who was actually handed a shotgun to help the guards preserve order. Known as "Tacks," a nickname

The collapsing roof, engulfed in flames, sealed the doom of those trapped on the top tier. *Courtesy of the Dailey Archives.*

he picked up many years earlier due to his "edgy" disposition, Clifford W. Latimer had played professional baseball for over fifteen years as a catcher with the Cincinnati Reds and the Pittsburgh Pirates. One of his teammates was Hall-of-Famer Honus Wagner. After leaving baseball behind, he became a police officer for the Pennsylvania Railroad. Then, on the day before Thanksgiving 1924, he was involved in a deadly altercation in Xenia, Ohio.

Charles Mackrodt, Latimer's former superior officer at the railroad, had been seething with animosity for a couple months. Demoted from his position as lieutenant, he had quit his job in a fit of anger. He blamed Tacks for his misfortune and threatened to "have it out" with him.[217] When he was confronted by Mackrodt, Latimer shot him four times, once in the back, piercing his heart. "It was one life against another," he said when he gave himself up.

At his trial in Greene County, Latimer was confident of an acquittal. Character witnesses included several men from the railroad and Bob Ewing, sheriff of Auglaize County. "Long" Bob, a former Reds pitcher, had remained friends with Tacks after their baseball careers ended.[218] Despite the testimony of his friends, Latimer was found guilty of second-degree murder on New Year's Eve and sentenced to life in prison. His seven-year-old son was sitting on his lap while the verdict was read. "The Lord is with me," he said, "and everything will come out all right."[219] He assured everyone he would be a model prisoner. At the Ohio Pen, Latimer soon became the warden's trusty at the front gate and assistant manager of the prison baseball team. His wife of twenty-seven years, whose devotion was unquestioned at his trial, was not long in obtaining a divorce.[220]

On November 9, 1926, Tacks was at his post at the outer gate when thirteen "red shirts"—prisoners deemed incorrigible and clothed in red shirts to make them stand out in the prison population—made a break. These crazed men clubbed, stabbed and shot their way to the prison entrance. Amanda Thomas, the warden's daughter, rushed from her living quarters above the noise. Latimer tried to persuade her to go back upstairs. When she refused, he stood in front of her, shielding her from the desperate killers and firing at them with a .45-caliber revolver he had wrested from one of them. He then joined the posse of guards in the manhunt.[221]

During the Easter Monday Fire, Latimer and his shotgun stood vigil throughout the night. The following Christmas, Governor Myers Y. Cooper personally presented Latimer with a pardon. He later died of a heart attack on April 24, 1936, at his home in Loveland, Ohio.

The inferno was brought under control by 7:30 p.m. but continued to burn for some time. A half hour later, guards organized inmates to return to the

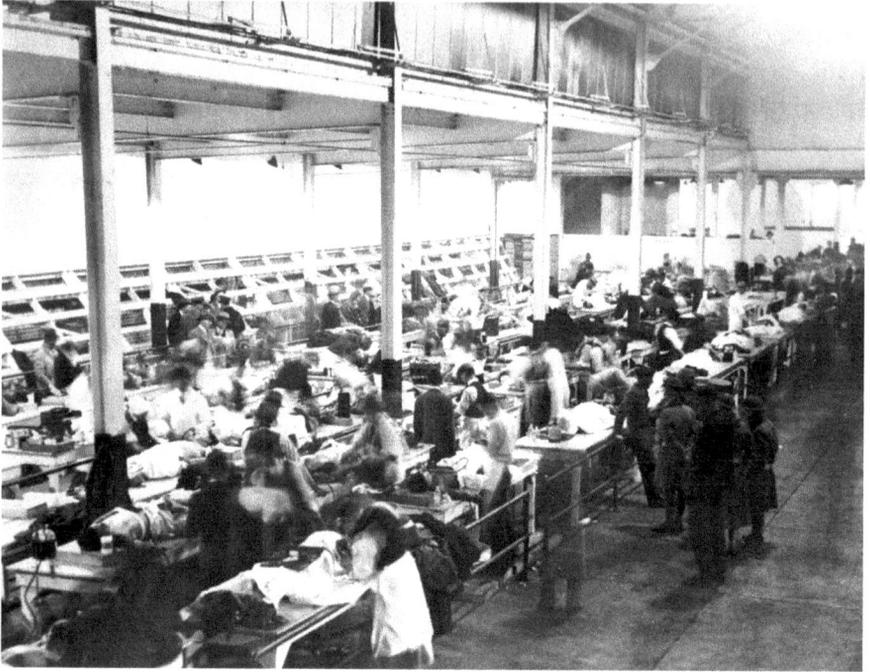

Scene at the Ohio State Fairgrounds horticulture building, which served as a morgue for the unfortunate prisoners. *Courtesy of the Dailey Archives.*

charred ruins to retrieve bodies. ROTC students from Ohio State had been pressed into service, issued rifles and told to patrol the outside of the prison to ensure no one escaped. Members of the Naval Reserve were also brought in to man the walls and fire over the heads of prisoners who were in the yard. Later, they helped carry out the corpses.[222] The prison hospital quickly filled to capacity, so the injured were transported to the Ohio State Fairgrounds, where an emergency hospital was set up. The horticulture building was converted into a morgue where an army of embalmers attended to the hundreds of victims.

Few reporters and photographers gained entrance to the grisly scene. Newsmen who managed to infiltrate the gauntlet of nervous guards armed with submachine guns faced mumbling convicts and indescribable horror. The prison looked like a battlefield strewn with corpses.[223] Ben Johnson, an inmate from Dayton, told how they had carried out the dead. "We handled everybody that was brought out. It made a fellow sick. We laid them out in rows while the flames still leaped and the roofs were caving in."

One sensational story revealed that Wilbur "Wild Bill" Croninger had perished while attempting to pull his thirteenth prisoner to safety.[224] Though

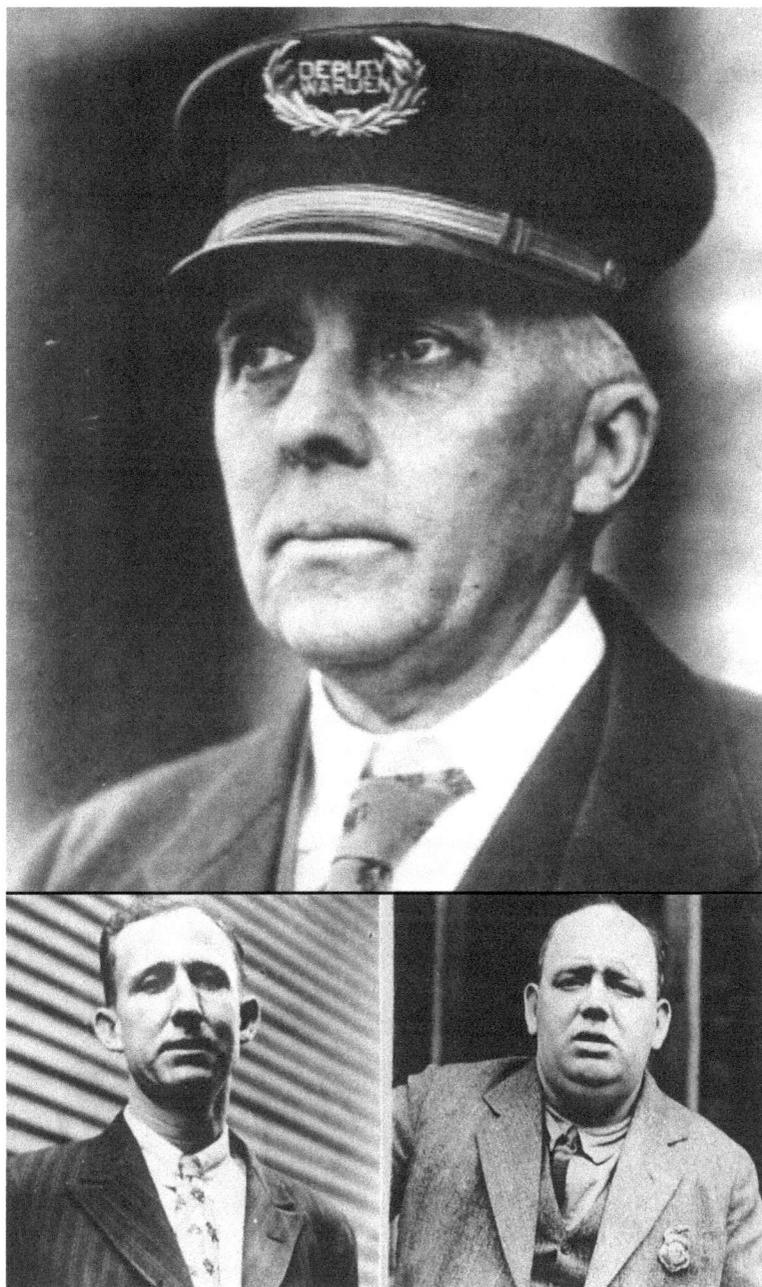

Clockwise from top, Deputy Warden James Woodard and guards William Baldwin and Thomas Little were praised from their heroism. *Courtesy of the Dailey Archives.*

similar acts of heroism had been on display that day, Wild Bill's name was not among the dead. A few years later, Croninger would be arrested for a spree of petty thefts. His codefendant was a boy of nineteen named Don Ford. The ex-con and the boy's father, Albert, had been friends at the Ohio Penitentiary, that is, until the elder Ford died in the Easter Monday Fire while serving time for child abandonment.[225] Clearly, Wild Bill was a poor substitute for a father.

Four brothers were all confined in the doomed cell house. John and William Angilan of Louisville tried valiantly to reach their siblings, Frank and Theodore, but were driven back by the lethal smoke and perished.[226]

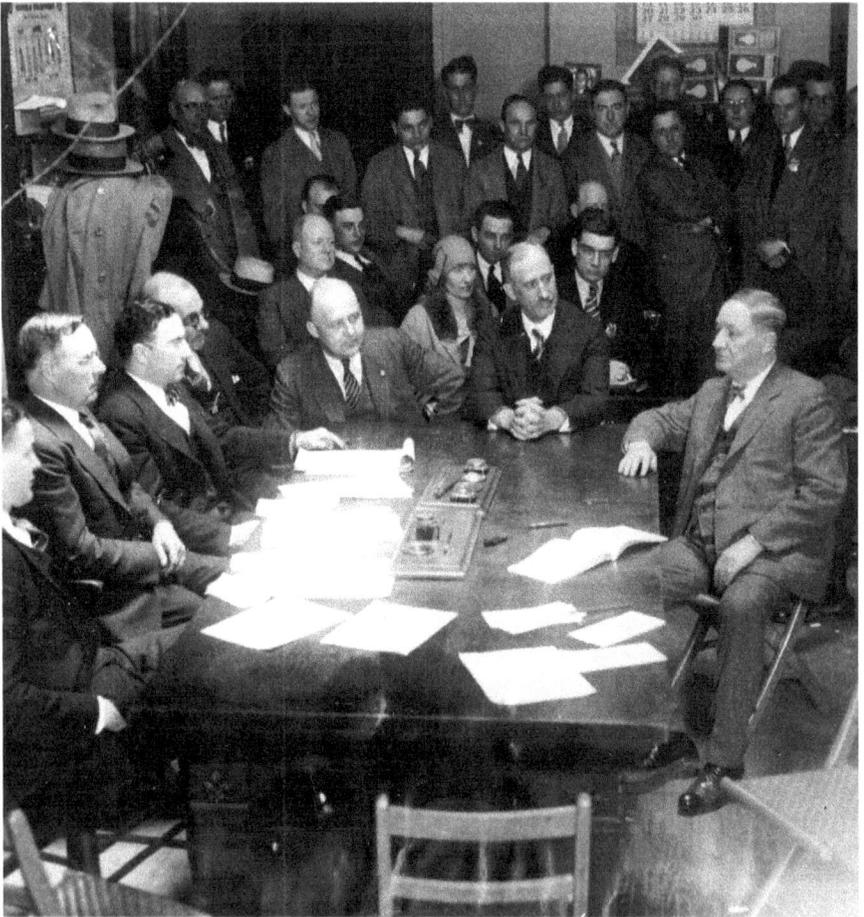

All eyes were on Warden Thomas (far right) as Governor Myers Y. Cooper (seated next to warden) headed the inquiry into the tragedy. *Courtesy of the Dailey Archives.*

Ben Henderson, a highway robber from Cincinnati, also lost a brother in the tragedy. Pointing to a charred cell, he said, "That is where my brother died. Died in there like a rat. He never had a chance." He also related another rescue attempt gone wrong: "They were letting a fellow down with a rope. The rope slipped and tightened around his neck. He strangled to death."[227]

Ed Sunkle of Napoleon, Ohio, was discovered sobbing uncontrollably in the Guard Office. His brother Charles had been serving time for auto theft prior to having his life snuffed out. Another victim was "John Doe," an automobile thief from Warren County who had been committed under that name.[228]

Robert Stone also died that day. He was in the penitentiary for killing Charles Thurston, a railroad detective and brother of the famous magician, Howard. Nine years after the murder, the conscience of Stone's partner in crime, Noah Burns, began to bother him, and he confessed that the two had been burglarizing a railroad car when surprised by the detective. Stone emptied ten rounds from his gun into Thurston and fled. When the triggerman was arrested in his home, officers discovered a poster of the magician hanging on the wall with a large question mark scrawled above it.[229] He had been in the penitentiary for a year.

The Catholic chaplain, Father Albert O'Brien, worked among the dead and dying, offering spiritual absolution. "I administered the last sacraments among men whose flesh was burned from their bodies," he said.[230] The priest collapsed several times in the smoke-filled prison yard. Each time, he was revived and continued his work of mercy.[231] He also sensed a divine presence. "I remember one life, Pete [Cafarelli], from Akron. When they found him dead, his hands were entwined, and a rosary was wrapped tightly around his locked fingers. The rosary was not burned."[232] Ironically, all the men who had been on death row had been moved to solitary confinement and were saved. In fact, the holocaust delayed, though didn't stop, some of their dates with the electric chair.

Though many of the inmates displayed selfless acts of courage, many others were angry and bent on revenge. Additional fires were set in the Catholic chapel and the woolen mills. Some of the convicts called for Warden Preston Thomas's dismissal (at least one in his presence). He had served the state as warden for seventeen years, having been a schoolteacher at the Mansfield Reformatory and at Wapakoneta for many years before that. His absence from the rescue efforts within the prison had not gone unnoticed. On that day, Deputy Warden James C. Woodard established himself as the only administrator the inmates felt was worthy of their trust.

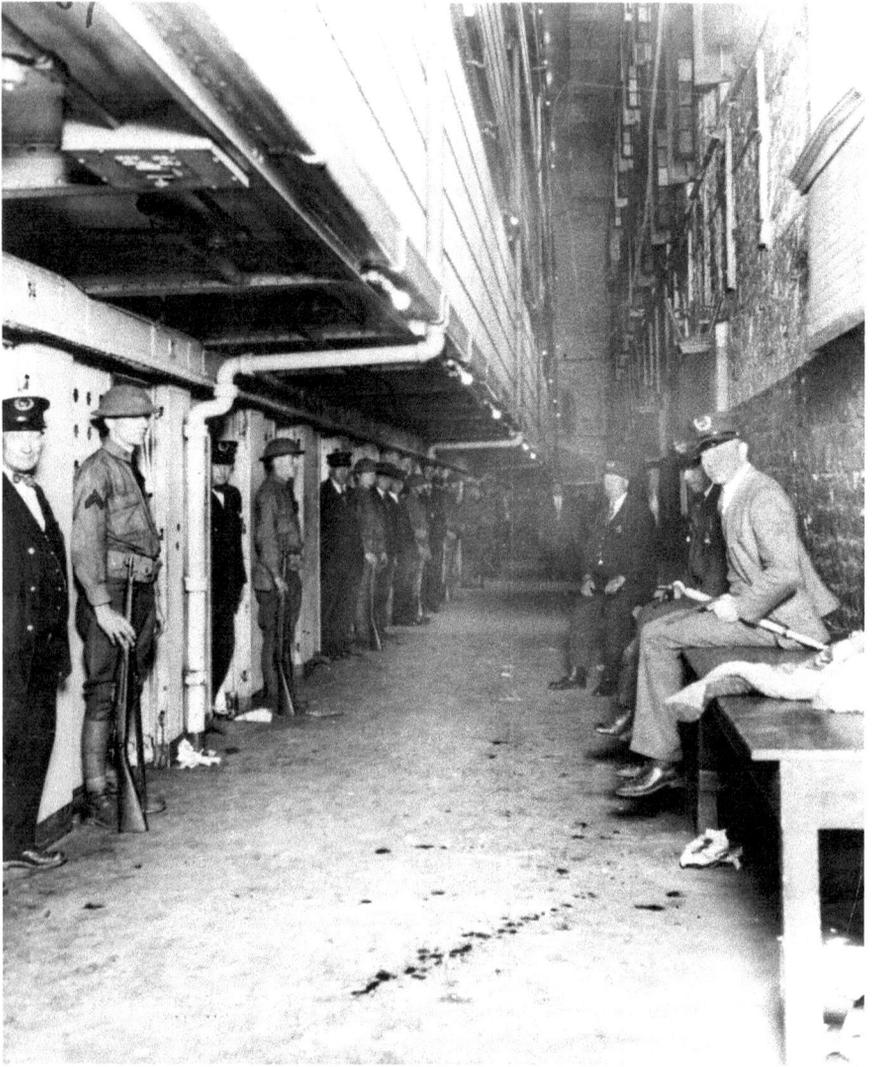

Ten days after the fire, order was finally restored within the White City cellblock. *Courtesy of the Dailey Archives.*

During the bedlam, only one prisoner escaped. Michael Dorn, age thirty-three from Wood County, had been serving one to fifteen years for burglary. When the fire started, he was at work in the prison hospital as a trusty. Dressing himself as an intern and carrying a doctor's bag, he nonchalantly walked out the front gate. Within a few days, he was apprehended in Cleveland.[233]

Famed African American author Chester Himes was an eyewitness to the tragedy. A former Ohio State University student, he had been sentenced to twenty-five years for armed robbery two years earlier. In 1934, while still an inmate, he sold the short story, "To What Red Hell,"[234] a fictionalized account of the fire, to *Esquire* magazine. He later revisited the subject in an autobiographical novel.[235]

A day or two afterward, songwriter Carson Jay Robison composed "Columbus Prison Fire." Considered by some to be the first recording cowboy star, he immediately entered the studio to cut a record. Copies hit the streets before the tragedy had a chance to fade from the headlines. His bathetic tear-jerker ends with the line, "God doesn't want even convicts to die like rats in a hole." Within three days, Charlotte and Bob Miller had recorded their own mawkish ballad, "Ohio Prison Fire." What sets their effort apart from Robison's was Charlotte's tearful dialogue with a prison official as she attempted to identify the charred remains of her son: "O, bodies, bodies, bodies. I can't stand it, I can't stand it, I can't stand it!"

Recording artists weren't the only ones quick to capitalize on the fire. Within twenty-one hours, New York moviegoers six hundred miles away were able to watch Pathé newsreel footage of the disaster. As the August 1930 issue of *Popular Science* magazine reported, "The theater patrons not only see the harrowing sights; they also hear the shrieking of the prison siren, the hissing as water hits flames, the howling of desperate prisoners, the crackling of burning logs, the thud of falling beams, the commands of Army officers and jail officials. More than that, they hear a brief talkie lecture by an expert on prison conditions, explaining the causes of the tragedy and suggesting means of preventing its recurrence."

Governor Myers Y. Cooper was quick to launch an investigation into the reason for the fire. The headline in the *Columbus Evening Dispatch* blared, "Guards Didn't Know What to Do, They Tell Probers."[236] Warden Thomas admitted he didn't have a plan for dealing with such emergencies—conducted no drills, held no discussions, etc. He simply expected his staff to use "common sense." One of the measures put into place immediately after the tragedy was to establish a "headhunter" squad of "straight shooting" guards. All involved agreed that most, if not all, deaths could have been prevented had evacuation begun immediately.

It was discovered that a few inmate conspirators had indeed started the fire, ostensibly to cover an escape attempt. Just beneath the roof of the empty cellblock, they had lit a candle floating in oil and wood shavings. Their intention was for it to ignite while they were all in the mess hall,

Ex-major league ballplayer "Tacks" Latimer as he left the Ohio Penitentiary a free man. *Courtesy of the Dailey Archives.*

giving them a window for escape. However, they had mistimed their crude fuse, and most of the prisoners had been locked back in their cells by the time the fire broke out.

James Raymond, an Akron burglar, confessed his role in the plot and demanded to be put in solitary confinement. Haunted by the screams of the dying, he soon hanged himself. Two others implicated were Clinton "Cotton" Grate and Hugh "the Jew" Gibbons. Grate, formerly of Virginia and in prison for a Dayton robbery, also hanged himself. As the decades passed, Gibbons, continued to struggle with his conscience and made repeated attempts to hang himself as well.

Despite clear negligence on his part, the embattled Thomas continued as warden of the Ohio Penitentiary for five more years until he was removed by the Ohio National Guard in 1935. Even then, he won reinstatement (and back pay) three months later, at which time he promptly resigned.[237]

Chapter 11
Handsome Harry and Fat Charlie

The exploits of the John Dillinger Gang are the stuff of American legend, though few recall that the trail they blazed led straight to the Ohio Penitentiary—and death for two of them.

Dillinger had taken part in a 1924 grocery store robbery that netted fifty dollars. At the advice of his father, he confessed and pleaded guilty without defense counsel, expecting a lenient sentence. Instead, he received ten to twenty-five years. Even Morgan County, Indiana deputy sheriff Russell Peterson thought that Dillinger's sentence was exceedingly harsh. "[He] was just a kid. He got a raw deal," Peterson said. "You can't just take away ten years from a kid's life."[238]

At the age of twenty-one, John Dillinger entered the Indiana State Reformatory at Pendleton. Upon admittance he ensured Warden A.F. Miles, "I won't cause you any trouble—except to escape."[239] It was there he first met bank robber Harry Pierpont. Eventually, they were both transferred to the Indiana State Prison in Michigan City, a prison designed for more hardened felons. There, a group of professional criminals would coalesce into what would become known as "the Dillinger Gang." Among them: Harry Pierpont, Charles Makley and Russell Clark.[240]

On May 22, 1933, Dillinger was released on parole at the height of the Great Depression. He was less than an hour too late to see his beloved stepmother, Lizzie, before she died from complications after suffering a stroke.[241] He immediately began robbing banks throughout Ohio and was eventually nabbed for knocking over the Citizen's National Bank of

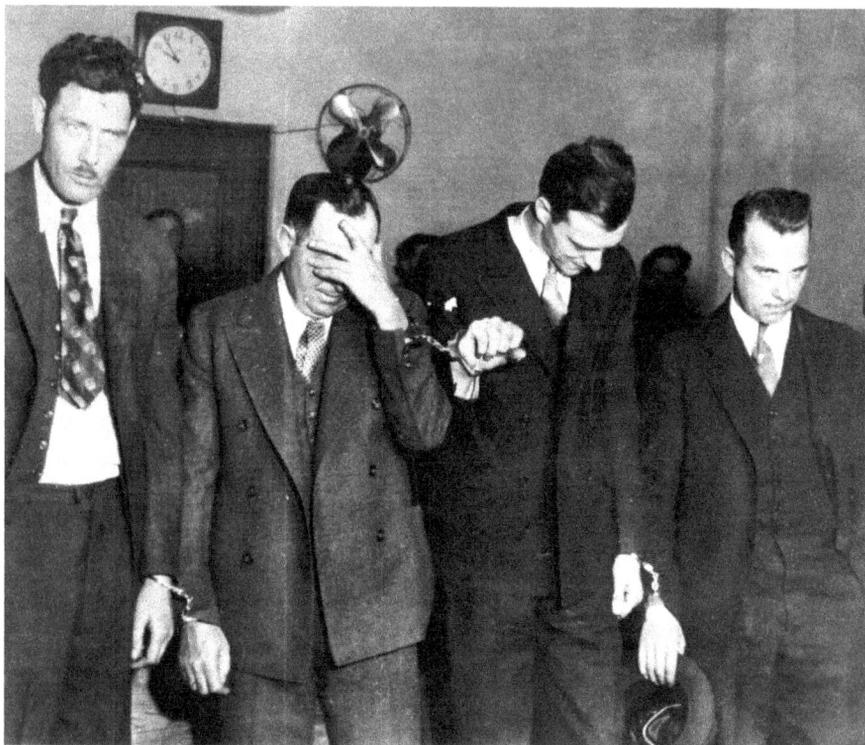

Gangsters nabbed in Tucson (left to right): Russell Clark, Charles Makley, Harry Pierpont and John Dillinger. *Courtesy of the Dailey Archives.*

Bluffton.[242] He was transferred to the Allen County Jail in Lima, Ohio, on September 22 to await sentencing. While being frisked, Lima police discovered a document that appeared to be plans for a prison break.

During his brief period of freedom, Dillinger had conspired to have guns smuggled into his comrades still incarcerated in Indiana. On September 26, 1933, ten armed men violently clubbed and shot their way out of the prison in Michigan City. They then discovered that their benefactor currently was residing at the Allen County jail. On October 2, the gang robbed the First National Bank of $15,000 in Charles Makley's hometown of St. Marys.

Around 6:30 p.m. on Columbus Day (October 12) 1933, Pierpont, Makley, Clark and several other cons returned Dillinger's favor. The three well-dressed desperados entered the jail's office and encountered Sheriff Jess Sarber, his wife and Deputy W.L. Sharp, a nine-year veteran of the force. Pierpont announced that they were from the Michigan City Prison and were there to interview Sarber's prisoner. When the sheriff

asked them to produce credentials, Pierpont leveled a pistol at him and said, "Here are our credentials."

As Sarber made a move for his own gun in the desk drawer, Pierpont fired, hitting him in the abdomen. He crumpled to the floor. The deputy was asked for the cellblock keys, but he said he didn't know where they were. When the injured sheriff tried to stand, he was promptly struck on the head with the butt of a gun.

"Don't hurt him anymore, I will get the keys and turn out Dillinger," Mrs. Sarber pleaded. She was told to get the inside door open and "make it snappy." Dillinger was in the cellblock playing pinochle with convicted murderer Arthur Miller. According to another prisoner, when the disturbance was heard, Dillinger put down his cards, grabbed his coat and said, "Looks like a break."[243]

Miller stated that Dillinger shook hands with him and said, "Well, goodbye, Art, I'm going." He also related that Harry Pierpont then entered and handed Dillinger a gun before they ran out. Pierpont returned with Mrs. Sarber and Deputy White. He told the other prisoners to get back and, according to Miller, "They got back."[244]

The gang quickly vacated the premises, leaving Mrs. Sarber and the deputy locked in the cellblock with the prisoners. The gunmen took the jail keys and Sarber's pistol. The sheriff's son, Deputy Don Sarber, age twenty-four, arrived soon after to find his father dying on the floor. The fallen sheriff was rushed to the hospital but was pronounced dead shortly after eight o'clock.

"He [Jess] had been so kind and considerate to the prisoners," Mrs. Sarber said. "Dillinger had received the best of treatment. As he walked past me, escorted by the gunmen, Dillinger kept his head down and avoided my gaze."[245]

The day before the raid, Dillinger had written home to his elderly father: "My home environment had nothing to do with my career of crime. If they hadn't given me such a long prison term for my first offense, this might not have happened. I went in a carefree boy and came out a hardened criminal. Leniency might have saved me. I know I can't win in this game."

Over the following months, the gang continued on a spree of daring bank robberies. The crimes extended to the Auburn and Peru, Indiana police stations, which were robbed of their arsenals (including Thompson submachine guns). The gangsters and their molls then went on vacation to Daytona Beach, Florida, renting a large house facing the ocean. On New Year's Eve, Dillinger, walked out to the beach and emptied one of the Thompson submachine guns at the moon.[246]

Anxious to get back to work, the gang headed back up north to rob banks. On January 15, 1934, Officer William O'Malley confronted Dillinger during the robbery of the First National Bank in East Chicago, Indiana. Though O'Malley shot Dillinger several times, the outlaw was unharmed, thanks to a bulletproof vest that was lifted from the prior police station heist. Officer O'Malley was shot and killed in the mêlée.

The robbers then fled to Tucson, Arizona. On January 22, a fire broke out at the Hotel Congress, where Charles Makley and Russell Clark were staying. When the fire department arrived, Clark and Makley paid firemen William Benedict and Russell Freeman to retrieve their suitcases. Days later, the firemen recognized the pair in a *True Detective* magazine.[247]

Through quick detective work, the Tucson police methodically rounded up the fugitives and their girlfriends. Protesting mightily, Dillinger was extradited to Crown Point, Indiana, to stand trial for the murder of Officer O'Malley. Pierpont, Makley and Clark, meanwhile, were escorted back to the Allen County jail to atone for the murder of Sarber. The martyred sheriff's son, Don, had succeeded him as sheriff of Allen County and anxiously awaited their arrival.

At the Crown Point jail, Dillinger was greeted by a flock of newsmen, as well as Lake County sheriff Lillian Holley and prosecutor Robert Estill. Holley, confident that her jail was "escape-proof," joined Estill in posing for photos with the bandit. Reporters were mesmerized by his charisma and sense of humor.[248] When Dillinger was introduced to the judge who would be trying him for murder, he asked with a grin, "Are you the guy that gives young fellows a break?" When he was asked how long it took him to rob a bank, he replied, "About a minute forty seconds flat."[249] Although he

Sheriff Don Sarber keeps a watchful eye (and machine gun) focused on the accused slayer of his father at the Allen County Courthouse. *Courtesy of the Dailey Archives.*

confessed to bank robberies that had netted over a quarter million dollars, he adamantly denied killing O'Malley.

Sheriff Holley stated, "We are taking every precaution and have extra guards to prevent any attempt to deliver Dillinger from his cell, but we're really not afraid of his escape." Holley, Indiana's only female sheriff, had succeeded her husband in the position after he was shot and killed by an insane farmer.[250]

On Valentine's Day 1934, Pierpont, Makley and Clark made their initial court appearance in Lima to face charges in the Sarber murder. The courthouse bristled with machine guns, rifles, revolvers and tear gas bombs in the hands of local authorities and national guardsmen. Several machine gun posts were set up in strategic locations around the jail and manned by Ohio militiamen in gas masks. The papers reported that the guns could fire seven hundred bullets a minute.[251] When Don Sarber received word that Harry Pierpont had boasted that no jail had held him yet, the young sheriff's eyes narrowed. "Allen County," he said, "learned its lesson at the cost of my father's life. Pierpont [nor any] other member of the Dillinger gang ever will escape from this jail."[252]

With tensions already high, events reached a boiling point on March 3, 1934, when it was learned that Dillinger had made good on his boast of escaping from the Crown Point jail. Allen County prosecutor Ernest M. Botkin made the drastic order to "shoot the prisoners" if an attempt was made by the fugitive Dillinger to free his henchmen. "It's a strong order," Botkin admitted, "but they're not getting out of here."[253]

Seeking Dillinger's testimony, Pierpont's attorneys, Prosecutor Botkin, and Sheriff Sarber had already set off to Crown Point while Dillinger was making his daring escape. He purportedly had whittled a wooden gun from the leg of a washboard and used it to disarm guard Ernest Blunk at about 8:30 a.m. He then held up his toy weapon and laughed, "Ha, ha, ha, I did it with a wooden pistol." He then instructed his hostage to call the remaining guards that were on duty. One by one, he locked them in cells and took two machine guns from the warden's office.[254]

In the garage, Dillinger took another hostage and asked him which car was the fastest. The man pointed to a brand-new black sedan. It was Sheriff Lillian Holley's Ford and was conveniently equipped with a short wave radio set, allowing Dillinger to monitor police broadcasts. Because guards detailed outside the jail were unaware of the escape, he had about a half hour head start. Dillinger had also locked all doors as he passed through the building, delaying their access. Upon hearing the news, Sheriff Holley

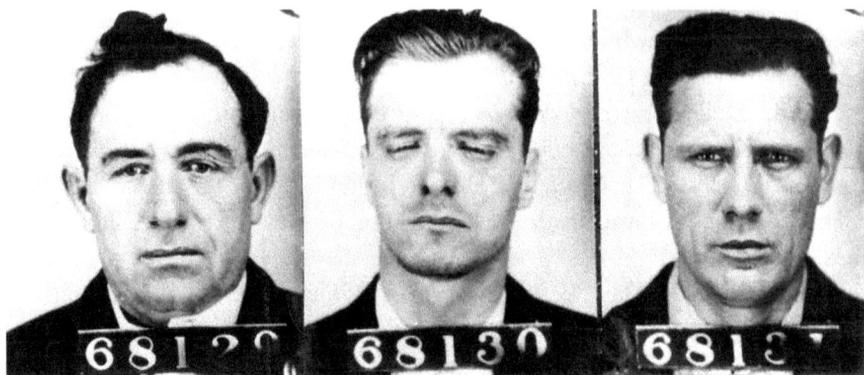

Makley, Pierpont and Clark traded their names for numbers upon entering the Ohio Penitentiary. *Courtesy of the Dailey Archives.*

vowed, "If I ever see John Dillinger, I'll shoot him through the head with my own pistol."[255]

Within a few days, Harry Pierpont's trial began in Lima. In a heated confrontation with Prosecutor Botkin, Pierpont said: "I'm not the kind of man you are—robbing widows and orphans. You'd probably be like me if you had the nerve." Though Pierpont was delivered to his proud parents in 1902, the violent "triggerman" and "brains" of the Dillinger Gang may have actually been "born" on June 1, 1921. It was on that date that he was accidentally hit in the head with a baseball bat and knocked unconscious for five minutes. He was laid up for three weeks. Hints of insanity began developing soon thereafter. He "has not been right since then," a relative said.[256]

Nevertheless, the jury found "Handsome Harry" guilty without recommendation for mercy. He was to be executed in the Ohio Penitentiary's electric chair on Friday, July 13, 1934. It was reported that a smirk spread over his face as sentence was pronounced. "Unlucky thirteen again," Pierpont mused. His birthday was October 13, and he had thirteen letters in his name. He joked with Makley about how Judge Everett had had tears in his eyes while handing down the sentence.[257]

"Fat Charlie" Makley received the same fate and was sentenced to die the same day as his friend. When he heard the verdict, he leaned heavily on his attorney, Miss Jessie Levy of Indianapolis. It was the first time he had appeared affected since the beginning of his trial. "Well, you can only die once," he told a guard on the way back to his cell.[258]

During Makley's trial, it was revealed that two members of his former gang, Ed Axe and Harry Smith, had "burned up" in the Easter Monday Fire

at the Ohio Penitentiary. They had all been arrested together for the same series of robberies, but the others had been extradited to Ohio while Makley had pleaded guilty in Indiana.[259]

Russell Clark was also found guilty, though the jury recommended mercy. He was sentenced to spend the rest of his life in prison. He too appeared moved for the first time since proceedings began, having been sleepy and disinterested to that point. Clark returned to the jail and, with a smile on his face, announced to his codefendants that he had escaped the electric chair. Pierpont laughed and yelled, "You poor boob, you think you got the best of it. You didn't. You got to serve 40 to 50 years in stir. Charlie and I got a sentence of only 111 days." They all appeared happier than at any time since their return to Lima for trial.[260]

Sightings and bank robberies attributed to John Dillinger persisted throughout the trials. Plans surrounding the ninety-mile trip to the Ohio Penitentiary in Columbus were shrouded in secrecy. On the cold, icy morning of March 27, a heavily armed caravan of fifteen vehicles escorted the men on their "last ride." Under the command of Brigadier General Harold M. Bush of the Ohio National Guard, fifty soldiers, some manning mounted machine guns, followed Sheriff Sarber to the prison. By 12:30 p.m., the high gray walls of the penitentiary had closed behind Pierpont, Makley and Clark.[261]

After the transfer was complete, the National Guard made note of the six machine gun nests that had been stationed around the Allen County jail during the trials. They revealed that four of them were "dummy weapons" constructed out of stovepipe and wood. "They served their purpose," General Bush stated, "and the beautiful part of it is that they antedated Mr. Dillinger's wooden pistol episode." For weeks, the weapons had contributed to the menacing atmosphere intended to prevent another "withdrawal" from the Allen County jail.[262]

Warden Preston Thomas upped security around his new tenants. Word was that Dillinger was continuing to rob banks to fund a raid on the Ohio Pen. As a result, additional officers were placed on duty, and new steel doors were put in place. Visitors had to speak loud enough between screens so that guards could hear (although it was said the gang had developed elaborate codes).

Hundreds of letters were received at the OP addressed to the three gangsters. Warden Thomas intercepted a couple pieces of mail addressed to Pierpont that he deemed sent by Dillinger. A pamphlet of St. John's Gospel had certain passages marked and lines underscored. The second, mailed

from Chicago, contained the following quotation: "Have no fear; Jesus has come once, he will come again." The scriptural pamphlet had a page turned down and a chapter marked in parenthesis with blue ink. It read:

> *Let not your heart be troubled;*
> *ye believe in God, believe also in me,*
> *In my father's house are many mansions;*
> *if it were not so, I would have told you. I go*
> *to prepare a place for you.*

These ingenious replicas of firearms were no match for the hard-nosed riot squad. *Courtesy of the Dailey Archives.*

Included in the marked passage, but not underlined, were the lines:

And if I go and prepare a place for you.
I will come again and receive you unto myself;
That where I am there shall ye be also.

The day before this message was received, it was reported that Dillinger had visited his father's farm, which was between Chicago and Columbus.[263] Ohio governor George White revealed that he had been sent a letter that stated he wouldn't live out his term if Dillinger's pals were not pardoned.[264] A short time later, he obtained "inside information" that the new Dillinger gang had established headquarters in Columbus with plans to kidnap the governor and his daughter Mary.[265]

Tension ran even higher on April 30, 1934, when three unrelated convicts successfully escaped from the penitentiary. Claiming to be repairing a searchlight, they used a ladder to climb the wall. With a pistol that had been smuggled in, they disarmed the tower guard, took his shotgun and slid to freedom.[266] It was later learned that a fireman employed at the prison had smuggled the gun in. He had been paid $115 by one of the convicts.[267]

When Pierpont entered prison, his mother ordered him a subscription for the *Lima News*.[268] This enabled him to keep abreast of Dillinger's exploits. Headlines included many bank robberies, the shootout with the FBI at Little Bohemia and much talk about supposed plans Dillinger had to storm the Ohio Pen. A week before their scheduled execution, Pierpont and Makley learned that they had been granted a stay by reading it in the *Lima News*.[269] The execution was delayed indefinitely pending their appeal to the state supreme court.

In their first interview with newsmen since entering death row, the condemned men remained bitter and defiant. Makley stated, "If Dillinger is running all over the country robbing banks to get money to spring us, I wish he'd send us a couple of lousy 'finns' (fives) for cigarettes." Pierpont added, "I don't expect any help from Dillinger, but I wish him luck. He's a nice guy." They also both said they had been framed for the Sarber murder.[270]

Whatever hopes they may have held for another Dillinger rescue evaporated two weeks later on July 23, when reporters informed them that he was dead, just a month after he had been proclaimed Public Enemy Number One. The night before, federal agents outside a Chicago theater gunned him down. He was thirty-two. Upon hearing the news, Pierpont responded:

"Fat Charlie" Makley avoided the electric chair when he was shot to death during a futile escape attempt. *Courtesy of the Dailey Archives.*

I might be willing to trade places with him. John was a very likeable fellow. As a man among men, he was sincere and congenial. If it's true, I'm sorry. John was a friend of mine. He didn't owe me anything. It's no surprise to me that he was shot in the back. I expected him to get it that way.[271]

A solemn Makley added, "As a man, you could be proud to call John brother."

On September 22, 1934, Warden Thomas was in his office speaking with several newspapermen. Suddenly a loud, continuous alarm bell rang, shattering the conversation. The warden leapt into action and began shouting orders to his men. Amanda Thomas, his daughter, paled visibly but kept her nerve. "Everybody get a gun out here and stand your ground," were the first words she spoke.[272]

On death row, an officer had been delivering Harry Pierpont a meal. "I want some salts; I'm sick," the inmate had said. As the officer turned, Pierpont slugged him and demanded, "Give me that key." The guard refused and was struck again. Pierpont then pulled out a .32-caliber revolver

Mary Kinder bids farewell to her late boyfriend, "Handsome Harry" Pierpont, following his execution. *Courtesy of the Dailey Archives.*

and unlocked the cell of Russell Clark, who was being held on death row for security reasons. They then opened the remaining cells and released all eight men in the death house, taking two officers hostage. A guard in the adjacent room triggered the alarm.

Charles Makley, armed with a .25-caliber automatic, joined Pierpont in smashing up a table and using pieces of it in a futile attempt to break their way through a steel door. As the riot squad burst in, the two men leveled their guns at the eight officers. "I don't know how many shots were fired. They came so close together, I couldn't count them," Deputy Warden James C. Woodard would later recall.[273]

When the battle-hardened riot squad opened fire, both gangsters instantly collapsed under a hail of bullets. Makley, age forty-four, died as a result of several gunshot wounds. Pierpont, with a bullet lodged in his spine, taunted the guards to finish the job. He was taken to surgery and returned to his cell within five hours. Guard Harold Whetstone, formerly of Wapakoneta, was hit in the hand by a ricocheting bullet during the assault.

Having been spared the electric chair, Russell Clark had many years to reflect on his life of crime. *Courtesy of the Dailey Archives.*

Upon inspecting the "weapons" used in the failed escape, authorities discovered that the gangsters had taken a page from Dillinger's playbook. They had fabricated replicas of guns that some prison officials at first doubted were fakes. The weapons were made from soap, softened with water and assembled using various odds and ends, such as fountain pens, small bits of wire, tin foil, puzzle pieces, thread from blankets, toothbrush handles and matchsticks. They were then blackened with lead pencil scrapings.[274] Coincidentally, Pierpont's .38 was a duplicate of Warden Thomas's personal revolver.[275]

On October 17, 1934, at 12:07 in the morning, Pierpont entered the execution chamber with a bullet still lodged in his back. He kissed a crucifix and handed it to the chaplain. Without a word and with a sardonic grin on his face, he sat in the well-used wooden chair. After he was strapped in and the electrodes were positioned, the death mask was placed over his head, eclipsing his twisted smile. Then a red light glowed above him, the dynamo whined and 2,000 volts of electricity flowed through the man who had promised never to sit in the "hot seat." A faint crackling was heard in the room. Eight minutes after shuffling into the death house, he was pronounced dead.[276]

Having been close associates in life, Makley and Pierpont expressed a wish to be buried side by side so they would not be separated in death.[277] Their request was denied. Fellow gang member Russell Clark was released from the Ohio Penitentiary on August 14, 1968, after serving over thirty-four years of his life sentence. He had been diagnosed with lung cancer and was not expected to live six months. He died on Christmas Eve of that year, and with him, the last remnant of the original Dillinger Gang passed into memory.

Friends in Low Places

On December 4, 1930, eighteen-year old Julius Krause arrived at the Ohio Penitentiary. It was a one-way ticket courtesy of the Stark County Court of Common Pleas. He had been convicted of first-degree murder and sentenced to life in prison. Police maintained that Krause and twenty-year-old Labanna Rohrbach robbed a small grocery in Canton, Ohio, on October 21, 1930.[278] A simple hold-up had quickly escalated to murder when the store's owner, Charles A. Bartlett, age eighty-three, resisted. Rohrbach later confessed that he clubbed the elderly man over the head with his gun. Bartlett died two hours later of a fractured skull. As a result, an innocent life had been taken for roughly forty-five dollars.[279]

On the day that the two men were charged with murder, American astronomers had gathered on a tiny island in the South Pacific to witness the "Dance of the Atoms"—a total eclipse of the sun. For ninety-three seconds, the scientists observed the curvature of space as the sun's gravity caused the rays of light from distant stars to bend around it. That was also about the amount of time it took for the trajectory of Julius Krause's life to be bent, too. As a result, he found himself living in a state of perpetual eclipse behind the walls of the Ohio Penitentiary.[280]

For the next ten years, Julius existed within the stone bubble of the ancient prison—that is, until August 19, 1940, when he disappeared from a work gang at the Ohio State Fairgrounds.[281] Authorities issued a fifty-dollar reward, and a manhunt ensued. For forty-five days, they searched in vain. Julius Krause had vanished. Then on October 3, the fugitive abruptly reappeared and turned

himself in to Canton authorities. And he wasn't alone. Accompanying him was a gas station attendant with an interesting tale of his own.

Stark County prosecutor A.C. Barthelmeh met with the men at a cottage on Turkeyfoot Lake, eighteen miles outside town.[282] Brought together by a former YMCA secretary who knew them both, Krause explained that he had escaped in order to track down the real culprit of the crime for which he had been imprisoned—a one-time "pal" named Curtiss Kumerle, age twenty-eight.[283] Barthelmeh had a court stenographer take down Kumerle's confession, which totally absolved Krause of complicity in the robbery and, more importantly, the grocer's slaying.[284] Still dressed in his filling station uniform, he explained that after Julius found him and begged him to tell the truth, he decided that he "wanted to get it off my chest." He had recently been released from the Ohio State Reformatory in Mansfield for an unrelated breaking and entering charge. On the night of the crime, Kumerle said he had remained in the car when Rohrbach first entered the grocery but, later, joined him to find he was looting the cash register. By then, the elderly proprietor was lying motionless on the floor. Afterward, the two robbers went to see their mutual friend, Krause, and gave him a portion of the cash. However, he would offer no explanation of why they would do that, an omission that would forever raise a question about the extent of Krause's involvement.[285] There was some suggestion he could have been the driver of the getaway car, for instance.

Krause felt it was useless for him to declare his innocence at the time of his trial since he had been caught with Rohrbach in a stolen car and in possession of a share of the loot. It didn't look good because it wasn't good. Besides, both of them had records. Rohrbach had served time at the Ohio State Reformatory, and Krause had been committed to the Boys Industrial School as a juvenile. Unaware of the old man's death, he had even confessed to being present at the robbery to shield Kumerle, who had a spotless record. When he later learned that he had implicated himself in much more than the theft of forty-five dollars, he recanted. Police laughed. The authorities also saw the situation as an opportunity to clear the books by hanging thirty-eight house robberies and seventeen auto thefts on Rohrbach and Krause as well. They supposedly had disposed of the items in Cleveland, Akron and Youngstown.[286] The prosecutor claimed that for the past year, he had been working on the theory that Krause was innocent and that he would seek a pardon for him once the new evidence was validated. [287]

According to Kumerle, he and Rohrbach had dropped Krause off at home before committing the robbery. Later, they met back up with him and

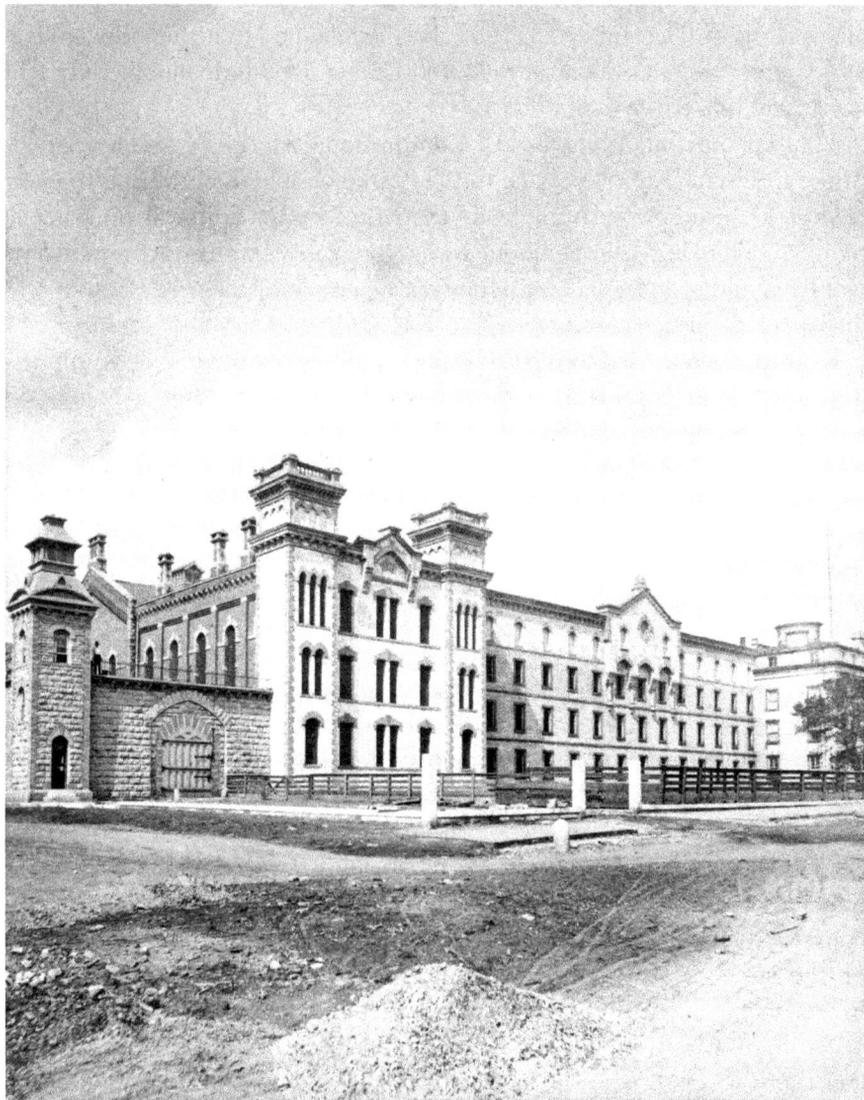

Nicknamed "the Walls," the Ohio Penitentiary was witness to untold human misery for 150 years. *Courtesy of the Dailey Archives.*

divided the ill-gotten goods but did not mention the assault on the grocer. After Kumerle left on his own, the other two men were arrested while driving around in the stolen vehicle. And there was another point to consider. During the intervening years, Rohrbach had made a deathbed confession clearing Krause. He also had signed statements to that effect before succumbing to

tuberculosis on December 28, 1935. Krause claimed that these documents were among his possessions at the Ohio Penitentiary and volunteered to go back there to retrieve them.[288]

"There's only one thing to do," Commissioner Harry W. Jewell decided. "Take this man (Kumerle) back to the Stark county jail and bring his case before the grand jury. After he is tried the commission will do what is right."[289] Thinking he was about to be vindicated, Krause was confident that he would soon be set free. However, he was to discover just how slowly the wheels of justice could turn.

Krause was returned to the OP while awaiting the outcome of Kumerle's trial, confident that his long ordeal was nearly over. After a couple of anxious months, the ex-con entered a plea of guilty to manslaughter and robbery, receiving a term of ten to twenty-five years. After the sentence was imposed, Prosecutor Barthelmeh announced he would again attempt to see to Krause's release.[290] He assured Krause that he would personally discuss the case with the governor. Newspapers throughout the country trumpeted that justice would be served after ten years. Meanwhile, several more pages were torn from the calendar in the Ohio Penitentiary.

On April 5, 1940, more than nine years after he entered prison, Julius Krause received word that the state pardon and parole commission made a recommendation to Governor John W. Bricker. They said he should continue to serve his life sentence in the Ohio Penitentiary. Following their advisement, the governor announced that he would not grant executive clemency. The commission had ruled that Kumerle's confession only indicated that there were three criminals guilty of the murder.[291] Of course, this conclusion completely contradicted the original testimony of the state's star witness in Krause's prosecution. Six-year-old Vera Ferguson had identified Rohrbach and stated that there was only one other man with him. However, the parole commission continued to feel there was more to the story than what they had heard.[292] "There is nothing more I can do," Prosecutor Bartelmeh responded tersely, unhappy with the defeat.[293]

Julius Krause continued to languish, watching not only the pages of the calendar but also the calendars themselves fall like leaves. Then, on January 11, 1947, after seventeen years of confinement, he again had reason to hope. As one of his final acts as governor, Frank J. Lausche commuted Krause's murder conviction from first to second degree, making him eligible for an immediate parole hearing. Furthermore, the outgoing governor named Krause as one of the men who never "should have served a day."[294]

A couple months later, on March 19, 1947, the day of Krause's parole hearing finally arrived. The Ohio Pardon and Parole Commission, which held the keys to the Ohio Penitentiary, denied his release. The governor's commutation had reduced his sentence from life to twenty years. The board decided that he would have to serve the full twenty in punishment for his escape.[295] Krause was returned to his cell, where he watched a few more winters come and go.

While Krause was in prison, he discovered he had a knack for drawing and eventually became a talented artist. About two years after he first entered the penitentiary, he started creating pencil portraits. Sometime later, he acquired some paints. Since their sentences overlapped, it is quite possible that he was influenced by the work of another Ohio Penitentiary inmate, Clarence Doss, who became famous for his portraits. He had taught himself the fundamentals of painting through studying books on the subject. Eventually

Krause's description and vital statistics were widely circulated in an effort to recapture the fugitive. *Courtesy of the Dailey Archives.*

Krause won a $300 correspondence art course of fourteen months after having responded to a magazine ad for Famous Artists School.[296] He painted the murals of the Madonna on the walls of both the Catholic and Protestant chapels. An oil painting of the warden's two young daughters testified to his impressive skills.[297]

After serving twenty years for a crime he said he didn't commit, Julius Krause again stood in front of the commission. On February, 20, 1951, it finally granted him a parole effective May 15 of that year. "I really can't say that I am bitter," he said soberly, "That's a negative sort of thing. It can't get me anywhere." Amazingly, he had never expressed any anger over his fate nor gave up faith that the legal system would eventually absolve him.

Curtiss Kumerle was released from the London Prison Farm on parole on April 11, 1951. Ironically, the admitted culprit of the robbery and murder of the elderly grocer was granted his freedom prior to the man he had tried to absolve of the crime. Just over a month later, on the crisp, spring morning of May 15, 1951, the gates of the Ohio Penitentiary creaked open and Julius Krause walked into bright sunshine after having twenty years and five months of his life stolen from him. The boy who had entered the grim gray bastille walked out as a prematurely gray-haired man of thirty-nine. After shaking hands, Warden Ralph W. Alvis skipped the customary lecture given to departing prisoners, saying later, "He doesn't need a lecture. I'm tickled that he is going to get a chance to do what he can and make a success of his life."[298] Although he was now free, Krause had not been cleared of the crime and never would be, even though no one involved doubted his innocence.

Setting out to thank those who had worked on his behalf, Krause stated, "There were times when I thought that prison had been my whole life; that there was nothing before. I was eighteen, you know when I came here. I thought the day would never come. And now I can't believe it is here."[299] He said he had no feelings of revenge or bitterness and that his main goal was to be a success.

From the penitentiary, he made his way to the governor's mansion to say goodbye to Mrs. Lausche. For several months prior to his release, he had worked as her gardener, chauffer, occasional secretary and caretaker of the mansion's four dogs. In return, she had taught him interior decorating and, more importantly, had become his friend.[300] "I can hardly keep from weeping," Mrs. Lausche said. "Julius is a fine, fine boy. He is a gentleman and his mother will be proud of him."[301]

Krause then traveled with Clyde Mann, an *Akron Beacon Journal* reporter who had championed his case since 1940, to thank the publishers and

editors of the paper for their persistence. Of the handful of people to whom he wanted to express his gratitude, there was one he could not. Common Pleas judge A.C. Barthelmeh, the former prosecutor who had fought so valiantly on his behalf, had passed away in 1949. After thanking those who he could, he planned to go to New Mexico to join his two brothers. "All I want to do is forget," Krause had said while awaiting his release.[302] And then he disappeared for the second and final time.

On November 22, 2011, James Dailey placed a call to the home of Robert Krause, Julius's brother in New Mexico. Doris, Robert's wife, answered the phone. When he explained that he wished to speak to her husband about his brother's time in prison, she responded, "He was waiting for you to

This family photo of Julius Krause attests to the fact that twenty years in prison failed to crush his spirit. *Courtesy of the Dailey Archives.*

call." He wasn't waiting to hear from Dailey specifically but, rather, from anyone who might be interested in his story. Unfortunately, the call came too late. Her husband had just passed away six days earlier on November 16, and Julius had died in her home in 1980. However, she had possession of some items that once belonged to her brother-in-law that she wanted to see go to a good home. Unfortunately, she also died a short while later.

After more research, contact was made with Julius's nephew. He turned up a fascinating cache of memorabilia relating to his late uncle including his driver's license, a signed photograph of him with Albert Dorne (the highest paid commercial artist of the 1950s) and even one of Krause with Norman Rockwell. Dorne and Rockwell were founding members of the Famous Artists School and had been the ones to award

him a scholarship to it while he was in prison. Finally, the nephew had an original Julius Krause painting of a seascape. These items have been proudly preserved in the Dailey Archives in remembrance of this man and his remarkable journey.

Chapter 13

The Halloween Riot

Octber 31, 1952, began like any other day in the Ohio Penitentiary: with breakfast. To paraphrase Napoleon (or Frederick the Great, to whom it is sometimes attributed), armies, whether of soldiers or inmates, march on their stomachs. The entire prison schedule revolves around mealtimes. Due to space limitations and security concerns, prisoners eat in shifts. The more overcrowded the institution, the more shifts required. As soon as the first group has finished eating, the second is ushered in. As soon as the second is done, the third is seated, and so forth. Sometimes the last shift has barely finished breakfast before it is time for lunch, and then it starts all over again. Inmates complain they are never permitted enough time to eat. Often, it is true. However, they cannot be released to go to their job assignments, attend school or participate in other programs until everyone has eaten. And if there is a delay for any reason, the whole day is thrown off.[303]

The OP was already bursting at the seams. At around 3,700 inmates, the state's maximum-security prison was just three years away from reaching its peak population of 5,235 (three times its designed capacity). Not only were living conditions cramped, but budget cuts had also adversely impacted the quality of the food. Fifty years earlier, the poor people of Columbus—women and children mostly—lined up every day with baskets to collect the prisoner's table scraps. By 1952, there would have been few takers. Along with everyone else, the inmates had endured rationing during World War II. They understood why. But when palatability of the meals did not improve after the war ended, many of them became disgruntled. Very disgruntled.

A month earlier, the *OP News*, an inmate-run newspaper, had published an eight-part series on life behind the walls. It was an attempt to make its noninmate readers aware of their living conditions. Among the issues raised were overcrowding, poor food and idleness. "[I]n prisons where today is exactly like yesterday and tomorrow holds no promise of change, men suffer untellable torment. Mentally, physically and spiritually they suffer."[304] Overcrowding had even become a topic of debate in the gubernatorial race that pitted Republican candidate Charles P. Taft against incumbent Democrat Frank J. Lausche. Although immensely popular, Governor Lausche was roundly booed when he suggested that Taft had been "hoping that a riot might break out in the state prison" when he mentioned the possibility at the GOP convention.[305] For his part, Taft promised that if elected, he would build a new prison. It wasn't a new idea by any means. The need to replace the Ohio Penitentiary was recognized as early as 1908. The Easter Monday Fire of 1930 revived the idea, but still nothing was done. In 1945, the Ohio legislature allocated $5 million for this purpose. But this initiative went nowhere, and the funds lapsed. Politics as usual.

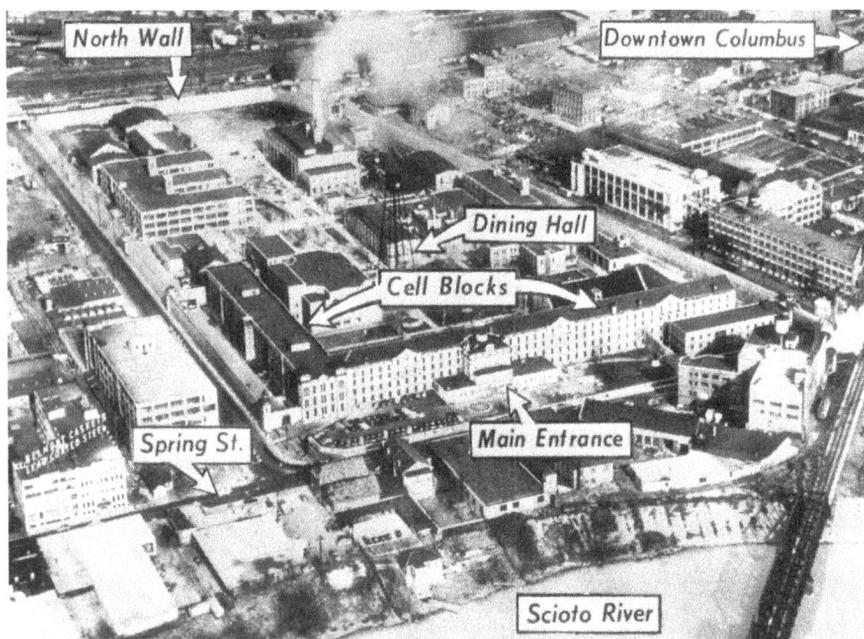

The walls of the Ohio Penitentiary enclosed some twenty-two acres (four more than the White House). *Courtesy of the Dailey Archives.*

Prisoners, especially those who are doing hard time, do not like surprises. They find comfort in the regimentation of their everyday existence. They know that any break in the routine can quickly escalate into a dangerous situation. For this reason, the old timers sometimes take it upon themselves to "correct" the unacceptable behavior of new inmates. They consider the prison their home and do not suffer "jitterbugs" gladly. Still, it was hard to contain the growing resentment over the unappetizing meals, and the discontent threatened to upset the delicate equilibrium of the institution. Inmate Gentry Richardson wasn't alone when he complained that "they would give us butter beans with a piece of fat sowbelly in there with hair on it, big hairs up to an inch long."[306] Another prisoner added, "Next morning we got ham, too. But we ain't had nothing but beans and cornbread since. And rotten coffee."[307]

At 5:00 p.m. on Halloween, the inmates decided they had had enough. It was trick-or-treat time. During supper, some nameless con started tapping his spoon against his cup, just like in the movies. It was the customary signal for an inmate waiter to pour him some coffee. Other inmates soon joined in, at first tapping on their cups and then banging their trays on the tables. Realizing the situation was rapidly spinning out of control, the guards summoned Warden Ralph W. "Red" Alvis. Generally respected by the convicts, "Big Red" (as they called him) climbed atop a dining room table to address them and was soon able to restore order. Unfortunately, another group of prisoners in a second dining room had also begun throwing food, trays and utensils in a full-scale revolt. This time, the agitators would not be assuaged with mere words.

Of course, not all prisoners were involved (and many more would later claim innocence). A number of them returned to their cells, not wanting to participate in the disturbance. Others, eager to set themselves apart from the troublemakers, surrendered to the guards and were summarily searched for weapons. Some just sat down in place and refused to budge. Those who did not submit to the authority of prison officials divided up into gangs and began looting and ransacking various sections of the prison. Not a few made a beeline to the hospital in search of drugs. A small group of convicts sought out specific inmates to settle long-standing grudges. Fires were set, and cell locks were smashed. In total, eight buildings were torched, including the commissary, laundry, hospital and chapel. The auditorium also sustained damage. The Reverend C. Valerian Lucier, Catholic chaplain, watched as his church was gutted by flames. He had stayed in the prison courtyard with many of the inmates even at the height of the violence. "You know, some of the better boys actually tried to save my chapel," he said.[308]

The Catholic chapel was among the buildings severely damaged by the rioting inmates. *Courtesy of the Dailey Archives.*

While many prisoners were forced back into their cells, the vastly outnumbered guards could not regain control of cellblocks G, H, I and K. Some 1,600 convicts continued to riot. They armed themselves with whatever weapons they could find or devise, including meat cleavers and spoons sharpened to a razor's edge. The atmosphere was explosive.

At midnight on November 2, the warden and Ohio governor Frank J. Lausche, who had to come in from the campaign trail, held a press conference attended by thirty journalists and photographers. The two men had been dealing with rioters for over six hours. They both stuck to the official line that "food complaints" were the reason for the rebellion, although there was reason to believe it wasn't the food alone. "We don't know what they want," Alvis would later admit. "And I doubt if they know either."[309] He also claimed to have sensed this would happen for eight months.

As *LIFE* magazine was quick to report, Lausche wasn't the only Democratic governor whose electioneering was disrupted by a prison riot. Governor Adlai E. Stevenson of Illinois, who was in Pennsylvania campaigning for the presidency of the United States, had to take a break from courting voters to direct operations at Menard State Prison, where 341 convicts were holding 7 guards hostage. By 10:30 a.m., Stevenson had somehow brought the incident to a peaceful conclusion. But just as Stevenson ("A President for all the People!") was returning to the stump, it was Lausche's turn. He had to swing down from Cleveland to evaluate the Ohio Pen situation firsthand.[310] After consulting with the warden and other officials, he apparently decided a show of force was in order.

Alvis had called for outside assistance as soon as he realized the situation could not be contained by his men. Highway patrolman Jay Devoll later recalled, "I was out on patrol when I got a radio call that said to go home and pack a bag and be ready to stay for a few days. It also advised us to stop by and pick up another officer [from Cambridge] and a submachine gun. We had one submachine gun in each district at that time." On November 3, 1952, 147 National Guardsmen, 30 toting machine guns, appeared at the gates. Another 250 men—Highway Patrol troopers and Columbus Police officers—would arrive later in the day. They carried M-1 rifles with fixed bayonets, Browning automatic rifles, 30-caliber machine guns with tripod mounts and an unspecified disabling gas.

Devoll was among the first wave:

> [T]*hey wanted to get a platoon, they wanted 30 (Patrolmen) to go in. Everyone else that went in did one at a time. They didn't have enough*

Warden Ralph "Red" Alvis conferred with Governor Frank Lausche, who had to come in from the campaign trail. *Courtesy of the Dailey Archives.*

people, but they sent them in to guard the fire trucks and things like that—there were a lot of fires going on. But we went inside in a platoon and formed a line across the yard so that we had them all corralled in one place. The warden at that time broke that one up…he had a big, and I mean big, black bodyguard, who was an inmate, and he walked out, walked right through that whole mob, and got up on the steps and got a bullhorn and he said, "All of you people know me and you know that I mean what I say. You've got 10 minutes to get back in your cells or you're going to suffer the consequences." And away they went![311]

While Alvis and law enforcement officials hoped to avoid violence, the convicts were still able to freely roam the cellblocks owing to the broken locks. They immediately began throwing heavy objects at the troops, who responded by firing shotgun blasts over their heads as a warning. One inmate Carlyle Noel, age thirty-five, was shot with a rifle when he came out of his cell and ran for a stairway.[312] Five others were injured, including T.W. Lawrence, a state highway patrolman who was grazed on the head

by a guard who mistook him for a rioting prisoner. The other three wounded were Harold Sweet, twenty-five, a first-degree murderer; George Grubb, thirty-two, a primarily white-collar criminal; and Ezra Cayson, twenty-seven, in for burglary. Another convict, Everett Hodge, twenty-eight, was shot while trying to pry his way through a screen to escape.[313] After several skirmishes, the decision was made to cut off heat and food supplies to the remaining rioters. Without electricity, the prisoners had no radios and no source of outside information regarding efforts to quell the uprising. Concerned about their safety, some of the inmates attempted to communicate with prison officials. At least thirty-five surrender notes, or "kites,"

The valiant Father Charles V. Lucier pleaded with prisoners to return to their cells as they broke out in wild disorder. *Courtesy of the Dailey Archives.*

written on cloth and paper scraps "fluttered" down out of the cellblocks. Warden Alvis read one of them to the press: "We give up. We are not in favor of this and we know when we are licked."[314]

Encouraged by the notes, Alvis entered the cellblock to speak to the prisoners. They had been without food since Monday and had suffered through a night of freezing temperatures. He soon returned to the yard with twenty-two prisoner representatives. Ten minutes later, the riot was over. By November 4, all prisoners had either given up or been subdued. Although it was rumored that some of the inmates would be transported by boxcar to Joliet Penitentiary in Illinois until the broken cell locks were repaired, Governor Stevenson was quick to issue a statement saying he knew nothing about such a plan.[315]

With the prison still in disarray as a result of the heavy damages it had sustained, the Ohio Highway Patrol (OHP) was kept on for some three months to ensure the institution was secure. Colonel George Mingle of the

OHP told reporters, "There is no question as to who has control. We have it because of our manpower and our guns." Nineteen days after the riot, some two hundred patrolmen, half the force, remained on duty in the Ohio Penitentiary.[316] According to Devoll:

> *We were 12* [hours on] *and 12* [off]. *We stayed at a dorm at the Ohio Pen. The main room we were in was 12 feet by 12 feet and there were eight doors on the room—that was so we could get out quick. They moved us every two hours, from the dorm to the cell block to the power house. You just kept moving every two hours so that you kept alert and didn't go to sleep and the prisoners wouldn't know the difference and wouldn't get acquainted with you.*[317]

In the aftermath of the riot, the prisoners grumbled more about the loss of recreation than the food. For example, Alvis canceled three games by the Hurricanes, the prison football team. Up to this point, the recreation program had been widely praised as one of the best in the country, but after the riot, it was the least of the warden's concerns.

By December, there were still over 100 guardsmen stationed at the prison. They were given the choice of either Christmas Day or Christmas Eve off. To temporarily alleviate the overcrowding while cellblocks were being cleaned and rebuilt, 578 prisoners were sent to Camp Perry near Port Clinton. Others were moved to Green Springs (Fostoria), Hocking Forest (Marietta), Hueston Woods (Oxford) and Shawnee Forest (Portsmouth).[318] Twelve ringleaders were named, as well as 67 "secondary rioters." Final damage estimates were between $100,000 and $500,000 (scaled back from early estimates of twice that amount).

Among the "excuses" for the riot cited by the inmates in the 605-page report issued by the Ohio State Patrol were: 1) Adequate, but improperly prepared food; 2) Too strict a parole policy; 3) Guards too stern; 4) Mail privileges too restrictive; and 5) Insufficient income to buy daily necessities. Warden Alvis was quick to defend his policies. For example, he declared the one-letter-a-week policy one of the most lenient in the country. He also had installed a new cook immediately after the riot.[319]

One positive outcome from the riot involved an attempt at correcting overcrowding by removal of inmates to surrounding prisons, including the Ohio State Reformatory in Mansfield, at the time under the leadership of Arthur Glatke, recently appointed commissioner of corrections.[320] Also, a new food supervisor was hired, and pay increases were given to

A navy floodlight illuminates the rioting cellblock throughout the night. *Courtesy of the Dailey Archives.*

the prisoners in the shops. As a result, a prisoner making half a cent an hour before the riot was raised to four cents an hour less than a year later. A prisoner making five cents an hour would now be receiving eight and a half. The pay rate was still based on behavior, length of time in prison and marital status. Of twenty-one prison disturbances that occurred during 1952, the Halloween Riot ranked twentieth on the list in terms of severity.[321]

Prison officials decided that the lessons they learned should not be forgotten. When another riot broke out sixteen years later, Warden E.L. Maxwell stated, "Ever since the Halloween riot and fire of 1952 (in which one inmate died), we have had two meetings each year of all area law-enforcement agencies who would be involved in a prison riot to work out

exactly what they had to do." In his opinion, that is the reason the 1968 riot was brought to a conclusion fairly quickly and almost bloodlessly.[322]

There was one other short-lived "benefit" of the riot. While penitentiary staff cleaned up and made necessary repairs to the institution, three inmates who had been sentenced to death received reprieves. Wife-poisoner Marvin Lucear, cop-killer George Ross and bookie-murderer Louis Allen Angel were all originally scheduled for dates with the electric chair in November and December 1952. Owing to the riot, they all received sixty day deferments.[323]

In January 1953, Governor Lausche said he expected the Ohio Penitentiary would be abandoned once other facilities were built.[324] He was right, but it would take another twenty years and another riot.

Dr. Sam's Magic Blood

In 1951, Henrietta Lacks, a thirty-one-year-old mother of five, died of cervical cancer in the "colored" ward of Johns Hopkins Hospital in Baltimore, Maryland. Before she passed away, cells from her tumor were taken without her knowledge. Labeled "HeLa" (from Henrietta's first and last name), these cells did something extraordinary and completely unprecedented in medicine at the time: they grew and continued to grow without end.[325]

Five years after Henrietta's death, cancer cells cultured from her original sample came to the Ohio Penitentiary in the purse of Dr. Alice E. Moore of the Sloan-Kettering Institute for Cancer Research. Dr. Moore was working for Dr. Chester M. Southam, chief of virology. Also joining Dr. Southam were his wife, Dr. Anna Southam, and a young professor of surgery at Ohio State University, Dr. Arthur G. James, who would later lend his name to the James Cancer Hospital at OSU.

Dr. Southam was born in Salem, Massachusetts, and received his MD from Columbia University College of Physicians and Surgeons. Soon after completing his training at Presbyterian Hospital in New York City, he began his career as a cancer researcher. He and his associates had been working with HeLa since shortly after Henrietta died, and he was becoming concerned that exposure to the cells, even in a laboratory setting, might endanger them. To test his theory, Southam decided to inject human subjects with the cancerous cells and then observe them to see if the cancer spread (metastasized) throughout their bodies.

Dr. Chester Southam felt that Ohio Penitentiary inmates would be ideal subjects for his cancer research. *Courtesy of the Dailey Archives.*

The good doctor began by injecting Sloan-Kettering leukemia patients—fifteen in all—with the HeLa cells. The cancer grew in thirteen of them and had to be surgically removed. In four instances, the cancer soon returned. Southam's theory was that those who already had cancer were not at all immune to acquiring other forms of cancer. He next decided to see if healthy people had sufficient immunity to fight exposure to live cancer cells. For what he had in mind, Dr. Southam felt prison inmates would be good candidates. He reasoned that their lives were controlled in such a way that there was little chance of environmental factors affecting the results of the study. Their relative health could also be guaranteed in a way that the health of the general public could not. As a result, they would serve as the perfect "control" group, with the sick hospital patients in New York serving as the "test" group.

Between 100 and 170 prisoners signed up when Warden Ralph Alvis and prison physician Dr. Richard H. Brooks initially requested 25 volunteers,

according to a 1956 article published by the *Ohio Penitentiary News*. One felon told the local media, "It's like the Boy Scout helping the old lady across a dangerous street. We're trying to help a lot of people across the street." Another said, "I've been in so much trouble all my life, and this is the first time I've ever done anything good. My grandfather and grandmother both died of cancer."

Despite the image of the hardened convict, this was not the first time inmates from the OP risked their health to help others. In a 1947 experiment, 1,500 prisoners and guards received a series of inoculations (once a week for three weeks, then once every three weeks thereafter) in the search for a cure to the common cold.[326] Another group of volunteers donated 640 square inches of skin for a young girl's skin graft. In 1963, more than 200 inmates signed up to have a portion of their leg bones removed for a bone graft benefitting nineteen-year-old Sandra Goldstein, whose leg was stunted from polio when she was seven. Again, many of the convicts expressed a desire to do good to make up for having done bad. It also didn't hurt to have some measure of "good behavior" on their records when and if they came up for parole.

While most of the volunteers put on a brave face, they were at least somewhat aware of the possible dangers. "I'd be lying if I said I wasn't worried," one said. "You lie there on your bunk, knowing you have cancer in the arm, and just think. Boy, what you think about!" Many of the inmates were injected up to three times with the HeLa cells over the course of the experiment. It is unclear whether any of the cancers spread. Some news accounts reported that the healthy prisoners easily fought off the disease. Other stories said that a percentage of the prisoners had to have emergency surgery to remove tissue from the injected portion of their arms. According to a May 1956 article in the *Lima News*, the original plan was to biopsy the prisoners' skin for study. Seventeen years later, *Jet* magazine reported that walnut-sized tumors appeared but disappeared on their own. There seems to have been little consensus from the beginning as to what the actual clinical procedure would be and how success would be defined.

In 1958, a little more than a year into his study, Dr. Southam claimed to have learned that people with naturally high levels of properdin in their blood were able to fight off the foreign cells better than those with lower levels. But it's hard to have too much confidence in results obtained after so little time had passed. Normally, it would take years of follow-up to reach any real conclusions.

The notorious Dr. Sam Sheppard, then incarcerated at the Ohio Penitentiary for the murder of his wife, Marilyn, was working in the

prison hospital at the time of the cancer experiments and became a test subject.[327] A graduate of the Los Angeles Osteopathic School of Physicians and Surgeons, he was put to work in the prison hospital shortly after his conviction. However, along with three other inmates who had been working as male nurses, he was transferred to the planing mill following the poisoning of two inmates, including William Miller, editor of the *Ohio Penitentiary News*. Originally, it was believed that they were poisoned with sodium pentothal, also known as truth serum, which was available only in the hospital. Dr. Sheppard was later transferred back to the hospital after it was discovered that the men died from drinking wood alcohol.

The exact number of inmate test subjects is hard to pinpoint. Accounts range from 120 to 253. This was due to the fact that the research was conducted over a series of years, so the number kept growing. Sheppard became one of them perhaps as early as 1957. In 1961, his brother Stephen, also a doctor, asserted that "there is no question Dr. Sam has a tumor." However, his other doctor-brother Richard disagreed. A biopsy was performed at the Ohio Penitentiary, and Dr. Watson Walker, prison surgeon, pronounced it was cancer free.[328]

During an October 1969 interview conducted in Hollywood, Sheppard claimed he was "the first person in the world ever to submit to live cancer" and that it was because of his example that two hundred other inmates followed. After his release, he had taken up professional wrestling in order to raise money for cancer research. The proceeds from his matches (less expenses) with tag-team partner George Strickland would be donated to Sloan-Kettering. He boasted that his body had rejected the cancer cells, and that as a result, his blood had developed special properties.

"I donate my blood about once a month to various hopeless cases," Sheppard said. "It will keep them alive for a few more months. We do it, for example, for people who want to make it through some special holiday, things like that." Shortly after the interview, he married Strickland's twenty-year-old daughter. When he died a year later at age forty-six, his attorney, F. Lee Bailey, suspected he might have succumbed to cancer. Apparently, he had told his young wife that he had cancer and was taking pills for it, but the coroner ruled there was no evidence to support that. Rather, he had experienced liver failure.

After completing his experiments at the Ohio Penitentiary, Dr. Southam returned to New York, where he continued the work others began, attempting to immunize subjects against cancer by injecting them with viruses such as West Nile. He was forced to discontinue his research

Signed photo of Dr. Sheppard being released from the Ohio Penitentiary. *Courtesy of the Dailey Archives.*

in 1963 after three colleagues declared his work at the Jewish Chronic Disease Hospital was in violation of the Nuremburg code (rules regarding medical research that came about as a result of the war crimes trials following World War II). Southam and his colleague, Dr. Emanuel E. Mandel, had not

asked the women for their consent before injecting them, fearing (no doubt correctly) that they would become upset if they knew they were being injected with cancer. His study was sponsored by the U.S. Public Health Service and the American Cancer Society. As a consequence, his medical license was suspended for a year by the Board of Regents of the University of the State of New York. Two years later, however, he was elected vice-president of the American Cancer Society.

In 1969, Southam asserted that the physician's creed—"do no harm"—was blocking important medical advances. He also argued that society, not the individual scientist, should be held financially responsible if "something goes wrong" during experiments. "We all want to do good," he insisted, "but there are times when you may not be doing good by doing nothing."[329] However, doing good apparently didn't include doing follow-up. Southam left Sloan-Kettering in 1971. Two years later, Dr. Arthur James of Columbus, president of the American Cancer Society, was trying to locate 120 of Southam's former "guinea pigs." James noted that statistically 25 percent of them should have developed cancer. If the percentage was found to be significantly lower, it might have implications for the development of a vaccine.[330]

The final results of Dr. Southam's research are almost impossible to determine since the few records left by him were sealed by Sloan-Kettering. Neither did he keep track of the inmates as he had originally said he would. In truth, when the funding ran out, the doctor moved on to other things, leaving the test subjects in the dark. As late as 1985, one former prison inmate in Akron was wondering whether his participation in the cancer research experiments was the cause of his son's development of Elephant Man's Disease (neurofibromatosis). He purportedly was one of 253 volunteers.[331]

After he was freed from prison, Sheppard tried his hand at professional wrestling with his partner, George Strickland. *Courtesy of the Dailey Archives.*

More than half a century later, Dr. Southam has sometimes been likened to Dr. Josef Mengele, the Nazi doctor responsible for some of the worst medical atrocities in human history. He has also been suspected by conspiracy theorists of being on the CIA payroll as part of Project MKUltra, a program in which U.S. and Canadian citizens were used in medical experiments, including LSD testing.

On the other hand, it is important to remember that these experiments did not take place in a vacuum. Dr. Southam did not hide what he was doing or keep quiet about his intent. The research was a combined effort of New York's Sloan-Kettering Institute and the Ohio State University Medical School. The experiments were widely covered by the national press, from *Time* magazine to the *Readers Digest*. The actual injections were documented by both photographers and TV cameras.

Dr. Southam's actions were witnessed by Warden Alvis; Dr. C. Earl Albrecht, the acting director of the Department of Mental Hygiene and Correction; Maury Koblentz, chief of the Division of Correction; Dr. Arthur James of OSU; and Dr. Richard Brooks, the prison physician. Any one of them could, in theory, have objected to the experiments or at least questioned the methodology had they had reason to believe anything was irregular. Instead, they all posed for the cameras while prisoners were injected with as many as five million live cancer cells.

Unlike Henrietta Lacks and perhaps the Sloan-Kettering patients, the Ohio Penitentiary inmates were willing participants in the project. Furthermore, Dr. Southam was neither the first nor the last doctor to inject cancerous cells into his patients. If he were guilty of medical misconduct or human rights violations, as history seems to suggest he was, he was not alone. His actions were a reflection of the times. People were desperate to find a cure for cancer and desperate men do desperate things.

Dr. Southam died in 2002 at the age of eighty-three, having retired in 1983 after forty-three years in medicine. True believers in his work to the end, his family asked that in lieu of flowers, donations be sent to the Sloan-Kettering Institute for Cancer Research.

The Summer of Our Discontent

In the history of the United States, 1968 was a tumultuous year. It was a time of upheaval, of transformation and of bloodshed. By summer, both Martin Luther King Jr. and Robert F. Kennedy had been assassinated. Across the country, law enforcement officers clashed with civil rights activists and Vietnam protesters, culminating in a "police riot" at the Democratic convention in Chicago. On June 24, this social unrest manifested itself at the Ohio Penitentiary as plumes of smoke once again filled the sky above the century-old limestone walls.

Inmates began rioting at about eight o'clock, just after breakfast. Armed with baseball bats, pipes, broken bottles and whatever else they could get their hands on, the prisoners began battling the guards.[332] Scissors from the tailor shop, butcher knives from the kitchen and golf clubs from the miniature golf course supplemented their arsenal. Fires quickly engulfed the print shop, two workshops, the hospital, the auditorium, cotton and woolen mills, the power plant, the mess hall and the shoe factory.

In an effort to restore order, one hundred police officers with bayonet-tipped riot shotguns rushed into the prison. "If you have to take them, take them, I don't care how," Columbus police chief Robert Baus ordered. "You are dealing with a hardcore outfit in here, not a bunch of teenagers."[333] At the height of the riot, over six hundred men—Columbus firemen and police, State Highway Patrol officers, National Guard troops and prison guards—were dispatched to quell the violence.

The show of force worked. By noon, just four hours after the first fire was set, the unruly convicts were herded together at the O. Henry baseball field

Police secure riot guns and await orders in preparation for entering the besieged penitentiary. *Courtesy of the Dailey Archives.*

to be returned to their cells. Although no shots had been fired, at least fifteen to twenty prisoners and eight guards were injured. An inmate nurse, Charles Jenkinson, had suffered a fractured skull while attempting to protect patients in the prison hospital. With hundreds of broken windows and numerous burned out buildings, the damage (estimated at $1 million) was the worst in the OP's history.[334]

Originally appointed in 1961, Warden Ernest Maxwell had been scheduled to retire on July 1 but said he would remain "until we get this place back on its feet again."[335] "The prison is a monstrosity," Chief of Corrections Maury C. Koblentz weighed in. "For just one thing there's less than an acre of recreation ground for the nearly 3,000 men. There's no freedom of movement and no separation of different types of criminals."[336] Clearly, there was some sympathy for the inmates' plights.

With much of the blame for the riot being placed on the antiquated prison itself, construction of the state's new maximum-security prison—to be located in Lucasville—was put on a fast (or at least a faster) track.[337] The hope was to avoid a political firestorm, but Representative Robert

G. Jones urged that "a real study should be made." While it was "too late" to do anything about the latest incident, he was concerned about preventing future disturbances. "Corrections is one of the poorest things we do," he said.[338] However, Governor James A. Rhodes indicated there would be no investigation.[339]

Some fifty-four prisoners were singled out as agitators and locked in solitary confinement pending investigation by the Franklin County Grand Jury. "It's up to them to return any indictments," Warden Maxwell said, although it was expected they would be charged with arson and rioting.[340] Meanwhile, the Ohio Committee on Crime and Delinquency pushed for a study of the state's prisons. The committee noted that low salaries made it difficult to attract and keep qualified individuals for prison jobs. It also cited the proposed Lucasville prison as an example of Ohio's choosing to continue its history of custodial orientation and large unmanageable facilities. According to the *Lima News*, "This is in spite of the knowledge that successful rehabilitation of prisoners in such large institutions is virtually impossible."[341]

On July 5, it was announced that Marion J. Koloski would become the new warden at the Ohio Penitentiary after Maxwell had entered a hospital due to "complete exhaustion." Most recently head of the Chillicothe Correctional Institute, Koloski had started out as a psychologist at the Ohio Penitentiary in 1960.[342] He immediately relaxed some restrictions on inmate mail and visitation.

An air of discontent enveloped the inmates and staff alike. By mid-July, a large portion of the guard force threatened to go on strike if their demands were not met. They wanted higher pay, free meals while on duty, opportunities for promotion, disability compensation and improvements in the retirement system. Martin A. Janis, director of the Department of Mental Hygiene and Correction, explained that those matters were out of his hands—his budget was entirely dependent upon legislative appropriation.[343] Although the guards received a twelve-dollar-per-month increase the following month, they felt it was "totally inadequate."

At 10:10 on the morning of August 20, the tension that had gripped the penitentiary finally snapped. With a crack of the loudspeaker came the announcement: "All personnel get to C and D blocks immediately! Repeat: all personnel to C and D block immediately!" Lieutenant Sam George jumped from his table in the cafeteria and rushed toward the disciplinary cellblocks that held the leaders of the previous revolt.[344] He did not realize the extent of the disturbance. Inmate John Howard Conte, a.k.a. "Paisan," had been

outside his solitary cell for a shower when he notified guard Jim Hailey that another prisoner needed help. When Hailey was isolated at the end of the corridor, Conte brandished a twelve-inch knife and took the guard's keys. He then confronted Don Dilly, another guard, and told him to "play it cool." Kelly Chapman, an inmate armed with a hospital scalpel, threatened Dilly's life when the guard insisted he did not have any keys. "We don't want any violence," Conte said, deescalating the situation.[345]

The convicts moved through C and D blocks, opening all the cells, and then crossed the partition into A and B. Soon, three hundred desperate criminals were running loose and seizing hostages. Accompanied by two sergeants, Lieutenant George continued toward the cellblocks, intending to return the prisoners to their cells. As the trio approached the entrance to A and B, the door burst open, and two inmates wearing hastily fashioned turbans grabbed the officer, putting a butcher knife to his throat. George swung at the man, knocking the knife to the floor, but just as swiftly, the other inmate put another blade in front of his face. "Well Mr. George," one of them said. "Let us take a little walk."[346]

As the convicts paraded their hostage through the riot-torn cellblock, someone screamed, "Let's kill 'im now!" Someone else yelled, "Let's cut his head off and roll it out in the yard to them!" A prisoner lunged at Lieutenant George, wildly waving a knife. "No! Use your head, man," another inmate replied. "This is George. He's brass. He's the best hostage we got!" Fortunately, the more levelheaded among them asserted themselves as leaders: Richard "Red" Armstrong and John Conte.[347]

Meanwhile, sixty members of the highway patrol entered the prison while fifteen city police cruisers guarded the outside perimeter. City firemen were ushered in to extinguish a fire in a three-story building housing the commissary and barbershop. It was accomplished in ten minutes without interference. Photographers and reporters joined authorities in the yard, trying to piece together what was going on.[348] In addition to George, ten guards had been captured by the mob. One of them, Ernest Salyers, was released due to a heart condition; another, Clarence Miller, was let go after suffering a badly cut head.

While Lieutenant George sat on a table amid the screaming inmates, the remaining seven hostages were locked in cells on the second range of the block.[349] Conte told him that no harm would come to him as long as their demands were met.[350] Taken back to see the other hostages, George tried to reassure them. "Boys, they say they're not going to do anything to us." But he had his doubts. There were too many prisoners yelling for blood, too

many knives being flashed around and too many fights breaking out. George took a mental inventory of his men: Charles A. Hickman, Harley M. Reeves, Steve F. Huffman, Glen R. Moler, Paul L. Freshour, Harry R. Myers and Don A. Dilly. Another one, Paul L. Davis, was being held in the adjoining area, and the lieutenant was unsure whether he was alive or dead.[351]

When one of the inmates shouted, "We want to talk!" from a barred window in the besieged block, reporters hurried to it, despite a warning from the a guard, "Watch out." An inmate hollered back, "Leave 'em alone!" He then added, "We're gonna send you goddam guards out one by one—dead, dead, dead!" However, he also quickly reassured the reporters, "We ain't gonna bother you. Stay here and talk to us."

Complaints flooded from the window. The men claimed they weren't permitted to shower, shave or brush their teeth. They told of beatings and shootings, of being treated like "dogs." One said, "If we can't live with the remnants of our pride and our honor, we don't want to live." A handful of reporters cornered Warden Koloski and began peppering him with questions. In a moment of candor, they learned that there had been conflict between the new warden and some of his predecessor's staff on the treatment of inmates. "I try to look at the good side—the wholesome side of each man," Koloski said. "I want to try to motivate them to something better. We all know their bad side."

Within the walls, the bad side was showing. Sam George continued to sit uneasily on the table, unsure of his fate. Suddenly, an inmate, "Buggerbear" O'Neill, grabbed him by the arm. "Let's go see the reporters," he barked. "We got to tell 'em how rotten this place is." He led the officer to the window and held a knife against his gut. "I got Lieutenant George here," he shouted. "Now, if everybody in this here place was like Mr. George, I wouldn't care. Mr. George is all right. Why, he can walk outta here right now if he wants to."

Reluctantly, Koloski agreed to allow the media to meet with the inmates so they could air their grievances. Accompanied by Maury Koblentz, the warden led seven volunteer reporters and photographers to the entrance of A and B blocks. Upon their arrival, Armstrong and Conte laid out their demands on behalf of their fellow prisoners. In the thirty-five-minute interview, they sought amnesty for the riots, immediate dismissal of twelve "sadistic" guards or supervisors and an outside investigation by an impartial agency. They also demanded replacement of the state parole board members. If authorities failed to meet their demands by 3:00 p.m., the hostages would be burned alive.

Left to right, Warden Marion Koloski attempts to negotiate with inmate spokesmen Richard Armstrong and John Conte. *Courtesy of the Dailey Archives.*

While the inmates expressed their belief that the new warden was a good man, they felt they still were having to contend with the holdovers from Maxwell's regime.[352] "Our backs are to the wall," Richard Armstrong defiantly shouted in the warden's face. "We have to win all the way or lose all the way." The sound of inmates chanting "dead, dead, dead" disrupted the news conference. However, Conte repeated that guards would not be killed unless authorities attempted to rescue them.[353]

Koloski said he would do what he could. He offered amnesty for the current disturbance but could not do so for the earlier one. Furthermore, he knew of no federal agency that could undertake the requested investigation and stated that the make-up of the parole board was a matter for the legislature.[354] Hearing this, the inmates declined to surrender, and the conference was ended. "It's a stalemate," Chief Koblentz announced.

Hours passed. The disgruntled prisoners continued to argue among themselves. As darkness began to fall, large generators were brought into the

yard and giant searchlights swept the prison walls. Still seated on the table, an exhausted Sam George leaned back and attempted to get some sleep. During the night, Warden Koloski called Governor Rhodes, requesting National Guard support. By 7:00 a.m. the next morning, about 140 helmeted National Guardsmen, commanded by General Sylvester T. Del Corso, arrived at the prison.[355] "I hope we'll be able to get something settled quickly," Del Corso told reporters, "whether they release them or whether we have to go in and get them."[356]

Breakfast was sent in to the angry convicts: pancakes, syrup, sausage, bacon, juice and coffee. The first tray was delivered to Lieutenant George, who thought to himself, "At least if I die, it'll be on a full stomach." He noticed that the wildness had faded from his captors' eyes. The sight of the heavily armed troops had unnerved them. "What's all them soldiers doin' out there?" one asked. They seemed confused and agitated.[357]

What the inmates didn't realize was that they were at war. A plan of attack had been devised that drew on Del Corso's World War II experience while in the Philippines. Japanese forces had held the municipal building in Manila for five days against his troops. Finally, he had a dynamite charge put on the roof and another on a wall. First the roof charge was detonated to divert the enemy; then a hole was blown in the wall to allow access. The GIs stormed through the opening and took control of the building. It had worked more than twenty years earlier; he could see no reason why it wouldn't do so again.[358]

On August 21, 1968, the National Guardsmen began to make preparations for the placement of the plastic explosives. Their actions angered the prisoners. "What the hell are they doin' on the walls?" one anxious prisoner asked. As the demolition experts continued their work, the leaders of the revolt put Lieutenant George on the radio. "Tell somebody out there they better pull them troopers back now," he said. "These guys are ready to start business up here…now. They're not bluffing."[359]

At two o'clock in the afternoon, Rabbi Nathan Zelzer asked to speak with the rebellious prisoners. He urged them to surrender, but again, they declined. Dejected, he walked back to the door. "You must reconsider," he said sadly. "There isn't much time."[360] A half hour later, the warden sent a message of his own: "You have 15 minutes to release the hostages." Holding a knife to George's windpipe, a convict named Richard Carroll issued a warning of his own: "If they do try to blow the place, it's your neck!"[361]

Having figured out what the demolition team was up to, the convicts warned, "We've got every guard standing in the window and just as soon as one charge

goes off we're going to kill every one of them and then you'll have that on your conscience!"[362] Over the radio, George pleaded, "I'm begging for my life right now. There's no question about it, we know what's going to happen. They've got knives on us and they're going to kill us." The men jeered and cursed as seventy-five pounds of explosives were attached to the wall and fifteen pounds to the prison roof. Time was up; the fifteen-minute deadline had expired.[363]

Silence, and then: BOOM! BA-BOOM! The charges exploded, echoing through the complex. Moments before, two of the hostages had heard inmates running toward them, yelling that they had gasoline to "burn the bastards." The rooftop blast floored both of them.[364] The concussion also knocked Carroll backward and George to the side. Lying flat on the floor, eardrums ringing, the officer couldn't see through the smoke and dust. He started to get up to escape through the hole in the wall but realized he was apt to be shot by his rescuers. Instead, he crawled under a bench and waited for the air to clear. Gunfire and screams of panic punctuated the darkness.[365]

Nearly thirty-five years later, Colonel Robert M. Chiaramonte of the Highway Patrol recalled:

Planting the explosives, setting off the charge and storming through the opening. *Courtesy of the Dailey Archives.*

147

One thing that stands out is the Pen Riot in '68, when we blew a hole in the Pen roof and two men went down that hole. Lt. Verlin "Gene" Archer and Ptl. Stanley Erter were the ones who went down. That took more nerve than anything I can think of—climbing down a rope to confront the hostage takers, to keep them from killing the hostages. At the same time, a hole was blown in the wall and two groups of men, one under (Capt.) Stanley Adomatis and the other was under (S/Lt.) Gerald ('Jack') Forbes and they ran up six flights of steps to get into C and D blocks, where they were holding the hostages, and they shot down those corridors to get those convicts back in their cells so they couldn't kill them before they got there. There was lighter fluid and they had that on the floor where they could set it on fire to kill the hostages.[366]

Liberated hostages (from left to right) Harry Myers, Glen Moler, Stephen Huffman and Don Dilley breathe a sigh of relief in the hospital. *Courtesy of the Dailey Archives.*

Lieutenant George saw legs running past as troops stormed through the fifteen-by eight-foot hole, guerrilla style. "Hey!" he yelled. "Don't shoot!" The weary hostage started to get up. A city policeman, failing to recognize him, clubbed him to the floor with the butt of his gun. Another officer spotted him and helped him to safety. Above, troops dropped through the hole in the roof to free the remaining hostages. Below, in C and D, a prisoner had thrown himself atop guard Paul Davis to shield him from the blast, saying simply, "Better me than you."[367]

During the siege, there were up to seventy-one shotgun blasts and five machine gun bursts. Intermittent gunfire continued to echo through

Exhausted and wounded, former hostage Lieutenant Sam George is led away from the riot scene. *Courtesy of the Dailey Archives.*

the limestone corridors until 4:18 p.m.[368] Among the hostages, only Lieutenant George suffered injury, sustaining a cut above his right eye.[369] In addition, three guards, two Columbus police officers and two patrol officers were also injured. Five inmates, however, were shot dead: Wesley L. Neville Jr., Washington Court House; Thomas Bradshaw Jr., Toledo; Burton Anderson and Walter G. Baisden, Cleveland; and Jess Wade, Canton. Ten others were injured. One of them, Leo F. Sersick, was serving a life sentence for his role in the slaying of Glen Farmer, a guard at the Lima State Hospital, during a 1955 escape attempt.[370] Another, Edward T. Spaulding of Akron, was found with his throat slit but still alive, undoubtedly from an attack by one of the other convicts.

Just twenty-eight hours after it began, the 1968 riot had been crushed. It would be the last to take place in the Ohio Penitentiary, which was

closed in 1984. However, an even worse riot would take place twenty-five years later, when members of the Aryan Brotherhood and the Gangster Disciples took control of the Southern Ohio Correctional Facility in Lucasville on April 11, 1993—also Easter Sunday.

Chapter 16

The Rogues' Gallery

The term "Rogues Gallery" was popularized by New York City police inspector Thomas Byrnes. In 1886, he published a photograph collection of "professional criminals" that he used for witness identification purposes.[371] Among the many thousands of prisoners who passed through the Ohio Penitentiary, there are dozens whose mug shots would be included in any figurative Rogues' Gallery. They are the ones who will be forever associated with the prison that the inmates called "the Walls." Many of their stories have already been told in the preceding pages, but here are a few more.

Alphonso J. "Al" Jennings may have been many things, but modest wasn't one of them. An attorney turned outlaw (not much of a stretch, really), he assured his place in history by attaching himself to someone more famous: William Sydney Porter, better known as O. Henry. The extent to which he was friends with the acknowledged master of the short story will never be known. There is little to go on except Jennings's word, and that was always suspect. What's more, he waited until Porter was in his grave before he began spinning his yarns. Still, it cannot be disputed that they were fellow inmates at the Ohio Penitentiary and continued their association after they got out.

During the summer and fall of 1897, Jennings was the leader of a sorry gang of misfits who held up trains, general stores and even a post office, but with little to show for it. Wounded in a shootout with the law, he was sentenced to life in prison, later reduced to five years. In 1899, Al took up residence at the Ohio Penitentiary. Three years later, he was released on technicalities and

The leader of the original gang-that-couldn't-shoot-straight, Al Jennings went on to star in silent movies. *Courtesy of the Dailey Archives.*

then pardoned by President Theodore Roosevelt in 1904. He went on to enjoy success as a writer, silent film star and B-list celebrity. Ten years before he died, a Hollywood movie was made of his life, *Al Jennings of Oklahoma*, starring Dan Duryea. He passed away in 1961 at the age of ninety-eight, having outlived Porter by more than half a century.

After he became a licensed pharmacist at the age of nineteen, young Bill Porter took a trip out West in the hopes it would cure him of a persistent cough. He worked a variety of jobs from babysitter to ranch hand to journalist. Along the way, he began dabbling in short story writing. Hired as a teller and a bookkeeper at the First National Bank in Austin, Texas, he was later charged with embezzling less than $1,000. It was never clear whether he was truly a thief or simply careless. Alcohol could have been a factor.[372]

There's reason to believe that had Porter presented himself for trial, he would have been acquitted. However, he didn't, and he wasn't. Instead, he slipped off to Honduras. While in the port of Trujillo, he met an American citizen named Al Jennings. He was also on the run from the law, and by Jennings's account, they bonded immediately. Soon, they were tramping around South America together until Porter learned that his wife was ill. Upon returning to Austin in 1897, he surrendered to authorities. Depressed due to his wife's recent death, he offered little defense and was convicted largely on the fact that he had fled from justice. On March 25, 1898, Porter was sentenced to five years in the Ohio Penitentiary.[373]

When prison officials learned they had a registered pharmacist on their hands, Porter was assigned the job of drug clerk in the penitentiary hospital working for Dr. John M. Thomas. "In my experience of handling over ten thousand prisoners in the eight years I was physician at the prison," Thomas

A rare photograph of photo-shy William Sydney Porter, a.k.a. O. Henry. *Courtesy of the Dailey Archives.*

later recalled, "I have never known a man who was so deeply humiliated by his prison experience…He was a model prisoner, willing, obedient, faithful." He also was so skilled at his profession that he was permitted to treat the prisoners for minor ills.[374]

In one celebrated incident, Warden Elijah G. Coffin had been accidentally administered an overdose of Fowler's solution, an arsenic derivative. He fell unconscious, and it was feared he would die. Porter, who had been tending to a sick inmate, quickly took charge of the situation. "Be quiet, gentlemen," he said and then mixed up some ingredients from the pharmacy before forcing the concoction down the warden's throat. In an hour, Coffin was out of danger.

The following day, Porter was promoted to night drug clerk.[375] From midnight to dawn, he worked in the hospital with Dr. George W. Williard. One night, Williard angered a prisoner by refusing to give him a drug he

wanted. When the man responded with "a fearful torrent of profanity," Porter "went over his counter liker a panther and punched the man in the jaw, knocking him to the floor"—or so Jennings would later record.[376]

In his spare time (of which there was plenty on the night shift), Porter resumed his writing. His earliest stories were published under the name Sydney Porter, but it was as O. Henry that the world first took notice of him. He used other pen names as well, including Olivier Henry. In time, he was recognized for his witty wordplay, sympathetic characterization and clever endings. In all, fourteen stories saw print while he was in prison, and according to Jennings, he provided his friend with the inspiration for more than a few.[377]

The year after Porter was committed to the penitentiary, Jennings joined him. "My arrival had been heralded by every newspaper in the State," Jennings wrote. "Every man in the prison knew it." He claimed that he was able to finagle a cell on "Bankers' Row"—a cellblock set aside for privileged inmates, mostly high financiers, who had committed white-collar crimes. "They had mirrors, a curtain on the door and a carpet on the floor." However, he wanted a job in the hospital, too, and Porter promised to do what he could.[378]

As the weeks went by and he heard nothing further, Jennings began to think that his old pal had forgotten about him. So he tried to escape and was placed in solitary confinement for fourteen days. When he refused to divulge where he had obtained the saw blades he used, the deputy warden ordered that he be given seventy-five lashes. Jennings claimed that he sprang at the man and had to be restrained by the guards. Fearing for his life, the deputy warden allegedly decided to forgo any corporal punishment but reduced Jennings's status to the fourth grade, dressed him in a striped suit, placed him in the lockstep gang and sent him to work in the bolt shop. Eventually, he was given a job in the post office, where the chief clerk was another train robber, Billy Raidler.[379]

The three of them—Jennings, Raidler and Porter—spent a lot of time in each other's company, swapping tales, some of which later figured in O. Henry's stories. For example, one of his most famous characters was Jimmy Valentine, who first appeared in the short story, "A Retrieved Reformation." It concerns a safecracker recently released from prison who is pressed into service to open an airtight safe in which a small child was accidently locked. If Jennings is to be believed, something similar actually happened to an inmate named Dick Price, only it wasn't a child but a collection of incriminating documents he was asked to liberate from a safe in the office

of the *Columbus Press-Post* newspaper. Jennings wrote that Price sanded down his fingertips until they bled so he could feel the tumblers fall into place and crack open the safe. Although he was promised a pardon if he succeeded, Governor George K. Nash turned it down. In the end, Price didn't care because, "I did it for you, Al," (or so Jennings quoted him saying). And then he died not long afterward.[380]

However, Dr. George W. Williard, the night doctor at the penitentiary, believed the model for Valentine was another inmate, James "Jimmy" Connors. His real name was John Berlo Jr., and he was the son of a successful Mansfield businessman. Committed in 1897 for robbing a post office safe in Excello, Ohio, he was Porter's counterpart on the day shift in the hospital. Williard said the two men were friendly and often talked in the evenings. Although he admitted to many other crimes, Berlo steadfastly denied blowing the safe. The sheriff who arrested him later discovered he had apprehended the wrong Jimmy Connors and endeavored to secure his freedom, spending $300 of his own money in the effort. (The real culprit was already serving time at the OP under the name "Melrose.") As was the case in Jennings's tale, Connors/Berlo died unpardoned on May 19, 1902 (he had kidney trouble). However, Porter had already been released by then.

On another occasion, Jennings wrote that Porter expressed a desire to interview someone who was facing death. As secretary to the warden, Al arranged for Porter to talk to a seventeen-year-old inmate on death row that he called "the Kid." Al related that the Kid was convicted of murdering a friend by drowning him in the Scioto River. Three weeks later, a decomposed body washed up and was identified by the boy's parents on the basis of a birthmark. Since the two men had been seen quarreling—and the Kid was heard to say, "I'll drown you for this!"—it was an open-and-shut case. However, the defendant insisted they had just been "funnin'." Porter was deeply troubled by his meeting with the Kid. Jennings quoted him as saying, "If I thought much about this affair of today I would lose all faith, all happiness." Sometime after Bill Porter had been released from prison, the purported murder victim, "Bob Whitney," turned up in Portsmouth, Ohio. The "shocking truth" was that the state had executed an innocent man—or so Jennings insisted.[381] But there are several problems with Jennings's tale of the Kid.

Porter was confined at the OP from March 25, 1898, to July 24, 1901. During this time, the following inmates were put to death: Frank Early, Charles Nelson, Bruno Kirves, Richard Gardner, Roslynn Ferrell and Edward Ruthven. By no stretch of the imagination were any of them a "kid" nor were

"Bugs" Moran at the height of his power (left) and after his ten years in the Ohio Penitentiary (right) *Courtesy of the Dailey Archives.*

any of them convicted of drowning anyone. Early shot and killed his wife. Nelson beat a man to death with a hammer. Kirves slayed his twenty-two-year-old daughter. Gardner murdered a little girl. Ferrell cut down a former co-worker in cold blood. Ruthven shot a police officer to death. There were no executions the following year when Jennings gained his release. A seventeen-year-old Carl Berg was sent to the electric chair two years later in 1904, but his crime was the shooting death of a tramp (and Berg may have actually been several years older). So clearly Jennings exercised considerable artistic license in writing about an incident that, at the very least, was not part of his experience nor Porter's and, possibly, no one else's.

Once he was a free man, Porter succumbed to alcoholism, and his health swiftly declined. Nine years later, in 1910, he died at the age of forty-seven. Four years after that, Jennings published his first book about their adventures.

With the arrival of Prohibition in 1920, the era of the gangster began to supplant the era of the outlaw. Although the terms are often used

interchangeably, a gangster generally engages in organized crime. Al Jennings, for example, may have committed crimes, but in no way could they be considered "organized." George Clarence "Bugs" Moran, on the other hand, was a Prohibition-era mobster who lost seven members of his gang to rival Al Capone in the St. Valentine's Day Massacre of 1929.[382] Credited with popularizing drive-by shootings, he had seen better days by the time he was sentenced to the Ohio Penitentiary for the 1946 robbery of a bank messenger. He served ten years for a crime that netted him a measly $10,000. Upon his release in 1956, he got sent up for another ten years, this time to Leavenworth. However, he died the following January and was buried in the prison cemetery.

While Bugs may have been the most notorious gangster to cool his heels behind the walls of the Ohio Penitentiary, he wasn't the most influential. That distinction is reserved for Thomas "Yonnie" Licavoli, who with his brother, Peter, and their cousin James, eventually controlled all the criminal operations in Detroit. A member of the legendary Purple Gang, he became well known for his extreme brutality in dealing with rival gangsters. "Scarface" Capone was even afraid to cross him.

After serving three years in a Canadian prison for carrying a concealed weapon, Yonnie set his sights on expanding from Detroit into Toledo. However, local bootlegger John Kennedy Sr. had other ideas. A gang war erupted. When Kennedy was found dead in July 1933, Licavoli, Sarafino "Wop" Sinatra and Jacob "Firetop" Sulkin were charged with conspiracy to commit murder. In 1934, Yonnie began serving a life sentence at the OP. Almost immediately, he began currying favor with Warden Preston Thomas. Within less than a year, matters had gotten so far out of hand that the warden was compelled to leave office. Apparently, a number of Toledo underworld figures were being permitted to meet with him regularly to get their marching orders.[383] Thomas's replacement, Warden James C. Woodard, was also denounced for granting special privileges to Licavoli and several other high profile inmates, leading to his removal from office in 1939.[384]

With the outbreak of World War II, Licavoli wrote a letter to a Columbus newspaper urging that prisoners with good records be allowed to fight. Warden Frank D. Henderson had, in fact, formed a prisoner "defense legion" at the Ohio Penitentiary that was undergoing military training (presumably without rifles).[385]

It was also revealed that Yonnie had become a songwriter under the pseudonym Tommy Thomas, turning out some forty-five songs in the span of four years. Among the numbers he "sold" to Valjean Music Company

Mobster Thomas "Yonnie" Licavoli before and after serving thirty-seven years in prison. *Courtesy of the Dailey Archives.*

in McAlester, Oklahoma, were "It Was Nice," "Recipe for Love," "Homesick for Old New York," "Alone with My Tears," and "I Wonder If You Care."[386] Licavoli admitted he didn't know one note from another, so he had to work with a collaborator, humming the tunes while another inmate wrote them down. He said that Joe Glaser, a mob-connected dealmaker who managed Louis Armstrong and Billie Holiday among others, was working on his behalf. "I'm counting on him to make my songs click," he said.[387]

In 1958, Licavoli made the news yet again when allegations hit the newspapers that he was receiving preferential treatment. Warden Ralph W. Alvis denied the reports, dismissing them as "just foolish" and "grossly exaggerated." But in reaction to the bad press, Alvis had him moved back to the Ohio Penitentiary from the Hocking Honor Camp.[388] Soon, Licavoli became well known for his newest hobby: stamp collecting. According to inmates who were imprisoned with him, he instructed those working in the records office to remove all the stamps from correspondence kept on file and pass them along to him. Some of these letters dated back to the Civil War.

When Yonnie had his sentence commuted from first- to second-degree murder in 1969, he became eligible for parole. Governor James A. Rhodes was heavily criticized for this action. "The Governor and the Mob," a 1970 article in *Life* magazine, intimated that money may have changed hands. It also charged that Licavoli still controlled the numbers racket in Toledo from his prison cell. When Rhodes later ran for the U.S. Senate, he was defeated in the Republican primary, possibly because of his association with Licavoli. The following year, Yonnie was paroled due to poor health. He settled in Gahanna, Ohio, with his wife and daughter and opened a stamp shop. He died on September 17, 1973.

If you hang around enough murderers, you'll come to see that they are not all the same. The husband who kills his wife in a fit of passion (or vice versa) is a different animal from the one who hires another to do the deed. (And will, no doubt, occupy a different level of hell.) But worse than either one is the person who takes the job: the contract killer. Take Patrick Eugene McDermott. An ex-con from Nanty Glo, Pennsylvania, McDemott gunned down Don R. Mellett on July 25, 1926, in the driveway of his home, after the newly appointed newspaper editor published the following declaration: "It is the opinion of the *Daily News* that Canton needs cleaning up. Bootlegging, gambling and houses of prostitution are running wide open in flagrant violation of the law."[389]

During the next six months, Mellett's campaign against the unholy alliance between the city's police chief, S.A. Lengel, and the local mob escalated. Floyd Streitenberger, a police detective, devised a plan to scare the crusading editor away. However, it went awry, and Mellett died. Because of the limitations of forensic science at the time, it could not be determined which of the six to twelve shots killed him, but it is likely McDermott was the triggerman. Five men were ultimately convicted on charges stemming from the murder, including Louis Mazer, a Massillon bootlegger. However, despite being fingered by both Streitenberger and Mazer, Police Chief Lengel went free. McDermott, on the other hand, kept his mouth shut. Meanwhile, Mellett was awarded the Pulitzer Prize, posthumously.

In 1929, two years after he began serving a life sentence, McDermott and four other inmates escaped from the Ohio Penitentiary by slipping out of their cells, making their way through a utility tunnel into a ventilation shaft and climbing up to an attic. They then made their way over the roof of the warden's residence during a driving snowstorm before using a ladder they fabricated out of bedding material to reach the ground. However, McDermott was captured eighteen hours later, hiding in the

power building of a stone quarry five miles away.[390] During the riot that followed the Easter Monday fire the following year, he was a member of Troop K and directed other inmates to calm down. Three years after that, McDemott failed in an attempt to hang himself. Apparently, prison life was starting to get him down.

When Streitenberger and McDermott came up for parole in 1948, the board refused to reduce their sentences from first- to second-degree murder. It felt that they "were not deserving of clemency and were lucky to have escaped the electric chair."[391] For the next six years, McDemott bided his time, becoming a prison trusty. Then in November 1954, he simply walked away from the penitentiary, dressed in civilian clothes, in the company of a visitor who had identified herself as "Nancy Mack." Three months after he escaped, the "cold-blooded assassin" was added to the FBI's Ten Most Wanted list. During McDermott's absence from the OP, Warden Ralph Alvis told the newspapers he was holding eighty dollars for him—payment from a publisher for some of the crossword puzzle designs he had submitted before he escaped. Finally, in July 1955, he was spotted by a policeman at

Patrick McDermott at his 1926 trial (left) and after his 1955 capture following his escape. *Courtesy of the Dailey Archives.*

New York's Jewish Memorial Hospital, where he was working under the name "Steve Garish." He had been given a job as an ambulance attendant and was living the Bronx with a "Rose Bern."[392]

Of the five men convicted for the murder of the newspaper editor, McDermott was the last to die, passing away on New Year's Day 1972 at the Lima State Hospital. A hard case right up to the end, he refused an interview request by a Dayton reporter shortly before his death, citing the advice given to him by his Canton attorney in 1926: "Never talk to a newspaper."[393]

In this book, we have attempted to convey an idea of what life was like within the storied walls of the Ohio Penitentiary by highlighting some of the more sensational incidents that took place there. What we do not want to lose sight of, however, is that not everyone was an irredeemable rogue. Most of those who entered it left again, never to return. Many went on to assume a place in society as husbands and fathers, citizens and breadwinners, neighbors and friends. In fact, it wouldn't be at all surprising if you knew one. We do.

Notes

CHAPTER 1

1. There had been earlier executions, such as Chief Leatherlips for witchcraft in 1810 and Private William Fish for desertion in 1812, but this was the first one conducted in accordance with the laws of Ohio. Leatherlips was put to death by other chiefs of the Shawnee Tribe and Fish by order of Major General (later president) William Henry Harrison.
2. Daniel J. Morgan, *Historical Lights and Shadows of the Ohio State Penitentiary* (Columbus: Hann & Adair Printers, 1899).
3. *Ohio State Journal*, February 9, 1844.
4. Foster is generally regarded as the first woman hanged in Ohio. In 1632, however, one Jane Champion was hanged in the Virginia Colony. Some sources suggest she was a slave who murdered her master's children.
5. *Ohio State Journal*, February 15, 1844.
6. Andrew Welsh-Huggins, *No Winners Here Tonight: Race, Politics, and Geography in One of the Country's Busiest Death Penalty States* (Athens: Ohio University Press, 2009).
7. The same year a law was passed moving all executions to the Ohio Penitentiary.
8. Sells was buried in Section R of Green Lawn Cemetery.
9. Charles C. Cole Jr., "The Last Public Hanging," *Columbus Monthly* (December 1993).
10. Victor L. Steib, *The Fairer Death: Executing Women in Ohio* (Athens: Ohio University Press, 2006).

11. Morgan, *Historical Lights*.
12. He was also a relative of John Sells who had tried to save Chief Leatherlips.
13. *The "Old Northwest" Genealogical Quarterly* 10 (1898).
14. Swan and Heyl were also buried in Green Lawn Cemetery.
15. Heyl later quit the law and founded a school for young ladies called the Esther Institute in a large building he constructed on Broad Street between Third and Fourth Streets. It was named after not Esther Foster but his own wife. Despite being highly renowned, the school failed financially. It later became the site of the Columbus Athletic Club.
16. Morgan, *Historical Lights*.
17. *Ohio State Journal*, February 9, 1844.
18. He died on October 6, 1844, and was buried at Green Lawn Cemetery, Section G, lot number twenty-three. Domigan was a friend of the Sells family and attended meetings of the Wyandotte Club held at the Sells farm.
19. Charles Chester Cole, *A Fragile Capital: Identity and the Early Years of Columbus, Ohio* (Columbus: Ohio State University Press, 2001).
20. Alfred E. Lee, *History of the City of Columbus* (Chicago: Munsell, 1892).
21. Robin Smith, *Columbus Ghosts* (Worthington, OH: Emuses, Inc., 2002).

CHAPTER 2

22. The island is, technically, located in West Virginia, but the fighting commenced on the Ohio shore.
23. Flora E. Simmons, *A Complete Account of the Raid of John Morgan Through Kentucky, Indiana, and Ohio* (Flora E. Simmons, 1863).
24. *(Cedar Rapids, IA) Evening Gazette*, March 2, 1883.
25. *New York Times*, August 7, 1863.
26. Faunt Le Roy Senour, *Morgan and His Captors* (Cincinnati, OH: C.F. Vent & Company, 1863).
27. *Semi-Weekly (Milwaukee) Wisconsin*, December 5, 1863.
28. Clint Johnson, *A Vast and Fiendish Plot* (New York, NY: Citadel, 2010).
29. *New York Times*, December 29, 1898.
30. Ibid., December 8, 1907.
31. *Iowa City Citizen*, June 24, 1911.

Chapter 3

32. Forty years later, Charles Fort provided a slightly garbled version in *Wild Talents* (New York: Claude Kendall, 1932).

33. Robert Damon Schneck, *The President's Vampire*. (San Antonio, TX: Anomalist Books, 2005).

34. Brian M. Thomsen, *Oval Office Occult: True Stories of White House Weirdness* (Kansas City, KS: Andrews McMeel Publishing, 2008).

35. *Richmond Dispatch,* June 27, 1885.

36. The rat purportedly was one of several pets kept by the keeper of the Catholic Chapel who had trained them to crawl into his pockets to get food, see Morgan, *Historical Lights*.

37. Gump would also tangle with John Atkinson, one of the so-called prison demons.

38. *Cedar Rapids Evening Gazette*, February 2, 1893.

Chapter 4

39. William G. Benham, *The Laws of Scientific Hand Reading* (New York: G.P. Putnam's Sons, 1901).

40. Born in 1962, he was the son of William Marlatt and Louisa Maneker or Mancker.

41. R. Max Gard, "Murder At Bells' Mill," *Farm & Dairy* (May–June 1954).

42. *Spirit of Democracy* (Woodsfield, Ohio, October 29, 1891).

43. Charles Edward Russell, "Beating Men to Make Them Good," *Hampton's Magazine* (October 1909).

44. In those days, inmates could purchase higher quality food from vendors who were allowed into the prison at night.

45. *Marietta Daily Leader,* July 14, 1896.

46. Al Jennings, *Beating Back* (New York: D. Appleton & Co., 1911).

47. *(Maysville) Daily Public Ledger*, October 5, 1896; *(Maysville) Evening Bulletin*, October 5, 1896.

48. Inmates of prisons and mental institutions used to be punished by being placed in a tub and held under water for prolonged periods of time; *Marietta Daily Leader*, November 25, 1896.

49. Morgan, *Historical Lights*.

50. *Columbus Citizen*, April 6, 1899.

51. *Akron Daily Democrat,* July 25, 1899.

52. *Marietta Daily Leader,* July 25, 1899.

53. *(St. John's, Newfoundland) Evening Telegram*, August 9, 1899.
54. *Kansas City Journal*, July 27, 1899.
55. Al Jennings, *Through the Shadows With O. Henry* (New York: H.K. Fly Co., 1921).
56. Jennings, *Beating Back*.
57. Ibid., *Through the Shadows*.
58. Jennings may be confusing him with Marlatt's fellow "demon," John Atkinson.
59. *Columbus Citizen*, December 9, 1904.
60. Ibid., December 26, 1906.
61. *(Hillsboro) News-Herald*, August 12, 1909.
62. *Mahoning Dispatch*, September 18, 1914.
63. *Columbus Evening Dispatch*, October 25, 1910.
64. *Mahoning Dispatch*, April 12, 1912.
65. *Newark Daily Advocate*, October 2, 1914.
66. *Evening Independent*, August 30, 1915.
67. *(Lima) Times-Democrat*, March 2, 1916.
68. *(Sandusky) Star Journal*, June 14, 1929.

Chapter 5

69. *Columbus Press Post*, September 11, 1898.
70. *Marietta Daily Leader*, March 28, 1899; *New York Times*, March 28, 1899; *Columbus Citizen*, March 27, 1899.
71. *Akron Daily Democrat*, July 14, 1899.
72. *Marietta Daily Leader*, April 07, 1899; *News-Herald*, April 13, 1899.
73. *Akron Daily Democrat*, July 13, 1899; *Maysville Daily Public Ledger*, July 13, 1899.
74. *Columbus Post Press*, July 21, 1899.
75. Ibid., July 25, 1899.
76. *Akron Daily Democrat*, July 28, 1899.
77. *Marietta Daily Leader*, August 04, 1899.
78. *Norfolk Weekly News*, December 07, 1899.
79. *Stark County Democrat*, December 05, 1899.
80. *Marietta Daily Leader*, February 06, 1901.
81. *Akron Daily Democrat*, January 07, 1902.
82. *Ohio Democrat*, August 07, 1902.
83. *Columbus Post Press*, August 19, 1904.

84. *Akron Daily Democrat*, August 20, 1902

85. *Mahoning Dispatch*, November 27, 1908; *Columbus Dispatch*, November 23, 1908.

86. Developed by Alphonse Bertillon, a French criminologist, the Bertillon system consisted of a series of physical measurements of various parts of the body used to produce a detailed description of a person.

87. *Marion Daily Mirror*, May 22, 1911; *Democratic Banner*, May 23, 1911.

88. *Marion Daily Mirror*, June 15, 1911.

89. *Democratic Banner*, September 12, 1911.

90. *Marion Daily Mirror*, October 21, 1911.

91. An Oregon boot is an iron shackle, weighing from five to twenty-eight pounds, that encircled the ankle and attached to the heel of a boot.

92. *Democratic Banner*, February 13, 1912.

93. Ibid., January 03, 1913.

94. *Perrysburg Journal*, May 30, 1913.

95. *Xenia Daily Gazette*, May 30, 1913.

96. Ibid., January 21, 1916.

97. *Newark Daily Advocate*, January 28, 1916. Hurley had fled Lima in the company of another inmate, an African American man named Tom Sawyer.

98. *Xenia Daily Gazette*, March 31, 1916.

99. *(Cincinnati) Labor Advocate*, September 23, 1916.

100. *(Maysville) Public Ledger*, September 15, 1916.

101. *Xenia Evening Gazette*, May 4, 1918.

102. *Mansfield Shield*, May 3, 1918.

CHAPTER 6

103. The assailant, Ralph Weshon, was sentenced to fifteen years in the Ohio Penitentiary.

104. The newspaper accounts were consistently inconsistent in the spelling of their names: O'Neal, O'Neil and O'Neill. To reduce confusion, we have chosen to differentiate them as Frank O'Neal and James O'Neil, although neither may be correct.

105. *Ohio State Journal*, November 18, 1898.

106. Clarence Troyer, *History of Villages, People, Places in Eastern Holmes County* (Berlin, OH: Berlin Printing 1975).

107. Some 117 guards and prison officials attended Lauderbaugh's funeral in Mount Vernon.

108. Because of his erratic and menacing behavior, O'Neal became the first inmate placed in the annex to the death chamber before receiving a death sentence, according to an article in the *Ohio State Journal*.
109. *Columbus Citizen*, March 1, 1899.
110. The day after his conviction, Atkinson was waxing philosophical in a conversation with a *Columbus Citizen* reporter. He was quoted as saying, "I tink I've seen some funny tings in my life, but dere's some blokies around dis jug dat beats de record. Say, you'd laugh yourself into a fit if you seen some of de geesers dat comes to them prayer meetin's."
111. *Perrysburg Journal*, March 11, 1899.
112. *Columbus Citizen*, April 4, 1899.
113. *New York Tribune*, January 9, 1887. Carroll secured several patents while an inmate and was responsible for inventing the steam heating system used in the penitentiary.
114. *Columbus Citizen*, April 7, 1899.
115. Ibid., March 14, 1899.
116. Ibid., March 8, 1899.
117. *Marietta Daily Leader*, April 6, 1899.
118. Ibid., April 07, 1899.
119. *(Washington D.C.) Evening Times*, August 2, 1899.
120. Ibid., September 16, 1899.
121. *Marietta Daily Leader*, September 17, 1899; *Ohio State Journal*.
122. Inmates who exhibited good behavior would have their sentences reduced by so many "good time" days.
123. *Akron Daily Democrat*, December 5, 1899; *Stark County Democrat*, December 5, 1899.
124. *Columbus Citizen*, March 25, 1904.
125. Robert McKay, for one, became a novelist, noted for the young adult books *Canary Red* (1968) and *Dave's Song* (1969), the latter a Junior Literary Guild selection.
126. *New York Times*, "Jon Jonson and His Pigeons Parted," June 10, 1894. As far back as 1884, inmate Jon Jonson was known as "the old pigeon man" for raising the birds at the Ohio Penitentiary.
127. "Training Canaries in a Death Chamber," *Popular Mechanics* (February 1913).
128. *Arizona Republican*, December 4, 1911.
129. His name was actually William N. Darby.

CHAPTER 7

130. *Yonkers New York Herald Statesman*, March 18, 1933.

131. Glick passed away in 1919 due to heart disease.

132. Daniel Frank was hanged in Virginia on March 1, 1622, for cattle theft. Even most "witches" were hanged, not burned.

133. Edison had embarked on a campaign to convince the public that AC current was too dangerous; he favored DC.

134. Nine years later, on March 20, 1899, New York's electric chair claimed its first female victim, Martha M. Place, for the murder of her stepdaughter.

135. In 1878, penitentiary officials had begun using electrical shocks from an induction coil, nicknamed the "hummingbird," to punish inmates while they sat naked and blindfolded in a tub of water.

136. Inmates always did the "grunt work," supervised by prison staff.

137. *Columbus Citizen*, September 18, 1906.

138. For some reason, H.M. Fogle in *Palace of Death* wrote that Frantz died in "one brief minute."

139. *Columbus Dispatch*, November 19, 1897.

140. F.O. Marsh, MD, "Some Medical Aspects of Capital Punishment," *Ohio State Medical Society: Transactions of the Fifty-Third Annual Meeting Held at Columbus, Ohio, May 4, 5, 6, 1898* (Cleveland, OH: J.B. Savage Press, 1898).

141. Early was the first African American to die in Ohio's electric chair.

142. *Western Electrician* 22 (May 21, 1898).

143. David Meyers and Elise Meyers Walker, *Historic Columbus Murders: Mama's in the Furnace, the Thing and More* (Charleston, SC: The History Press, 2010).

144. Cleveland Police Inspector Rowe purchased an old Dresden clock from Ruthven's estate only to find that it would stop every morning at the exact time of his execution.

145. *Columbus Citizen*, "Schiller as Visitor Sat in Death Chair," June 17, 1904. As a visitor to the Ohio Penitentiary on July 30, 1903, Schiller asked to be strapped into the death chair so he could see "how it felt."

146. Ibid., June 28, 1904.

147. Ibid., June 18, 1904.

148. Ibid., June 17, 1904.

149. *Hillsboro News Herald*, "Moses Johnson Electrocuted: Five Shocks Were Administered Before He Was Pronounced Dead," June 23, 1904. Five shocks were also reported by the *Columbus Evening Dispatch*, but the *Columbus Citizen* reported only four.

150. H.M. Fogle, *Palace of Death* (Columbus, OH: Self-published, 1909).

151. "Fisher" was an alias; his true name was never known.
152. Hugh C. Weir, "The Menace of the Police V: Substituting Brains for Clubs," *Hearst's International* 19 (1910).
153. October 28, 1904.
154. *Washington (D.C.) Times*, November 25, 1904.
155. *Animosa (IA) Prison Press*, September 3, 1904. Hershey passed away on August 21 "due to the rupture of an abdominal aorta into the stomach."
156. *Bluffton Chronicle*, "Herman Hamilton Electrocuted," March 29, 1905.
157. *Emporia Gazette*, March 21, 1907. Haugh was to be weighed immediately before and after his execution to determine the weight of his soul, the assumption being that the man who killed his mother, father and brother actually had one.
158. *Marion Daily Mirror*, July 19, 1907.
159. Ibid., November 1, 1907. Fowler had to remind them to slit his trouser leg so that the electrode would be in direct contact with his skin.
160. Earl only had one arm, having intentionally cut the right one off in a machine to avoid work during a previous prison stay.
161. *Utica-Herald Dispatch*, September 2, 1910. Swan was able to bid farewell to his accomplice, Della McKinley, since she was serving a life sentence in the Female Annex.
162. *Columbus Evening Dispatch*, October 29, 1909.
163. David Meyers discussed the case of Charles Justice in "Death By Handiwork" on the Discovery Canada series, *Curious and Unusual Deaths*, 2012.
164. Michael V. DeSalle, *The Power of Life or Death* (New York: Random House, 1965).
165. Ibid.
166. Ibid.
167. *To Abolish the Death Penalty: Hearings Before the Subcommittee on Criminal Laws and Procedures* 91–92, on S. 1760, March 20, 21, and July 2, 1968.

Chapter 8

168. The Ohio Reform Farm opened for boys in 1858.
169. This was actually the third penitentiary, the first having been built in 1815 and the second in 1822.
170. *Columbus Dispatch*, October 28, 1984.
171. Morgan, *Historical Lights*.

172. Julian H. Matthews, *Historical Reminiscences of the Ohio Penitentiary* (Columbus, OH: C.M. Cott & Company, 1884).

173. *Reports of the Prison Discipline Society, 1836–1845* (Boston, MA: Press of T.R. Marvin, 1855).

174. Sarah M. Victor, *The Life Story of Sarah M. Victor* (Cleveland, OH: Williams Publishing Co., 1887).

175. *Connersville Daily News*, June 27, 1901.

176. *Greenville Evening Record*, November 20, 1901.

177. She is buried at Mount Calvary Cemetery in Columbus.

178. The phrase "Crime of the Century" was used so frequently it became idiomatic.

179. Amanda Thomas is buried in Columbus's Union Cemetery with her parents.

180. *Columbus Monthly*, August 2008.

181. Cardwell was nicknamed ".38 Shorty" by the inmates.

182. Ysabel Rennie died in Connecticut on July 19, 2006.

CHAPTER 9

183. A rolling pin may have been missing as well.

184. *New York Daily News*, March 25, 2008.

185. *Joplin News Herald*, March 13, 1926.

186. *Piqua Daily Call*, March 13, 1926.

187. Peter Levins, "Murder Before Breakfast," *American Weekly* (February 17, 1946).

188. *(Zanesville) Time Recorder*, February 2, 1945.

189. *Woodbridge Leader*, May 7, 1928.

190. *(Xenia, OH) Evening Gazette*, September 25, 1926.

191. Ibid., January 14, 1935.

192. *Piqua Daily Call*, March 2, 1926.

193. Well over $100,000 in 2013.

194. *Piqua Daily Call*, March 1, 1926.

195. Sumner is credited with the first use of the expression "my two cents' worth" in a 1926 article.

196. *Bismarck Tribune*, June 25, 1929.

197. Meyers and Walker, *Historic Columbus Crimes*.

198. *Hamilton Journal*, April 5, 1954.

Chapter 10

199. *Athens Messenger*, April 22, 1930.

200. *Appleton Post Crescent*, April 22, 1930.

201. Richard Barrett, *Columbus and Central Ohio Historian*, November 1984.

202. *Sandusky Register*, March 11, 1928.

203. *Athens Messenger*, April 22, 1930.

204. *Appleton Post Crescent*, April 22, 1930.

205. *Albuquerque Journal*, April 22, 1930.

206. *Athens Messenger*, April 22, 1930.

207. *Zanesville Times Recorder*, April 23, 1930.

208. *Dunkirk Evening Observer*, April 22, 1930

209. *Athens Messenger*, April 22, 1930.

210. *Albuquerque Journal*, April 22, 1930.

211. *Lima News*, April 22, 1930.

212. *Albuquerque Journal*, April 22, 1930.

213. *Appleton Post-Crescent*, April 22, 1930.

214. Ibid.

215. *Athens Messenger*, April 22, 1930

216. *Cleveland Plain Dealer*, April 22, 1930.

217. *Massillon Evening Independent*, November 26, 1924.

218. While playing with the Cincinnati Reds, Ewing compiled an earned run average of 2.37—the best career ERA record ever compiled by a Reds pitcher.

219. *Xenia Evening Gazette*, January 1, 1925.

220. *Elyria Chronicle Telegram*, May 4, 1926.

221. *Sandusky Register*, November 10, 1926.

222. Interview with James Loeffler, whose father, William, was one of the reserves.

223. *Ellensburg Daily Record*, April 22, 1930.

224. *The Pittsburgh Press*, April 22, 1930.

225. *Findlay Republican Courier*, February 26, 1934.

226. *Ellensburg Daily Record*, April 22, 1930.

227. *Athens Messenger*, April 22, 1930.

228. *Ellensburg Daily Record*, April 22, 1930.

229. *Zanesville Times Optic*, February 5, 1929.

230. Edmond Ceslas McEniry, *Hero Priest of the Ohio Penitentiary Fire* (Somerset, OH: Rosary Press, 1934).

231. *Cumberland Evening Times*, April 23, 1930.

232. *Pittsburgh Press*, April 22, 1930.

233. *Sandusky Star Journal*, May, 5, 1933.

234. Oscar Wilde, *The Ballad of Reading Gaol* (1898):
So with curious eyes and sick surmise
 We watched him day by day,
 And wondered if each one of us
 Would end the self-same way,
 For none can tell to what red Hell
 His sightless soul may stray.

235. Chester Himes, *Yesterday Will Make You Cry* (New York: W.W. Norton, 1999).

236. *Columbus Evening Dispatch*, April 22, 1930.

237. *Gettysburg Times*, April 20, 1935.

Chapter 11

238. Robert Cromie and Joseph Pinkston, *Dillinger: A Short and Violent Life* (Evanston, IL: Chicago Historical Bookworks, 1990).

239. Jeffery S. King, *The Rise and Fall of the Dillinger Gang* (Nashville, TN: Cumberland House Publishing, 2005).

240. Martha Jane Makley, an aunt (and great-aunt) by marriage of two of the authors, David Meyers and Elise Meyers Walker, was Charles Makley's cousin.

241. Cromie and Pinkston, *Dillinger.*

242. John Wilson Behm and his daughter, Leora, subsequently discovered a Dillinger escape vehicle that had been abandoned in the woods near New Bremen. Behm was the maternal grandfather and great-grandfather, respectively, of David Meyers and Elise Meyers Walker.

243. *Lima News*, October 13, 1933.

244. *(Massillon) Evening Independent*, March 9, 1934.

245. Ibid.

246. G. Russell Girardin and William J. Helmer, *Dillinger: The Untold Story.* Anniversary ed. (Bloomington: Indiana University Press, 2009).

247. *El Paso Herald Post*, January 26, 1934.

248. *Joplin (Missouri) Globe*, January 31, 1934.

249. *Hammond (Indiana) Times*, February 1, 1934.

250. *Monessen (Pennsylvania) Daily Independent*, February 6, 1934.

251. *Lima News*, February 14, 1934.

252. *Zanesville Times Recorder*, January 27, 1934.

253. *Sandusky Register*, March 4, 1934.

254. Ibid.

255. Ibid.
256. King, *Rise and Fall.*
257. *Zanesville Sunday Times-Signal*, March 25, 1934.
258. Ibid.
259. *Lima News*, March 16, 1934.
260. Ibid., March 25, 1934.
261. Ibid., March 27, 1934.
262. Ibid.
263. *Piqua Daily Call*, April 21, 1934.
264. *Hammond Times*, April 21, 1934.
265. *(Albert Lea, MN) Evening Tribune*, April 28, 1934.
266. *(Danville, VA) Bee*, April 30, 1934.
267. *Sandusky Register*, May 9, 1934.
268. *Lima News*, April 1, 1934.
269. *Sandusky Star Journal*, July 5, 1934.
270. *Brainerd (MN) Daily Dispatch*, July 9, 1934.
271. *Sandusky Register*, July 24, 1934.
272. *Sunday Times-Signal*, September 25, 1936.
273. *New Castle (PA) News*, September 22, 1934.
274. *Lima News*, October 16, 1934.
275. *Sandusky Register*, September 23, 1934.
276. *Lima News*, October 17, 1934.
277. *Sandusky Star-Journal*, September 27, 1934.

Chapter 12

278. Rohrbach's first name has been reported variously as Lebannan, Labanna and Labannan.
279. *Massillon Evening Independent*, October 21, 1930.
280. Ibid.
281. *Toledo Blade*, May 15, 1951.
282. *Mansfield News-Journal*, October 4, 1940.
283. *Findlay Republican Courier*, October 4, 1940.
284. Kumerle is reported as Kuemmerle, Keummerle or Kuemerle.
285. *Sandusky Star Journal*, November 18, 1940.
286. *Massillon Evening Independent*, October 22, 1930.
287. *Findlay Republican Courier*, October 4, 1940.
288. *Mansfield News-Journal*, October 4, 1940.

289. *Sandusky Star Journal*, November 15, 1940.
290. *(Massillon) Evening Independent*, December 19, 1940.
291. *Mansfield News-Journal*, April 5, 1941.
292. *Findlay Republican Courier*, March 20, 1947.
293. *Van Wert Daily Times-Bulletin*, April 5, 1941.
294. *Zanesville Times Recorder*, January 16, 1947.
295. *Sandusky Register Star-News*, May 15, 1951.
296. It was founded in 1948 by artist Albert Dorne as the result of a conversation with Norman Rockwell. The faculty was composed of the most successful commercial artists of their era.
297. *Zanesville Times Signal*, February 25, 1951.
298. *(Massillon) Evening Independent*, May 15, 1951.
299. Ibid.
300. *Toledo Blade*, May 15, 1951.
301. *(Massillon) Evening Independent*, May 15, 1951.
302. Ibid.

Chapter 13

303. David Meyers and Elise Meyers, *Central Ohio's Historic Prisons* (Charleston, SC: Arcadia Press, 2009).
304. Lisa Forster, "Colliding Ideologies and Inmate Violence: The Final Chapter in the Life of a Prison Newspaper" (thesis, Ohio University, 2007).
305. Forster, "Colliding Ideologies."
306. Ohio Department of Corrections website, http://www.drc.ohio.gov/web/histop.htm, May 22, 2013.
307. *Van Wert Times-Bulletin*, January 7, 1953.
308. *Zanesville Signal*, November 1, 1952.
309. *Pittsburgh Press*, November 3, 1952.
310. "Rioting Convicts Disrupt Campaign," *LIFE*, November 10, 1952.
311. Ohio Highway Patrol 75th Anniversary, http://statepatrol.ohio.gove/doc/1950s.pdf, May 22, 2013.
312. *Pittsburgh Press*, November 3, 1952.
313. *(Findlay) Republican-Courier*, November 3, 1952.
314. *Hamilton (Indiana) Journal*, November 4, 1952.
315. *Pittsburgh Press*, November 3, 1952.
316. *East Liverpool Review*, November 19, 1952.
317. Ohio Highway Patrol 75th Anniversary, http://statepatrol.ohio.gove/doc/1950s.pdf, May 22, 2013.

318. *(Massillon) Evening Independent*, December 11, 1952.
319. *Van Wert Times-Bulletin*, January 7, 1953.
320. Meyers and Walker, *Historic Columbus Crimes.*
321. *Portsmouth Times*, October 19, 1953.
322. *Columbus Dispatch*, June 24, 2012.
323. *Newark Advocate and American Tribune*, December 6, 1952.
324. *Delphos Herald*, January 5, 1953.

CHAPTER 14

325. Rebecca Skloot, *The Immortal Life of Henrietta Lacks* (New York: Crown Publishing, 2010).
326. *Sandusky Register-Star-News*, February 24, 1947.
327. Sheppard claimed the murder was committed by a "bushy-haired" stranger. He was convicted largely because of his alleged three-year-long extramarital affair (which he denied) with a nurse, Susan Hayes. Later, the Sheppard case may have served as the model for the long-running TV series *The Fugitive* (1963–1967). By that time, Hayes had married Ken Wilhoit, who, coincidentally, was music editor for the show.
328. *Albuquerque Journal*, June 29, 1961.
329. *Colorado Springs Gazette Telegraph*, March 24, 1969.
330. *Hamilton Journal-News*, March 28, 1973.
331. *Elyria Chronicle-Telegram*, December 11, 1985.

CHAPTER 15

332. *Appleton Post-Crescent*, June 24, 1968.
333. *Mansfield News Journal*, June 24, 1968.
334. *Appleton Post-Crescent*, June 24, 1968.
335. *The Times-Reporter*, June 25, 1968.
336. *Mansfield News Journal*, June 26, 1968.
337. *Coshocton Tribune*, June 28, 1968.
338. *Zanesville Times Recorder*, June 30, 1968.
339. *Lima News*, June 29, 1969.
340. *Coshocton Tribune*, June 27, 1968.
341. *Lima News*, July 1, 1968.
342. *Mansfield News Journal*, July 5, 1968.

343. *Van Wert Times Bulletin,* July 17, 1968.
344. Don David, "We're Gonna Send You Goddam Guards Out One by One: Dead Dead Dead!" *Man's Magazine* (June 1969).
345. Dave Ghose, "The Ohio Pen's Avenging Angel," *Columbus Monthly* (August 2008).
346. Ibid.
347. Ibid.
348. *Las Vegas Optic*, August 20, 1968.
349. Ghose, "Ohio Pen's."
350. Ibid.
351. Ibid.
352. *Daily Chronicle Centralia (Washington)*, August 20, 1968.
353. *Redlands Daily Facts*, August 20, 1968.
354. *Hamilton Journal Daily*, News August 21, 1968.
355. David Meyers was working on a survey crew that summer. His party chief, Jerry White, belonged to a unit that was called up, and he drove him to the prison so he could report for duty.
356. *Hamilton Journal Daily*, News August 21, 1968.
357. Ghose, "Ohio Pen's."
358. Ibid.
359. *Sandusky Register*, August 22, 1968.
360. Ghose, "Ohio Pen's."
361. Ibid.
362. *Aiken Standard and Review,* August 22, 1968.
363. Ibid.
364. *Dover Times Reporter*, August 22, 1968.
365. Ghose, "Ohio Pen's."
366. Ohio State Highway Patrol 75th Anniversary History, http://statepatrol. ohio.gov/doc/1960s.pdf, May 22, 2013.
367. Ghose, "Ohio Pen's."
368. *Scottsboro Daily Progress*, August 22, 1968.
369. *Anderson Herald*, August 22, 1968.
370. *Lima News*, August 26, 1968.

Chapter 16

371. Thomas F. Byrnes. *Professional Criminals of America* (New York: Cassell & Company, 1886).

372. Charles Alphonso Smith, *O. Henry Biography* (Garden City, NY: Doubleday, Page & Co., 1916).

373. Jennings, *Beating Back*.

374. Smith, *O. Henry*.

375. Ibid.

376. Jennings, *Through the Shadows*.

377. Smith, *O. Henry*.

378. Jennings, *Through the Shadows*.

379. Ibid.

380. Ibid.

381. Ibid.

382. When asked who he thought did it, Moran responded, "Santa Claus."

383. *Hamilton Journal*, January 22, 1935.

384. *Circleville Herald*, March 25, 1939.

385. *Mansfield News Journal*, August 1, 1942.

386. *Lima News*, March 14, 1945.

387. Curiously, McAlester was known mainly for being the home of the Oklahoma State Penitentiary, while Jean Valjean was the inmate hero of Victor Hugo's *Les Miserables*.

388. *Dover Daily Reporter*, November 8, 1958.

389. *(Massillon) Independent*, April 17, 1976.

390. *Sandusky Register*, February 20, 1929.

391. Thomas Crowl, *Murder of a Journalist: The True Story of the Death of Donald Ring Mellett* (Kent, OH: Kent State University Press, 2009).

392. *Ironwood Daily Globe*, July 20, 1955.

393. *(Massillon) Independent*, April 17, 1976.

Index

Index

About the Authors

A graduate of Miami University and Ohio State University, David Meyers worked for thirty years in both adult and juvenile corrections. His experiences at the Ohio Penitentiary, the Ohio State Reformatory and other institutions helped inform his earlier book, *Central Ohio's Historic Prisons*. Among his local histories are *Columbus, the Musical Crossroads*; *Historic Columbus Crimes: Mama's in the Furnace, the Thing and More*; *Look to Lazarus: The Big Store*; *Ohio Jazz: A History of Jazz in the Buckeye State*; and *Columbus State Community College: An Informal History*. He also authored a novel, *The Last Christmas Carol*.

E lise Meyers Walker has a degree in art history from Hofstra University. She has worked as a freelance writer and photographer on such national magazines as *Teen Trend* and *Multiples*. She joined her father as coauthor on *Prisons*, *Crimes*, *Lazarus* and *Columbus State*.

A native of Wapakoneta, Ohio, James Dailey II graduated from the School of Advertising Art in Dayton, Ohio. He is curator of the Dailey Archives, an important assembly of artifacts, early photography and ephemera. It also comprises the largest privately held collection of Ohio prison memorabilia. *Inside the Ohio Penitentiary* is his debut work as an author.

Visit us at

www.historypress.net

···

This title is also available as an e-book

www.ingramcontent.com/pod-product-compliance
Lightning Source LLC
Chambersburg PA
CBHW060758100426
42813CB00004B/871